THE PAINTED PANORAMA

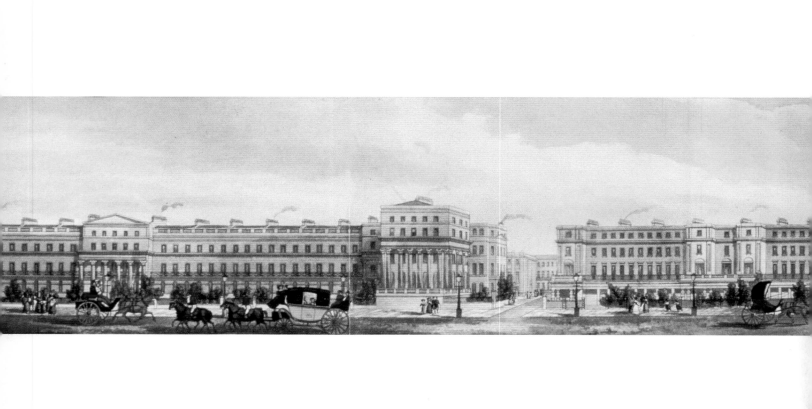

The Painted Panorama

BERNARD COMMENT

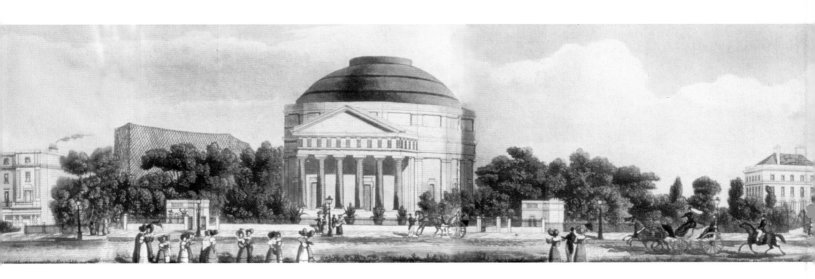

HARRY N. ABRAMS, INC., PUBLISHERS

Translated from the French by Anne-Marie Glasheen

Designed by Philip Lewis
Jacket design by Dana Sloan

On the title page: detail of Richard Morris, *A Panoramic
View round Regent's Park* (illus. 118).

Library of Congress Catalog Card Number: 99–73779
ISBN 0–8109–4365–4

This is a revised, expanded edition of a book originally
published in France in 1993 by Société Nouvelle Adam Biro, under
the title *Le XIXe siècle des panoramas*.

First published in 1999 by Reaktion Books, London,
under the title *The Panorama*.

English-language translation © 1999 Reaktion Books

Printed and bound in Italy

Harry N. Abrams, Inc.
100 Fifth Avenue
New York, N.Y. 10011
www.abramsbooks.com

CONTENTS

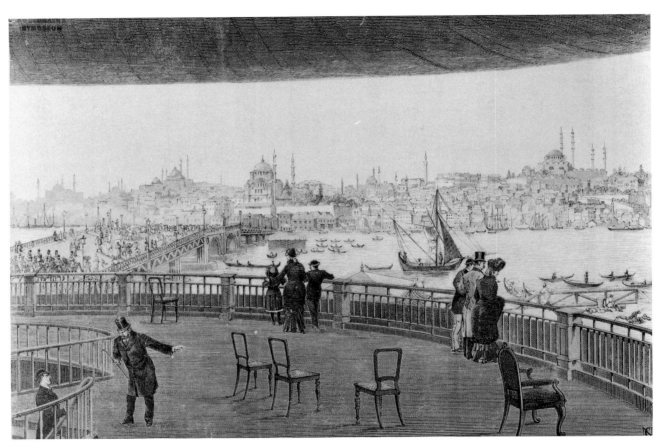

1. C. V. Nielsen, Viewing platform with spectators and detail of a panoramic view of Constantinople by Jules-Arsène Garnier (1847–1889) on exhibit in Copenhagen, *c.* 1882, wood engraving. Copenhagen City Museum.

INTRODUCTION

Panorama: a building in which a painting referred to as
a *panorama* is exhibited, that is to say painted on the inside
wall of a rotunda, covered by a cupola or cone-shaped roof.
 These paintings are faithful reproductions of what a place
looks like when viewed from all angles and from as far as the
eye can see. To that end, the spectator is placed on a platform
or circular gallery that simulates a tower and that is located at
the centre of the rotunda; the light flows in from above,
through an area of frosted glass fitted to the lower part of
the roof so that it falls onto the painting. A huge parasol,
suspended from the timbers above the platform, which is
greater in diameter, keeps the spectator in the dark and at
the same time conceals the sources of light.
Dictionary of Building Terms, vol. III (Paris, 1881–2)

The panorama was one of the most popular and most typical phenomena of
the nineteenth century, of which it is in a way the signature. A motley crowd in
search of wanton, enigmatic and rarely denied pleasure would rush to see these
spectacular paintings. It is my intention to explore the nature of this pleasure
and the issues it raises. A fundamental shift had taken place in the logic and
focus of representation; I feel that it would be interesting to examine this shift
with a view to understanding certain alienations of the modern age.

What, then, is a panorama? When in 1787 Robert Barker registered his
patent in London, he listed all the principles and features of an invention that
would remain pretty much unchanged over the years, apart from a few modifi-
cations aimed at perfecting the illusion it set out to create. The invention was
originally christened 'La Nature à Coup d'Oeil'; it was not until January 1792,
following an announcement in *The Times*, that the neologism *panorama* was
born. Derived from the Greek, it literally means 'see all'. A panorama is a
continuous circular representation hung on the walls of a rotunda specifically
constructed to accommodate it. Panoramas had to be so true to life that they
could be confused with reality. Having walked along a corridor and up a stair-
case darkened to make them forget the landmarks of their city, visitors reached
a platform surrounded by a ramp to stop them from going too near the canvas,
so that it might, 'from all parts it [could] be viewed, have its proper effect'
(illus. 1). The lighting was natural, emanating from the top, but its source was
concealed by a roof or veil that made it impossible to see beyond the upper
edge of the canvas, while a fence or other natural objects masked the lower

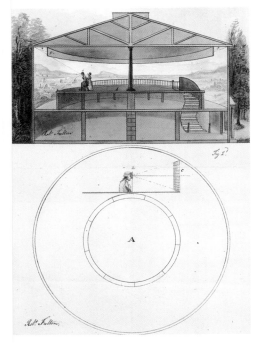

2. Robert Fulton (1765–1815), Plan and cross-section of panorama with observation platform, from *Description explicative du Panorama ou Tableau circulaire et sans borne ou manière de dessiner, peindre et exhiber un tableau circulaire*, certificate dated 26 April 1799, pencil drawing with colour, 48.5 × 33 cm. Institut National de la Propriété Industrielle, Paris.

edge. Everything was arranged so that nothing extraneous could encroach upon the display and disturb the spectator's field of vision (illus. 2). Such was the paradoxical status of the panorama: an enclosed area open to a representation free of all worldly restrictions.

It is important to visualize the situation at the end of the nineteenth century: a landscape transformed by the Industrial Revolution and the emergence of the first great metropolises, beginning with London. The city exploded, becoming opaque, no longer visible. In conditions like these, the panorama had a decisive role to play. Not only did it express the perceptual and representational fantasies that befitted such troubled times; it was also a way of regaining control of sprawling collective space. However, it was at the very moment when individuals seemed to want to escape from mass culture and loss of identity that they became party to the primary alienation of the image. They returned to the *imaginary* situation that reality was preventing them from living. It therefore should come as no great surprise that the subjects of the first canvases were the actual towns in which they were exhibited. I shall have occasion to examine the reasons behind this curious duplication in Chapter 14.

Another theme soon emerged: that of war, of military power. The situation in Europe was convulsive, and – by circulating a view of history focused on heroes and momentous events, founded on nationhood and states in confrontation – the panorama became a propaganda machine, one that – in direct opposition to the social history espoused by Marx – sought to identify larger movements, more complex interests. Painters of panoramas endeavoured to be as faithful as possible to events, and sometimes it was only two or three months before a canvas depicting heroic deeds appeared to exploit moments of patriotic fervour and keep them alive.

Finally, a third theme emerged from the production of panoramas: that of travel and distant lands. At times, historic cities were portrayed (in particular those of the Grand Tour: Rome, Florence, Naples, Palermo, Pompeii, Athens, Constantinople), and at other times imposing landscapes (Switzerland, Etna, the Alps) or exotic places such as Calcutta, Rio de Janeiro and others often associated with colonial and imperialistic policies that were thereby assured of being promoted in the public mind.

Whether military scenes or representations of distant lands, everything was done to achieve the greatest visual accuracy. Panoramists worked on the spot to plot the terrain with the help first of the camera obscura and then of photography. Technical and compositional difficulties remained unresolved, however. Transferring sketches to large-scale formats and from flat surfaces to cylinders meant that horizontals needed constantly to be readjusted to compensate for the proliferation of vanishing-points and the distortions this entailed. The main co-ordinates were fixed by means of a two- or three-tiered

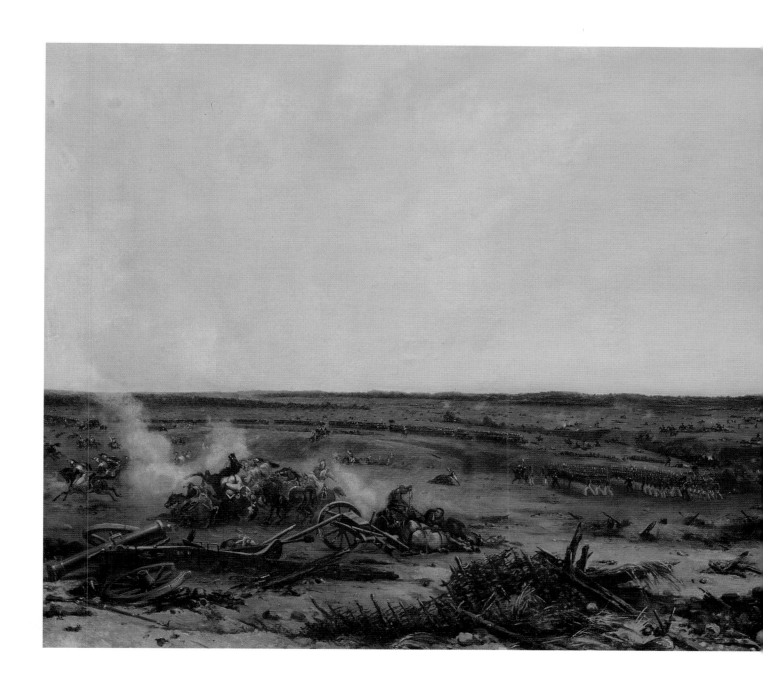

3. Charles Langlois (1789–1870), Study for *The Battle of Moscow*, 1838, oil on canvas. Musée de l'Armée, Paris.

A student of Horace Vernet, Langlois had been well schooled when it came to painting battle scenes and sweeping vistas. His experiences as an officer in Napoleon's army determined his choice of themes for the panoramas which he produced for the rotunda inaugurated in 1831 with his *Naval Battle of Navarino*. *The Battle of Moscow* shows a particularly dramatic moment during the Napoleonic era, which still haunted people at the time.

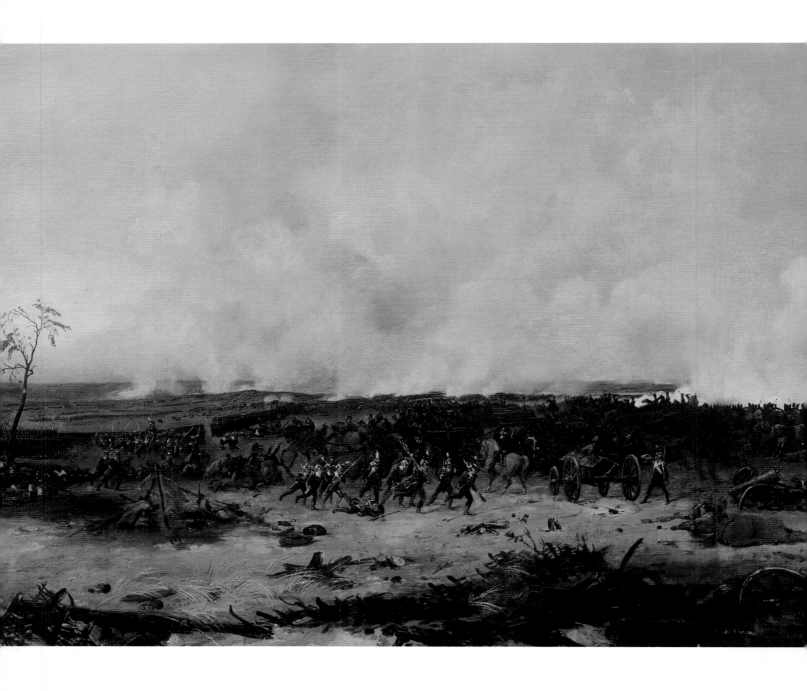

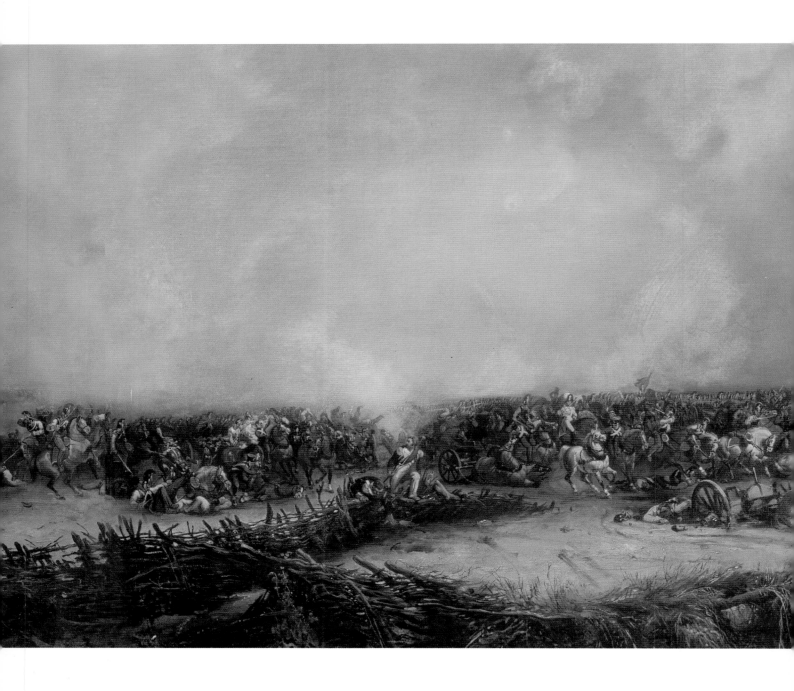

platform on tracks for the horizontals and a plumb-line for the verticals. Moreover, the problems with perspective were compounded by the enormous dimensions of panoramas. If the standard dimensions were 15 by 120 metres, the resulting tension in the weight of a painted canvas was around 47 kilos per metre! Even by slightly reducing the lower diameter and pulling the canvas down as much as possible, or 'shrinking' it by applying an aqueous solution which, as it dried, stretched the calico, there could still be a convex curve of as much as a metre. Nor should we overlook the enormous variations in temperature created by glass roofs or the humidity produced by the influx of visitors. Nonetheless, Germain Bapst stated in his *Essai sur l'histoire des panoramas* (1891) that these conditions could produce 'natural vanishing-points and gradations of tone that helped perspective' and that 'the light coming from above fell onto the upper part of the canvas, that is to say the sky, and that by highlighting that, rather than the curving portion of the foreground, it produced a more natural appearance than would have been possible with a flat surface.'

The scale and complexity of the task demanded that teams be assembled based on the principle of the division of labour (Marx's famous *Arbeitsteilung*), which, from an artistic point of view, created major problems (illus. 4). For in matters of colour and lighting, each artist initially tended to adopt his own method and style. It was therefore deemed necessary to establish a hierarchy so that a co-ordinating of activities, unity of style and harmonization of composition could be achieved. The leader directed his team from a platform set back from the work and made the necessary adjustments (illus. 5). Specialists soon emerged in perspective, skies and landscapes, while others took charge of architecture, vegetation, costumes, weapons and other details. Painters of miniatures

4. Adolf Oberländer (1845–1923), Caricature of painters of panoramas, 1887, lithograph. Private Collection.

Teams of artists were assembled to produce panoramic canvases. Since each worked in his own way, things did not always go smoothly, as could be deduced from the coherence (or otherwise) of the finished products.

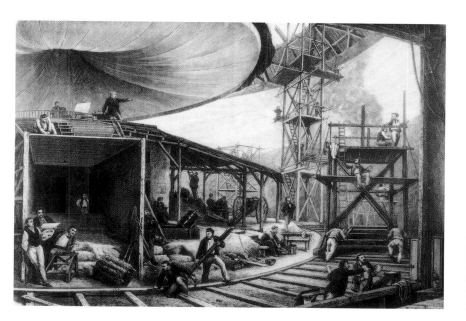

5. Félix-Emmanuel-Henri Philippoteaux (1815–1884) overseeing the production of his *Panorama of the Champs-Élysées* and colleagues busy with the laying of the fake terrain, engraving from *Le Monde illustré*, 2 November 1872.

6. John Buckler, The panorama studio of
Robert Barker and Son in West Square,
Southwark, 1827, ink drawing,
15 × 23 cm. Guildhall Library,
Corporation of London.

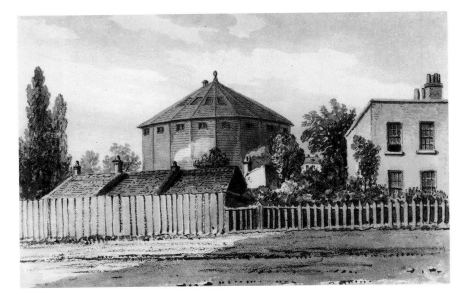

and portraits with a reputation for precision and attention to detail were taken
on, for, as we shall see, the documentary merit of panorama painting was
founded on hyperrealism.

The panoramic phenomenon was not solely pictorial, however; we should
not forget that from the outset, Barker's brand of neologism dictated both
a 360-degree representation and a rotunda to accommodate it. The large
investments required involved the formation of small neo-capitalistic structures
that brought together businessmen, financiers, architects, designers, teams of
workers and project co-ordinators. From the 1850s onwards, limited com-
panies were formed, some of which soon became international. Distribution
networks were set up and standards set so that the canvases could be exhibited
in more than one town, despite their unwieldiness (they weighed several tons)
and the fact that the painted surfaces could deteriorate rapidly as a result of
being rolled, unrolled and transported. Highly competent teams were formed
that produced canvases with ever-increasing rapidity. Comprising between
two and five artists and assistants, they could produce a panorama in six to
twelve months. In order to speed up the series of shows and avoid exhibition
rotundas, they sometimes hung their works in wooden rotundas or makeshift
workshops (illus. 6). The growth of industry in art could not have been more
apparent; developing over the years, it culminated in a plethora of panoramas
in the great exhibitions held at the end of the nineteenth century, in which the
triumphant device flaunted its novelty, increasing sophistication and boldness
– even at times its power to shock.

In the first part of this book, chapters 1–5 are organized along geographical
and chronological lines. They follow the history of the panorama, describing
its evolution, variations and spread, its locations and movements in such a way

as to equip the reader with the necessary information to address the interpretations that follow. Chapters 6–14 deal with the theoretical aspects of the panorama, both as a phenomenon in its own right and as a type of representation. According to one approach that embraces aesthetic, topological and sociological preoccupations, the panorama constantly raises the question of the individual's place in the world or community and the different ways in which he or she can or has to relate to them. The second part of the book provides a survey of the panoramic medium, including preparatory drawings, prints and finished canvases, as well as advertising and other information associated with these mass entertainments.

The invention of the panorama was a response to a particularly strong nineteenth-century need – for absolute dominance. It gave individuals the happy feeling that the world was organized around and by them, yet this was a world from which they were also separated and protected, for they were seeing it from a distance. A double dream came true – one of totality and of possession; encyclopaedism on the cheap.

But by marking the transition from representation to illusion, the panorama also introduced a new logic pregnant with consequences. One of its many culminations is modern-day television, whose evolution has been particularly enlightening. The image no longer seeks to present nature in an ideal or even idealized state. It replaces reality, does away with the need for practical experience, and soon deprives observers of personal experiences that help them see and acquire knowledge. Under the guise of entertainment, enlightenment or education, a collective imagination forms that – sooner or later – propaganda, advertising or commerce can come along and claim.

I

'THE PURSUIT OF MAXIMUM ILLUSION'

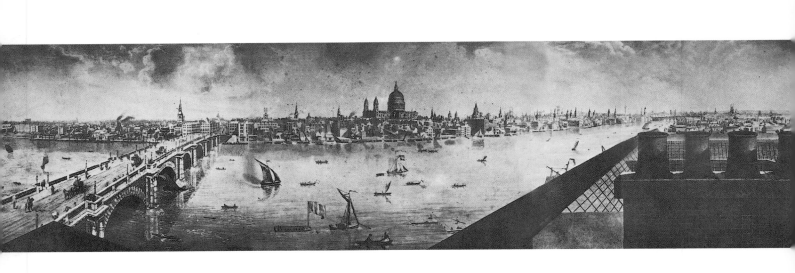

The London Panoramas: From Leicester Square to the Colosseum

Taking a walk one day in 1787 on Calton Hill with Edinburgh at his feet, Robert Barker, self-taught painter of portraits and miniatures, suddenly hit upon the idea of a circular representation that would display the whole of the magnificent landscape he could see. The *panorama* that would assure his fame and fortune was born.

The reaction of Sir Joshua Reynolds, consulted in his capacity as President of the Royal Academy, was not favourable. He could not see how this new form of painting would be of any interest. The configuration had probably not yet been perfected, and the results were not convincing, particularly with regard to lighting and dimensions, which had to allow the spectator to stand sufficiently far away from the work. Moreover, Barker's first creation was semi-circular. But Barker was not a man to be easily discouraged. On 19 June 1787, he registered a patent; in the following year, he set off to establish himself in London with the *Panorama of Edinburgh*, which he exhibited in his house. It was not a great success. Having nonetheless decided to undertake a second and much larger canvas, he chose the view of London from the Albion Mills, a symbol of the Industrial Revolution (illus. 7). Despite the inappropriateness of the temporary rotunda set up at 28 Castle Street (as it was too small to accommodate the whole canvas, a reduced version had to be shown), Reynolds had a change of heart on his visit and expressed his admiration thusly: 'Nature can be represented so much better there than in a painting restricted by the normal format.'

7. Frederick Birnie (*fl. c.* 1791–3), six engravings after a drawing by Henry Aston Barker (1774–1856) to a design by Robert Barker (1739–1806), *London from the Roof of the Albion Mills*, 1792, coloured aquatints, 43.2 × 330 cm. Guildhall Library, Corporation of London.

Despite the lukewarm reception given his first, imperfect view of Edinburgh, Robert Barker followed his idea through and produced a circular canvas. It was his son Henry Aston, then aged sixteen, who was sent up onto the roof of the Albion Mills to make the preliminary drawings. A first version, in tempera, measuring 137 square metres (probably copied here by Birnie), was produced for the temporary rotunda built in Castle Street. A second version, 250 metres square, was created (this time in oil on canvas) for the new rotunda in Leicester Square, which opened on 25 May 1793.

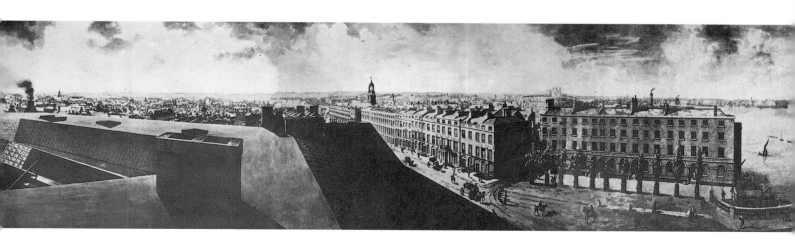

8. Thomas Hosmer Shepherd
(*fl. c.* 1817–40), Entrance to Barker's
(subsequently Robert Burford's)
rotunda on Cranbourne Street, 1858,
watercolour, 22.4 × 17.1 cm. British
Museum, London.

The Leicester Square Rotunda

The takings from the London panorama gave Barker the wherewithal to finance other ambitions. He bought a plot of land in Leicester Square (illus. 8), where the architect Robert Mitchell built him a rotunda made up of two levels, each of a different size (illus. 80). The building, with its two complementary windows set in the roof, one external for the great hall, the other internal for the small hall, allowed two canvases to be exhibited at the same time. The long path that separated the two platforms was in fact designed to plunge spectators into darkness and, by obliterating the memory of the first, prepare them for a second illusion. Ingenious though Mitchell's prototype was, it would never be reproduced; the single rotunda proved more popular.

In the summer of 1793, Barker and his son Henry Aston Barker went to Plymouth to prepare the way for the inaugural panorama *View of the Fleet at Spithead*, which for the first time was painted in oil rather than tempera. This became the artistic event of London, and on 1 May 1794 the Royal Family graced the panorama with their presence. It was reported that Princess Charlotte admitted suddenly to feeling seasick when she found herself surrounded by boats. The platform had been disguised as the afterdeck of a frigate so that the spectator would feel totally immersed in the experience of the sea.

In 1795, the Spithead panorama was replaced by one depicting an important naval battle that had taken place near Queffant and had been won by Admiral Howe on 1 June 1794. Patriotic fervour was evident in this scene, as there was a particularly strong English taste for anything connected with the sea. But the panorama that created the greatest stir was that of another naval battle fought in 1799. The enthusiasm with which the *Battle of Aboukir* was received was unanimous. The correspondent of the German *Journal London und Paris* advised his readers to wait a while before going to see this new show: because of the great crush of people, it was difficult to move around the platform, which meant that the visual unity of the canvas was impaired and, as a result, people were prevented from enjoying it as much as they should have done.

Also in 1799, Henry Aston Barker undertook his first study tour, which took him to Constantinople, from where he returned with enough drawings for two different panoramas of that city. Taking advantage of the Peace of Amiens, he went to Paris in 1802 and was received by Bonaparte. When his father died in 1806, Henry Aston inherited his estate; from then on, he steered the ship alone. After Napoleon's abdication, the panoramist visited the Emperor on the island of Elba.

In the early days of the panorama, canvases were sold after they had been exploited for a few years, to be hung in new rotundas (first in towns outside London, then in Germany, France and Holland). But the takings remained low, barely covering the initial cost of materials. Moreover, it had become the

Barkers' habit to paint over old views rather than sell them. Until its disappearance in 1861, the Leicester Square Rotunda would put on a new show every year or two in rotation. In all, no fewer than 126 productions were exhibited there!

Other Rotundas

Few panoramists were as successful as the Barkers in attracting the favours of the London public. Robert Ker Porter was one, although it is not known whether he painted completely circular canvases (his were probably horseshoe-shaped). His first canvas, *The Storming of Seringapatam*, related in subject to the colonization of India, was a great success in 1800 (illus. 9–11). It was immediately followed by *The Liberation of St John d'Acre*, an episode in the Egyptian war in which the English army liberated the battalion captured by Bonaparte. Thomas Girtin's *Eidometropolis*, inaugurated in 1802, was introduced as a 'vast picture' of London and did not refer explicitly, until it was too late, to the panoramic style that became the vogue.

In fact, the Leicester Square Rotunda's chief rival was a member of the Barker clan: Henry Aston's brother, Thomas Edward, who in 1802 opened the Panorama Strand, in association (in this instance) with the painter Reinagle, who undertook most of the artistic work. This collaboration lasted until 1817, when the two men sold their property to Henry Aston. He monopolized the production of panoramas in London until 1826, when, having made his fortune, he decided to retire following the incredible success of *The Battle of Waterloo* (illus. 12).

It was the Burfords, father (John) and son (Robert), who took over the reins in Leicester Square and the Strand before the latter site was converted to a theatre in 1831, having probably fallen victim to the new Colosseum, which opened in 1829 (illus. 13). John Burford was known for settings connected with travel and changes of scene (Mont Blanc, Rome, Benares, Macao, Kabul, Damascus, Pompeii, etc.). It was because he repeated the same themes that he was so successful. The genre was beginning to run out of steam, however, so he attempted to

9–11. Robert Ker Porter (1777–1842) and John Vendramini (1769–1839), *The Storming of Seringapatam* ('This Plate of the last effort of Tippoo Sultaun, in defence of the Fortress of Seringapatam; The Storming of Seringapatam; To the most noble The Marquis Wellesley . . . The Glorious Conquest of Seringapatam'), *c.* 1800, reproduction, probably of a semi-circular panorama, in the form of three prints, each 60.3 × 91.5 cm. National Army Museum, London.

The battle was on 4 May 1799, and among the officers involved was Arthur Wellesley, future Duke of Wellington.

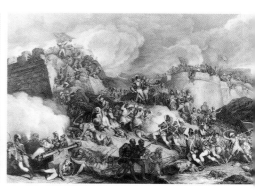

12. Henry Aston Barker (1774–1856) and John Burnet, *Explanation of the Battle of Waterloo, Painted on the largest Scale, from Drawings taken on the Spot, BY Mr. Henry Aston Barker Now . . . Exhibiting in the Panorama, Leicester Square*, 1816, 23 × 15 cm. David Robinson Collection.

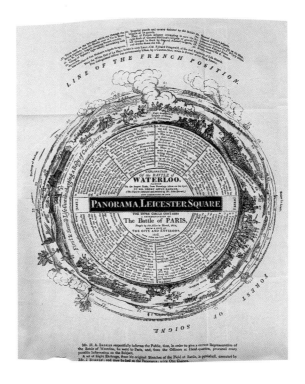

13. Robert Burford (1792–1861), *Explanation of a view of the city of Pompeii, exhibiting in the Panorama, Strand*, 1824. Guildhall Library, Corporation of London.

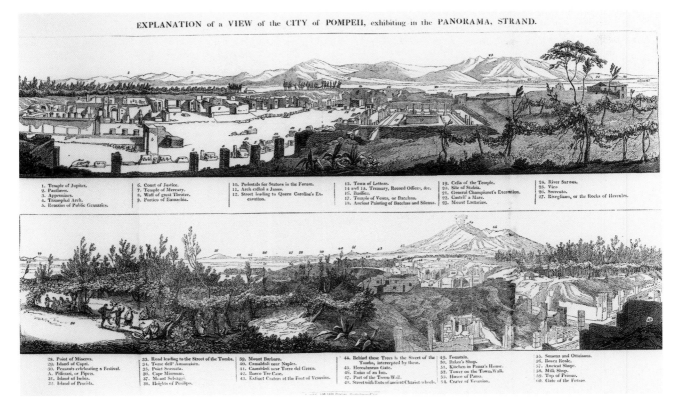

break new ground with a 'Pandemonium' based on Milton's *Paradise Lost*, but the literary mood barely touched a public unfamiliar with the material.

The Colosseum

Only the famous Colosseum (illus. 14) was able to rekindle the popularity of the panorama, at least for a while. The revival came about almost by accident: between 1822 and 1824, scaffolding was being erected for the renovation of the bell tower of St Paul's Cathedral. The designer Thomas Hornor took advantage of the opportunity to have a small hut installed at the top of the tower (illus. 61) from which he studied his surroundings for what at first was supposed to be a simple Leporello in aquatint, but which — having resulted in an enormous number of drawings (around 280) and sketches and a proliferation of views — very soon developed into a colossal project capable of using up all this material.

Hornor then had to overcome the usual problems of teamwork. As a result of inadequate supervision, he found himself with a composition that did not hang together and whose effects of sun and wind changed from one artist to the next. He then called upon the marine artist Chambers to work on a new version. In November 1829, with work still in progress, the Colosseum opened its doors to the public. Only the panorama as such had been completed. It had an internal diameter of 38 metres and was 24 metres high. The whole was crowned with a semi-circular cupola topped with a glass lantern 11.5 metres high. The solid part of the cupola was covered with a coat of plaster on which was painted a sky that blended with the canvas. The platform was reached either by a staircase in the form of a double helix (with observation windows that betrayed its classical configuration) or by a lift on the axis of a central pillar supposedly modelled on the bell tower of St Paul's (illus. 21, 81). In his 'Aperçu historique sur l'origine des panoramas', Johann Ignaz Hittorff voiced his misgivings with regard to a design that, in his opinion, violated the unifying and synchronized relationship between platform and canvas:

> The space occupied by the spectator is also an excellent reproduction of the reality seen by the painter as he drew his view; but premises like these are no more than narrow corridors that only allow you to look at the painting directly in front of you. You can neither look to the right nor to the left nor behind you without displacing yourself. The final effect is far from satisfactory. The same criticism can be made of the strange notion of having the spectator climb up to three different floors, each raised 3 metres above the next, so that he can see a perspective that, with the exception of the level the perspective was made from, is not an illusion, as it is being viewed from a completely different angle.

He went on to criticize the strength of the shadows cast on the canvas because frosted glass had not been used, falsely concluding:

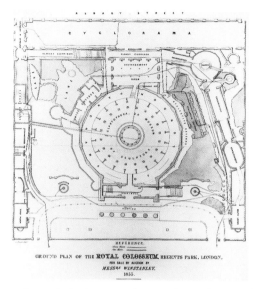

14. James Basire (1730–1802), *Ground Plan of the Royal Colosseum, Regents Park, London*, 1855, tinted lithograph, 57.2 × 47 cm. Westminster City Libraries, Marylebone Collection, London.

Any feeling for the real in art is still so alien to the majority of Londoners that the consecutive and multiple appearance of these projections of light and shade on the sky and objects furthest away from and nearest to the eye usually delights the majority of spectators without shocking them.

The hut Hornor had used to make his studies was on show on the top platform, where fresh air circulated to create the illusion that the spectator was at the top of the dome of St Paul's.

Despite healthy audiences, Hornor was never able to pay off his initial debt. In 1835, he sold the Colosseum to an unknown buyer who fared no better than he had. Not until 1844, when it was bought up by a financier with a feel for business, was the project finally finished. William Bradwell closed the place down for a year, restored the canvas, finished the surrounding fixtures and fittings (a glyptological collection, Swiss 'cottage', galleries, exhibitions, etc.) and then opened the doors of what was to become one of London's great cultural centres, attracting even more people to what had become a show, a museum and a club. The Colosseum became an extremely fashionable place whose popularity lasted until the end of the 1850s, when it in turn gave way to the exotic panoramas (Rome, Paris, the Lake of Thun) and, more particularly, the new attractions on offer at the Crystal Palace.

There were no new panoramas following the death of Robert Burford in 1861. Fashions changed, and the few attempts to import panoramas from France and Germany between 1880 and 1890 ended, more often than not, in failure.

The Paris Panoramas: From Prévost to Langlois

Barker's early London panoramas toured the major cities of the United Kingdom and then Europe. But they soon deteriorated as a result of constant handling. Consequently, it quickly became apparent to Continental Europeans that there was a need for independent, locally produced panoramas so that original and recently painted canvases could be exhibited.

It was the American engineer Robert Fulton, probably after having come to an agreement with Robert Barker, who first applied for an import licence. On 26 April 1799, he was granted a ten-year licence, which he sold on to his fellow countryman James Thayer on 8 December of the same year. But there is no reason to think that in the meantime he produced no panoramas. Several sources confirm the existence of one in the Jardin des Capucines in Paris, bounded by the Boulevard des Capucines and rue Louis-le-Grand. (The exhibition area was therefore separate from the rotundas of the Boulevard Montmartre, although it was confused with them by historians from Hittorff to Oettermann via Bapst.) From the summer of 1799, it was possible to see a *View of Paris from the Tuileries* made by Pierre Prévost with the help of Constant Bourgeois, Denis Fontaine and Jean Mouchet. The following year, this same Prévost painted *The Evacuation of Toulon by the English in 1793*. He was soon acknowledged as the greatest first-generation French panoramist, initially as an employee, then in partnership and finally working for himself.

Unable to obtain the necessary financial backing to pursue his enterprise, Fulton sold his patent to the promoter Thayer. Between 1800 and 1801, the latter erected two rotundas one after the other in the gardens of the Hôtel de Montmorency-Luxembourg, which gave onto the Boulevard Montmartre and of which he was the proprietor and developer (illus. 15). However, as Hittorff pointed out, these panoramas were small:

> . . . [they] were only 14 metres in diameter, with a central platform whose circumference was 18 metres. Bearing in mind the smallness of size and lack of illusion produced by the close proximity of spectator to painting, we have every right to be amazed at how effective these panoramas were . . . But if Mr Prévost's panoramic views [*sic*] were such a success, this was first and foremost because new and extraordinary things are always inspiring even when they have not been perfected.

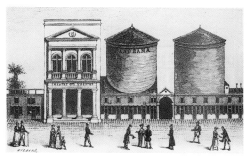

15. The panorama rotundas in the Boulevard Montmartre, Paris, 1802, from Germain Bapst, *Essai sur les dioramas et panoramas* (Paris, 1891).

In 1801, Prévost exhibited a *Panorama of Lyon* in one of the new rotundas, although it is not certain whether it was meant to inaugurate the space or was replacing a panorama taken from the Jardin des Capucines. Whatever the circumstances, it was not long before the Parisian public were invited to come along and discover the first panorama of London painted by Barker. The seven-page guide with map, specially published to mark the occasion, ended with an invaluable reminder: 'The *Panorama of Lyon*, Boulevard Montmartre, as well as the one of Paris, Jardin des Capucines, are still open to the public.' The three rotundas no doubt functioned in unison, with comings and goings that make it difficult to work out the exact chronology of those early years of exploitation.

In 1804, the *Panorama of Lyon* was replaced by a winter *View of Amsterdam*, an extremely melancholic, misty landscape also by Prévost. That same year, a new panorama of London was exhibited that could well have been Thomas Girtin's *Eidometropolis*, on show in London from August 1802 to March 1803. However, the dimensions of the canvas (with its smaller diameter of 13 and height of 5.5 metres) were much smaller than the Paris rotunda could accommodate (a diameter of 17 and height of 7 metres), which may explain why it was criticized in the *Journal London und Paris*, in an article deploring the fact that the platform, clearly larger in Paris than in London, brought spectators too close to the canvas, thus destroying the illusion despite the painting's enhanced clarity and precision.

In 1806, after the successful showing of his panoramas of Rome and Naples, Pierre Prévost advertised a panorama of the *Fleet at Boulogne Preparing to Invade England*, glorifying the naval prowess of the Napoleonic army. To coincide with this, the other rotunda revived the panorama of London previously exhibited in 1804 with the obvious intention of having the two cities confront one another. The reporter from the *Journal des Luxus und der Moden* (vol. XIX [1807]) praised the quality of the Boulogne panorama, but criticized Prévost's excessive patriotic zeal. He had apparently retouched the canvas in order to darken the English capital, erasing the majority of the ships on the Thames with a view to creating the image of a weak, cheerless and underdeveloped nation. This was the first sign of the panorama being modified for use as a propaganda tool, a development that would increase in later years.

A New Rotunda

In 1808, Thayer and Prévost joined forces and opened a rotunda at the corner of Boulevard des Capucines and rue Neuve-St-Augustin (which became rue Daunou in 1881; illus. 17). This was a plot of land which had been part of the former convent of the Capuchins; Franconi had built a stone circus there, but had sold it in 1806 in the wake of the division of the gardens when the rue de la

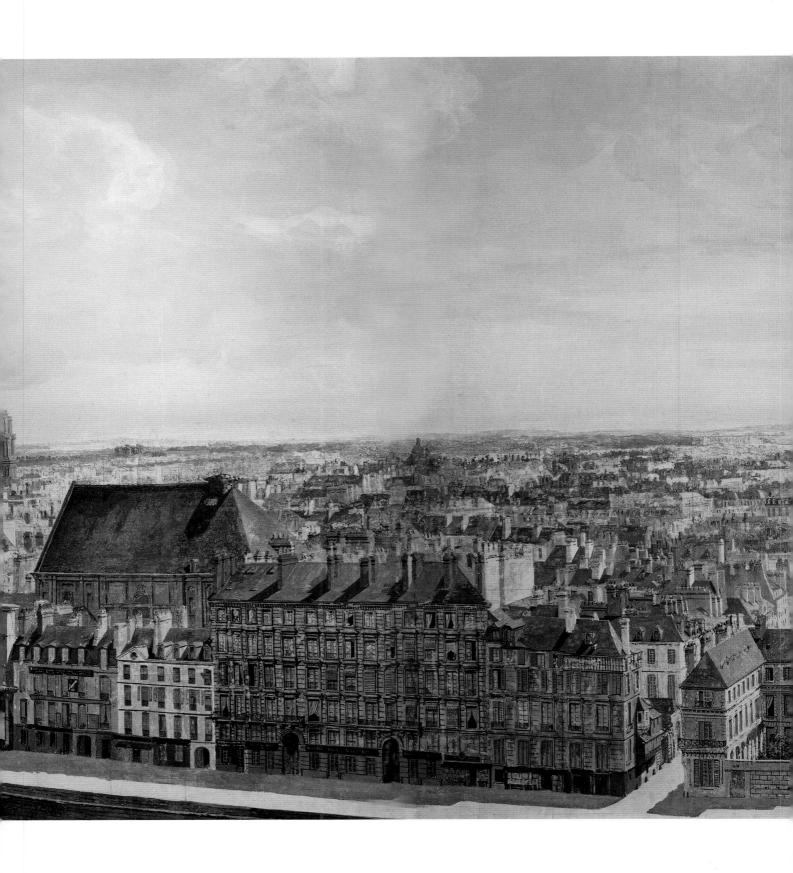

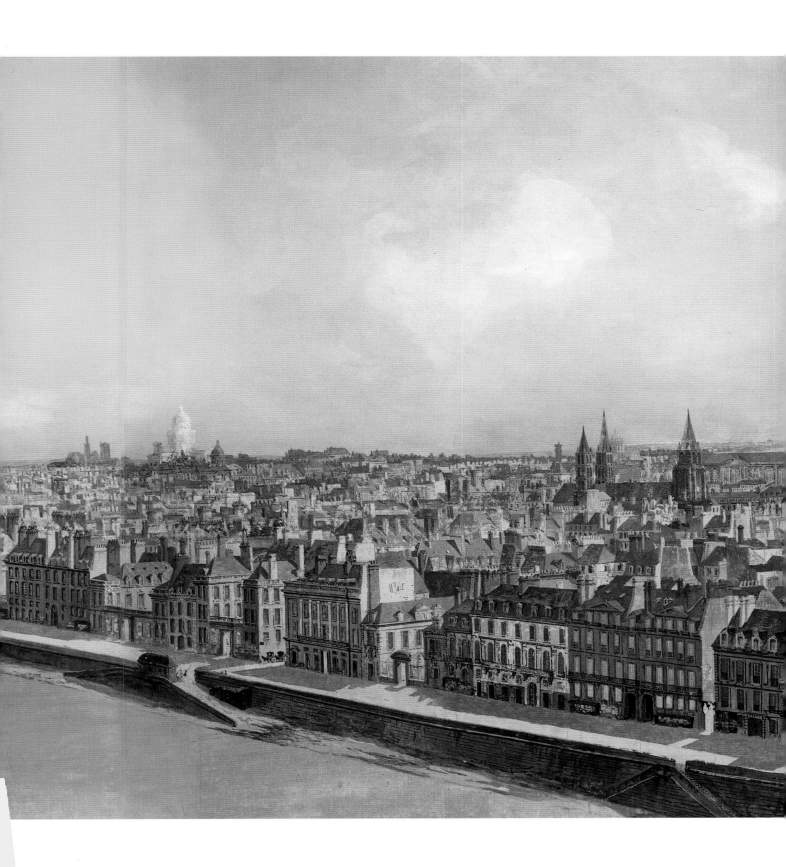

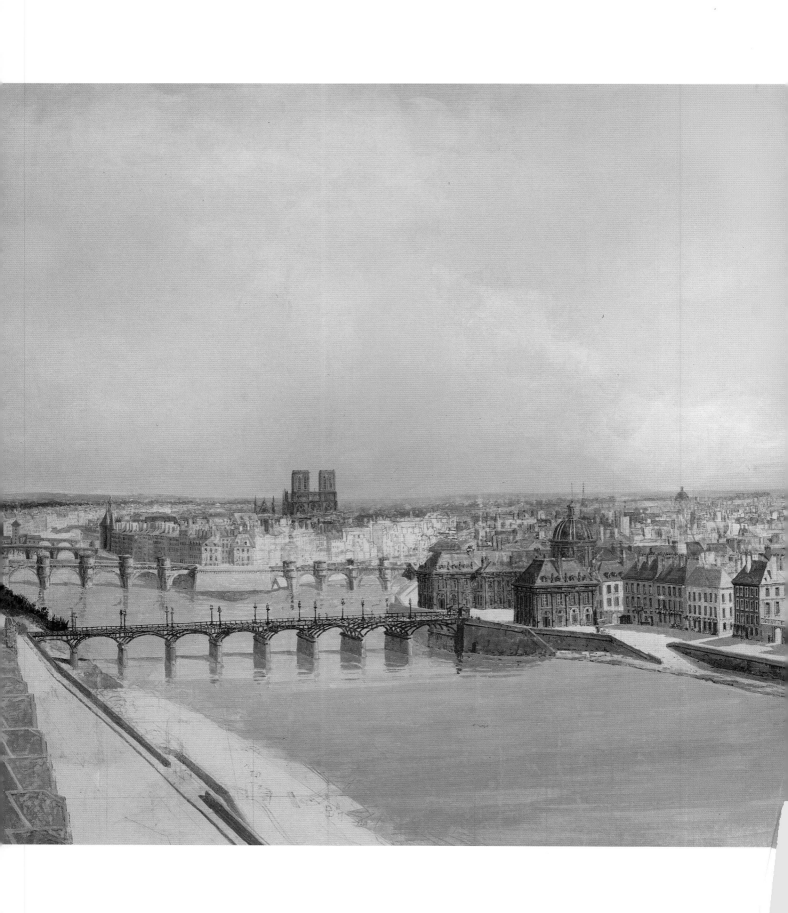

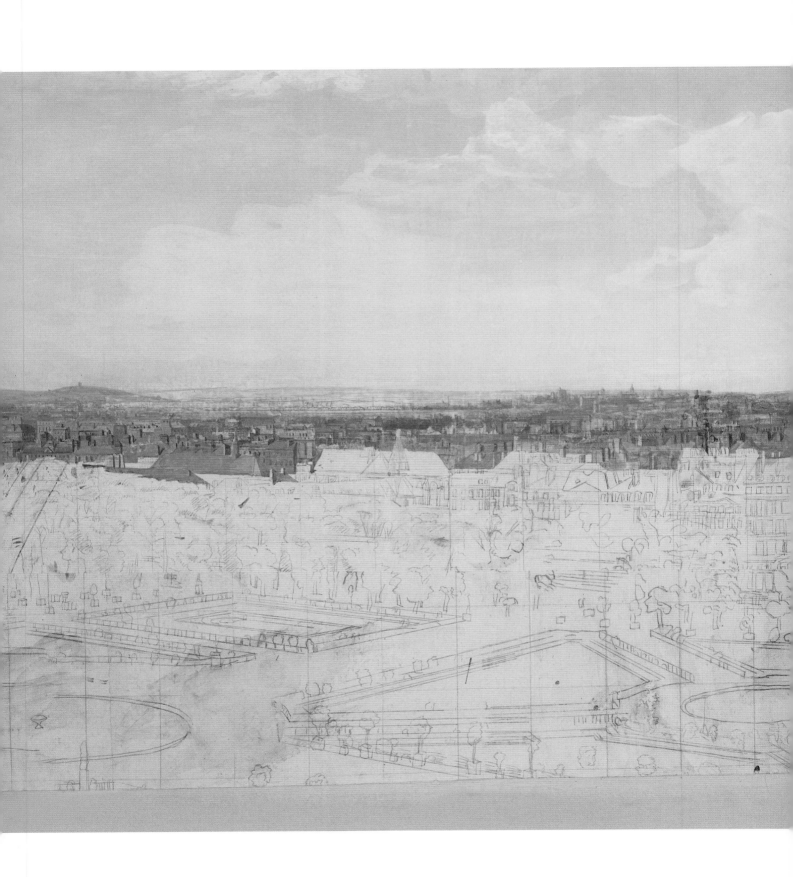

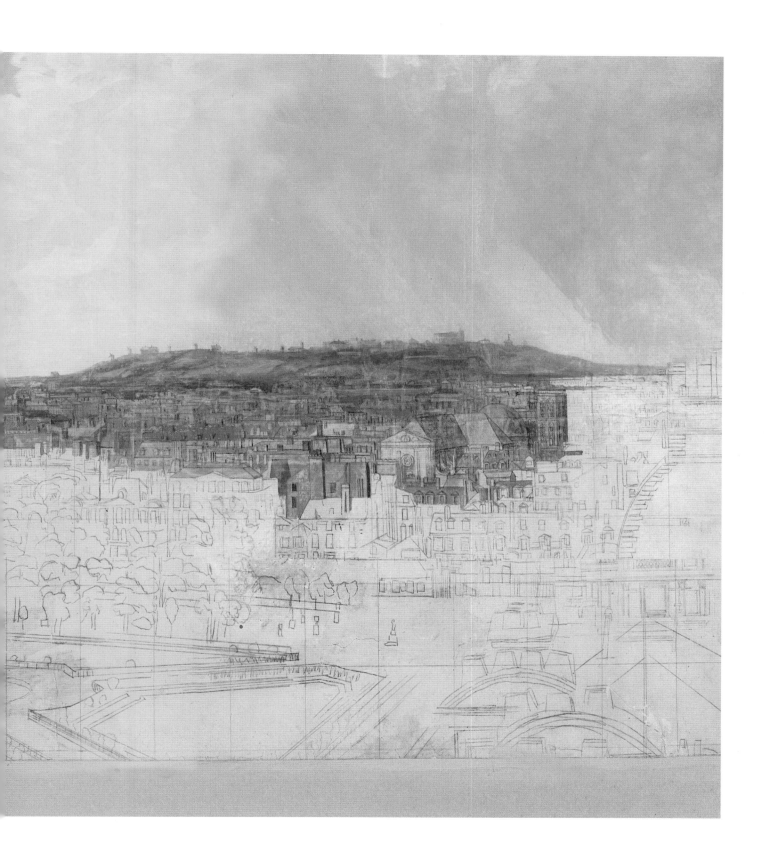

PAGES 31–43

16. Pierre Prévost (1764–1823), Preliminary drawing of Paris in 1804 for the panorama of Paris exhibited in Vienna in 1814, *c.* 1805–13, crayon and gouache on paper mounted on canvas, hand-coloured, 64 × 817 cm. Collection Galerie J. Kugel, Paris.

All of its characteristics would lead us to presume that this is a preliminary drawing (probably the tenth) for a panorama of Paris seen from the Pavillon de Flore, drawn and then painted by Prévost prior to producing the full-scale piece for Vienna. Documents tell us that in 1812, the rotunda in the Boulevard des Capucines exhibited a *Panorama of Vienna* based on a drawing Prévost had made during a trip in 1809. It is not difficult to imagine that the panoramist took advantage of Napoleon's victories to accompany the army in order to make contact with Mme Barton, the proprietor of a rotunda in the Prater gardens. In 1814, a *Panorama of Paris* went on show which Heinrich Klauren, in his *Kurze Bemerkungen auf langen Berufswegen* (1816), described as having been executed from the windows of Napoleon's apartments in the Tuileries: 'Napoleon must have thought that if great Paris was shown to the rest of the world, it would no longer be his Paris. As fate would have it, Mme Barton opened her Panorama on the very day that news reached Vienna that the Allies had entered the capital of Europe – as the proud French often call it. A minor historical inconsistency depicting the Place du Carrousel as though it were already finished, and in a lay-out that it would have subsequently, has such a vivid effect in this painting that one might think one had been transported to the centre of Paris, since all one can see is the city in its immensity, spread out at one's feet far into the distance.

The topographical explanation of this panorama (illus. 83) shows that, unlike the drawing, the full-scale canvas depicted the Place du Carrousel as it would be under the Second Empire. The painter may have been inspired by existing plans for the joining of the Tuileries palace and the Louvre. But was this panorama the work of Pierre Prévost? In the historical note his brother Jean wrote about Pierre, Jean noted (having recalled the later panoramas of Tilsit and Wagram as masterpieces): 'The other panoramas painted by Prévost are those of Paris, drawn from the pavilion in the middle of the Tuileries . . . the second is the view of

Toulon, taken from the Lamalgue fort. These works were a great success. They were followed by Lyon, Paris from the Pavillon de Flore . . . and then Boulogne.' Although this publication contains a few chronological errors it would seem that Pierre had the idea for a panorama of Paris as seen from the Pavillon de Flore around 1804/5. Since no such spectacle is documented in any of the Paris rotundas of the time, we can only conclude that this view of a city-within-a-city was never realized.

Any effort at dating this preliminary work suggests that two realities have been superimposed as in a palimpsest. It is possible to see a number of differences between the *drawn* version and the *gouache* one. For example, an area has been left blank in the gouache 'layer' where the present-day Musée d'Orsay should appear. We should remember that the area between the rue de Poitiers and the rue de Bellechasse was, in 1810, the vast building site of the Palais d'Orsay, which was not finished until 1838. When he was making the coloured version of this drawing, the artist must therefore have had a wasteland or, at best, the foundations of a building in front of him. Hence the blank area. This 'blank' includes buildings in the drawn 'layer', probably those destroyed in 1810 to make way for the palace. A void exists on the topographical indication, whereas in an identical view (illus. 18) dating from around 1830–33, the palace was still under construction.

Another example of changes between the drawn and gouache 'layers' can be found if we look carefully at the angle of the wing at the end of the Grande Galerie, of which all that can be seen is the rectilinear roof, in the extension of the Pavillon de Flore. The artist covered with his brush the existing drawing in which a roughly sketched tower can be seen; this could be the chapel of St-Louis-du-Louvre, which was destroyed in 1811. The most striking element of the drawn 'layer' is, however, the alignment of the houses on what would today be the middle of the Place du Carrousel. The painted version takes into account Napoleon's 1806 decision to create a link between the Louvre and the Tuileries. The drawing must have been made before 1806, and the painting over it some years later.

As to the dating of this drawing, I have already referred to the disappearance of St-Louis-du-Louvre in 1811. Just opposite,

at the end of a promenade along the river and almost on a level with the Place de la Concorde, is a small wooden pavilion: probably that known as 'of His Majesty the King of Rome', built in December 1812. The particular brightness of the dome of the Invalides reminds us that it was first gilded in 1715, undergoing no restoration work until 1813. The clarity with which it is shown here suggests that it had just been redone. There is therefore every reason to suppose that the painted 'layer' was not executed before 1813.

It is similarly clear that the view cannot have been made later than 1822, the date that marks the destruction of the Théatins and the disappearance of the towers of St-Germain-des-Prés. But it is the Galerie Napoleon (today the Musée des Arts Décoratifs) that gives us the best clue. Building on the Galerie was halted at the height at which it appears in the canvas; it was only in 1816 that work was resumed.

This suggests that the canvas was painted between 1813 and the end of 1815 and justifies its attribution to Pierre Prévost, who thus 'recycled' a sketch made in 1804 or 1805. That he then decided to colour it with gouache probably has to do with the fact that the actual panorama could not be made on site in Paris, but had to be made in Vienna. So he was obliged to record every detail with care, as well as the colours of the city.

There remains the problem of the triumphal arch at the Carrousel, erected between 1806 and 1808. In the drawn version, we can recognize the railings that existed before the arch was built. But in the painted version, the triumphal arch does not appear. At most, a lightly drawn monument can be seen which may resemble it. Did Pierre Prévost imagine that this monument, designed to honour Napoleon, might disappear the moment its model was disgraced?

It is unclear whether we should endow Prévost with anti-Napoleon feelings, although two other monuments built to honour the Emperor and his conquests are curiously absent: the Arc de Triomphe and the Vendôme column. These are recorded on the topographical explanation of the completed panorama; perhaps their fate had become clearer, at least for Prévost.

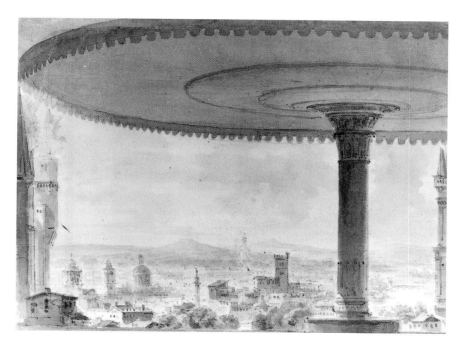

17. Louis-Jacques-Mandé Daguerre (1787–1851), *View inside Pierre Prévost's Panorama Rotunda in the Boulevard des Capucines*, c. 1808, pencil drawing and watercolour, 19.5 × 24.3 cm. Musée d'Orsay, Paris.

Paix was built. The circus was partially re-integrated into a panorama capable of accommodating canvases 30 metres in diameter and 16 metres in height. There were no external decorations, underlining the fact that a panorama was above all an investment designed to make money as quickly as possible rather than a contribution to urban harmony. As to the interior, renovations of a functional nature were carried out, with a staircase installed at the entrance and another at the exit to improve the flow of spectators. The lighting was also improved, for the rotundas in the Boulevard Montmartre were only bright on sunny days, when people out for a walk were more interested in having a stroll or sitting on a café terrace. When the weather was bad, visibility was appalling, which had an adverse effect on takings.

The year 1809 saw the inauguration of a *View of the Meeting between the French and Russian Emperors at Tilsit*, in honour of Napoleonic diplomacy. When, the following year, the Emperor visited the panorama of the *Battle of Wagram*, also by Prévost, he declared how impressed and flattered he was, adding for the benefit of his entourage: 'There is more than one cannon range from where I am to the horizon.' As a result, Napoleon commissioned the architect Jacques Cellerier to build seven rotundas on the square of the Champs-Elysées with a view to featuring the principal battles of the Revolution and Empire. His idea was that the canvases should then 'tour' France and the major cities of the empire for propaganda purposes. The military setbacks that were to ensue prevented this vast project from ever seeing the light of day.

In 1814, Prévost gave a perfect demonstration of opportunism when he designed a panorama depicting the arrival and landing of Louis XVIII in Calais,

18. Pierre Prévost (1764–1823), *Panorama of Paris Seen from the Roof of the Pavillon de Flore at the Tuileries*, c. 1833, oil on canvas, 97 × 599 cm. Musée Carnavalet, Paris.

This panoramic view, an extension of Prévost's sketch (illus. 16), might well have been inspired by it (the vantage-point is identical). It shows some of the transformations Paris had undergone in the interim. The north wing of the Louvre had been completed; the Théatins church had disappeared, as had the two lateral towers of the Church of St-Germain (in 1822). Retouching suggests that this might also have been a preliminary sketch used to produce Prévost's panorama.

but no one knows what happened to the canvas (was it in fact ever finished?) when Napoleon returned in the Hundred Days.

As a result of the crisis triggered by Napoleon's defeat (France had had enough of war stories), panoramists found themselves having to deal with mounting financial problems. In 1816, Prévost re-exhibited a view of London. But soon after its inauguration, he set off on a journey that would take him to Athens, Jerusalem and then Constantinople (illus. 63). For a period of three years, the public had to put up with repeats.

On his return, Prévost capitalized on sketches he had made during his various stops. Starting with the *Panorama of Jerusalem* in 1819, he launched a new series that was a resounding success, earning him almost 30,000 francs. The panoramas of Naples and Amsterdam on show together in the Boulevard Montmartre from 1804 had brought in just over 3,000 francs.

In 1821, the long-awaited panorama of Athens opened. It was favourably received. Admittedly, the *Kunstblatt* (25 October 1821) had reservations: 'Mr Prévost has surpassed himself with this new painting; the effect he has achieved is extraordinarily true to life; the illusion is complete even though he should perhaps have put fewer people in the foreground, their immobility lets the painter down . . .' Hittorff, however, not an easy man to please, as we have already seen, expressed his great admiration: 'No artist of our time can think of the views of Jerusalem and Athens without rapture. Those who have had the pleasure of visiting these famous cities thought they had never left them and those who had not been granted this privilege thought they had been transported there.'

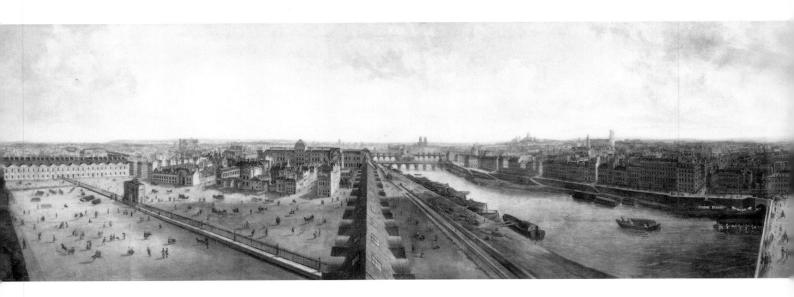

Prévost died in 1823 soon after starting work on the third canvas, that of Constantinople, which was exhibited in 1825. But the contrast between what he painted before his death and the work undertaken subsequently by one of his former students and his brother Jean was glaringly obvious. That same year, this panorama was withdrawn, and the building sold and demolished.

The survival of the rotundas in the Boulevard Montmartre after the construction of the one in the Boulevard des Capucines was due mainly to their privileged position. They still managed to draw a small, ever-decreasing array of spectators from the constant flow of passers-by and tourists. They seemed happy to continue exhibiting panoramas that had already been shown. Finally, victims of declining popularity superseded by new and more attractive galleries, they were demolished in 1831.

Charles Langlois

It was in the same year that Charles Langlois, former officer of Napoleon and student of Horace Vernet, opened his huge rotunda (15 metres high, 38 metres in diameter) at 14 rue des Marais-du-Temple, behind the present Place de la République. It was inaugurated with the *Naval Battle of Navarino* (illus. 59). One of Langlois's great innovations was that he replaced the traditional platform with the poop deck of a frigate that had actually taken part in the battle: the *Scipion*, known to the public for its feat of arms. The illusion was thereby reinforced and carried to its ultimate height. Bapst stated that 'while his predecessors had left the spectator isolated and distanced from a spectacle presented as the crow flies, Langlois transported him to the very centre of the action.'

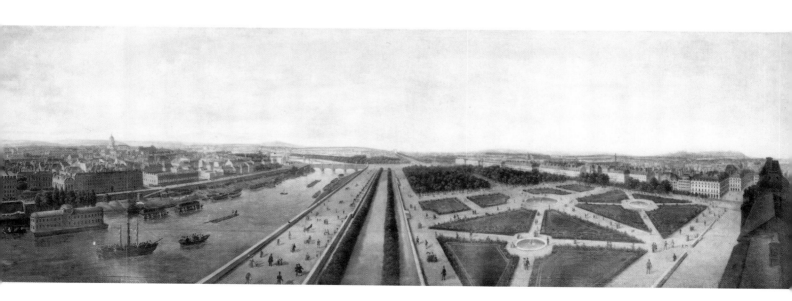

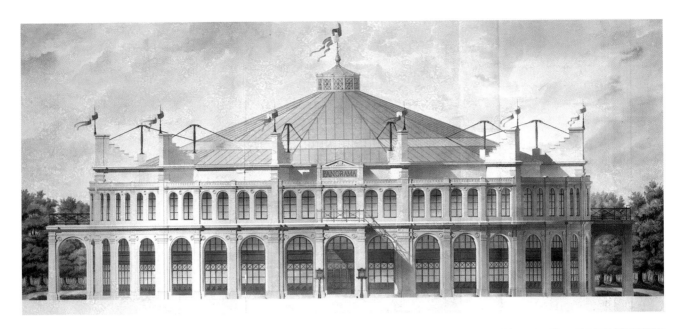

19. Johann Ignaz Hittorff (1792–1867), *Charles Langlois's Rotunda in the Grand Carré, Champs-Elysées, Paris, in Its Final Form*, c. 1839, ink, watercolour and gold, 59.5 × 45 cm. Wallraf-Richartz Museum, Cologne.

20. Johann Ignaz Hittorff, Elevation and cross-section of the panorama in the Champs-Elysées, 1840, print taken from Hittorff's drawing. Bibliothèque Nationale de France, Paris.

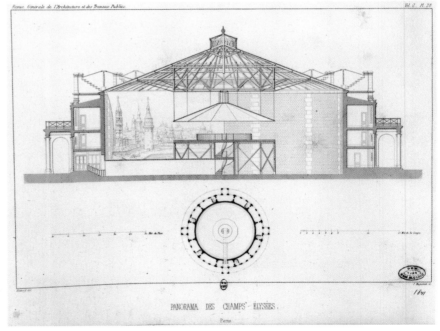

Moreover, Langlois perfected the imitation terrain (not invented by him, since its origins can be found in the panorama of Rome hung by Johann Adam Breysig in Berlin in 1800) and reinforced the effect by using gas lighting to simulate fire and ventilation to fake the sea breeze. Finally, to prevent shadows being cast on the canvas, he replaced the ordinary glass of the roof with frosted glass. The reaction of the *Journal des artistes* was very positive:

'This really is the century of innovation, if not invention, for here we dare to make so substantial and complete a mixture of painting and reality for the first time.' Hittorff saw this as the turning-point in the history of the panorama and as 'such an extraordinary manifestation of reality that it has not been surpassed since and probably never will be'. It was the platform in particular that captured his imagination:

> The site was transformed into a fully armed and rigged vessel, the end of which gradually merged with the canvas at the back with the help of the authenticity of the relief, the shapes of the bas-reliefs and the painting. This *tour de force* of art and ingenious industry in the pursuit of *maximum* illusion was crowned by an epoch-making success.

The *Battle of Algeria* was to follow in 1833. Langlois's biographer, Bourseul, appeared to regard the latter as a break from tradition:

> Thanks to the way panoramas were once painted, we were able to take in the magnificent view of an entire city, like that of Athens for example. With Colonel Langlois's method, the spectator enters this city, goes into the palaces and can gaze at his leisure at all the wonders they contain.

Some time later, in 1834, it was Langlois's tour of the *Battle of Moscow* that would be an overwhelming success.

21. *The geometrical ascent to the Galleries, in the Colosseum, Regent's Park*, 1829, aquatint published by R. Ackermann & Co., London. Guildhall Library, Corporation of London.

The public acclaim he received and the support of Louis-Philippe enabled Langlois to commission Hittorff to build him a sumptuous rotunda with a diameter of 40 metres, located at the northern end of the Champs-Elysées between the Cours la Reine and the Grand Carré des Fêtes (illus. 19). The lighting was particularly well thought out and the façade extremely elegant. By modernizing the design of the roof, the architect was able to eliminate the central pole and completely free the platform, which resulted in a significant strengthening of the illusion (illus. 20, 21). This panorama opened in May 1839 with a *Fire of Moscow* seen from one of the towers of the Kremlin. The latter remained on view until 1843, when it was replaced by the *Battle of Eylau* – a triumph that was to guarantee Langlois fame and fortune. It was another ten years before he made another panorama, the *Battle of the Pyramids*, a lively tribute to Napoleon I, probably meant to flatter the other Emperor who had not long been on the throne. But in 1855, after having been annexed by the neighbouring Palais de l'Industrie, the rotunda was razed to the ground. Langlois returned to active service in the Crimean War.

In 1859, Langlois formed a limited company, and in 1860 he opened an exhibition space in the Champs-Elysées at the corner of the rue d'Antin, next to the site of the earlier one. The space was still at the planning stage when Delacroix gave his impassioned report in support of Langlois to the Paris municipal council. Delacroix maintained that 'the beautiful does have its uses' when it contributed to attracting foreigners to the capital, adding that 'the sight of our great deeds painted in proportions and with an illusion that no painting can achieve is a beautiful thing not only to behold, but because of the feelings it inspires.'

The architect Gabriel Davioud designed a simple, spartan rotunda without arches and with a circumference of 20 metres. It opened with the *Seige of Sebastapol*, the site of which Langlois had visited in the meantime. To record the events, he had taken an enormous number of photographs (he was the first to use this new technique to plot terrain). The *Siege* was replaced by the *Battle of Solferino* in 1865; this resulted in the limited company's shareholders receiving substantial dividends.

Langlois died in 1870. He had contributed greatly to improving the conditions in which panoramas were exhibited and to 'totalizing' the impact of the illusion. By introducing a theme to link the entrance (seamen's quarters, corridors of the kasbah, etc.) to the canvas, he plunged the spectator straight into the atmosphere he wanted to create. As far as optical lay-out was concerned, however, he was in no way innovative and stuck to accepted conventions. He certainly attracted more people and touched the families of those who were the victims of war as well as old soldiers, who, on rediscovering places where they had fought, were able to describe the tragic events they had witnessed.

Panoramas of Germany, Switzerland and the United States before 1870

On 14 September 1799, Barker's panorama of London went on show in Hamburg. It was enthusiastically received by both the public and the critics. When it was hung in Leipzig for the 1800 *Ostmesse* (Fair of the East), the reaction was less favourable, and there were innumerable comments to the effect that the canvas was atrocious. This mood was reflected in the *Leipziger Zeitung*: 'The painting is so used and faded, the parts so unintelligible and confused, that all our restrained and compliant Saxon courtesy is needed if we are not to find that this spectacle falls short of the grand statements made about it.'

A double platform had been arranged on two levels, with tickets for the lower level sold at half-price (the need to distinguish between social classes was apparently still very much in evidence) to compensate for the inconvenience of having the perspective seem fake and the illusion appear noticeably weaker. It is also quite possible that the size of the canvas had been reduced in transit in order to remove the worst of the damage and that by the time the panorama arrived in Leipzig it was semi-circular. (Nonetheless, in a letter to his wife dated 4 May 1800, Goethe spoke of its 'remarkable' and 'enchanting' effect.) Other canvases were exported from England and France, but they were not very successful. The public had no appetite for work that appeared to have lost its novelty.

The first locally produced panorama opened in Berlin in June 1800: *Rome from the Palatine Hill* by Johann Adam Breysig. Breysig claimed for a long time that he had been the first to envisage a 360-degree representation. He said that the idea had come to him in 1792 while he was in Rome, but that lack of funds had prevented him from carrying it out. (When you read his memoirs, you realize that his project was a development of the landscaped drawing-room or global scene and not the panorama, since there was never any attempt to regulate the distance accorded the spectator. Moreover, features used to link the representation to external reality were judged to be unnecessary, whereas to Barker they were crucial to the production of total illusion.)

For Breysig's panorama, a canvas sheet made to look like marble was laid between the platform and the canvas on which scattered leaves, rocks and rubble were placed in an attempt to recreate the ruins from which Rome could be seen. This was, even before the term existed, imitation terrain, albeit on a

modest scale, a concept that would not be taken up again or systematized until 30 years later, when Colonel Langlois arrived on the scene in Paris. But Tielker, the Roman panorama's entrepreneur and financier, ignored the instructions Breysig had left him, and the glass roof was placed just above the canvas, leaving no gap; this darkened the representation and distorted the effect. The *Journal des Luxus und der Moden* called the work a badly painted decoration and concluded that the illusion the painter was endeavouring to create had failed. No doubt discouraged by the relative failure of this first attempt and the inherent problems of such a large-scale project, Breysig abandoned panoramic painting.

Karl Friedrich Schinkel was more fortunate. The exhibition in Berlin of his *Panorama of Palermo* in 1808 was a great success (illus. 22). He subsequently sold the work to the mask manufacturer Gropius, who 'toured' it in Germany and elsewhere in Europe. We should also mention a panorama of Frankfurt made by Johann Friedrich Morgenstern and Johann Karl Wilck in 1817 and hung in Frankfurt (illus. 23–31), as well as a *Panorama of Etna* painted by August Siegert in 1821 which was highly praised by the critics of the time.

But on the whole, the situation in Germany remained fragile, proving that the panorama was above all a phenomenon of the metropolis. Because canvases

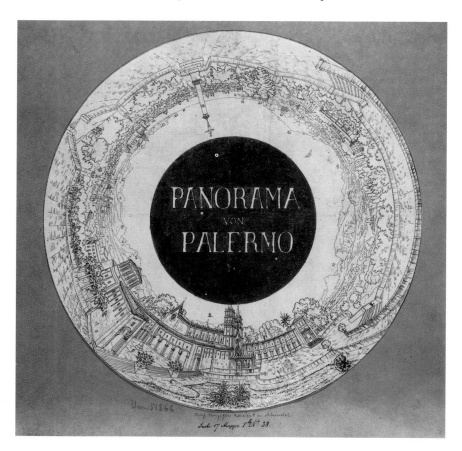

22. Karl Friedrich Schinkel (1781–1841), Anamorphic projection of panorama of Palermo, 1808(?), print, diam. 29.4 cm. Nationalgalerie, Staatliche Museen zu Berlin.

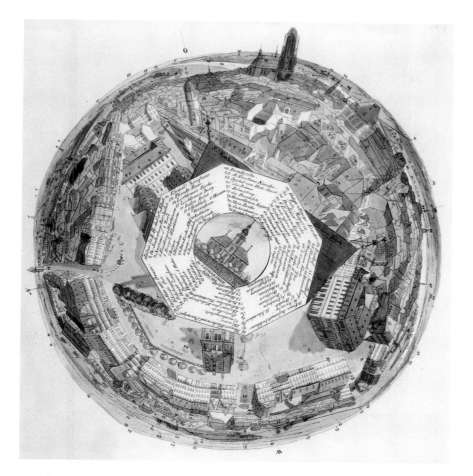

23. Johann Friedrich Morgenstern (1777–1844) and Bernhard Hundeshagen (1784–1858), Orientation plan of Frankfurt am Main panorama, 1811, coloured engraving, approx. 34 × 34 cm. Historisches Museum, Frankfurt am Main.

could not draw audiences from big cities there (the population of Berlin was just over 150,000 while London's was already well over a million), they were doomed to being carted around, which was not only costly but physically damaging. Although there were great influxes of people into towns like Leipzig and Frankfurt whenever they held their famous annual fairs, these did not last long enough to make the permanent installation of a large panorama financially viable. It is therefore not surprising that during the first half of the century, smaller panoramas, dioramas and other optical illusions were made that were both more economical and easier to transport.

In Switzerland, potential audiences were still fairly limited. In the latter half of the eighteenth century, the theme of the Alps inspired a profusion of works with a panoramic bias. But real panoramas were rare. Yet it is no coincidence that the first and almost the only panorama in Switzerland at the time, inaugurated in Basel in 1814 (illus. 32, 33), took as its theme the town of Thun (one of the stops on the Grand Tour) and the surrounding mountains.

Two other unmistakably Alpine panoramas, each a view taken from the summit of the Rigi, were produced before 1870. The first, dating from around

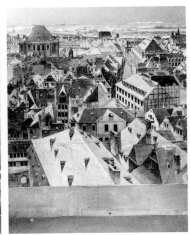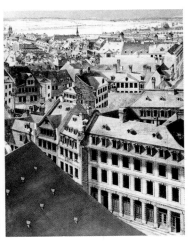

24–31. Johann Friedrich Morgenstern and Johann Karl Wilck (1772–1819), *Frankfurt am Main, Seen from the Katharinen-Kirche,* 1809–10, pen and watercolour, eight preliminary drawings for a panorama, each 89 × 70.5 cm. Historisches Museum, Frankfurt am Main.

1830, was by Rudolf Huber, although very little is known about it. The other, by Georg Meyer, painted on a surface that measured 245 square metres, was exhibited in Zurich around 1868.

Even Vienna, which could claim to be a great European capital at the time, could not draw the audiences necessary to develop and maintain a substantial panoramic movement. A wooden rotunda erected in the alleys of the Prater started out by showing the usual imported products, including Barker's indefatigable view of London, and then, in 1804, a *View of Vienna from the Catherine Tower* made by Laurenz Janscha and Carl Postl.

In 1811, William Burton built a new rotunda on the site of the original one, which had been destroyed in 1809 during the French occupation. Burton exhibited a view of Gibraltar which attracted public attention because it depicted a place of strategic importance, the focus of many press reports on the Franco-English conflict.

Given the lack of potential audiences, the best solution was perhaps that of Johann Michael Sattler, who had a movable rotunda constructed. Made up of pillars and planks that screwed together and a copper roof, it was easy to dismantle. In Salzburg in 1829, he exhibited the panorama of the town which he had started in 1824. Given that it was such a small area, it attracted an astonishing number of people. In 1830, Sattler set off on a long tour that took him across Austria, Germany, Denmark, Sweden, the Netherlands, Belgium, possibly Paris, and then back to Germany, before returning in 1838 to his point of departure 'with 30 tons and crossing approximately 30,000 kilometres of land and water, a feat no one had ever done before me and one which would be difficult to repeat in the future'. Incredible: 30 tons, 30,000 kilometres! This was an even greater achievement if we take into account the relatively poor means of communication of the time. Transporting materials and such a huge canvas could not have been easy.

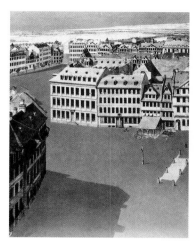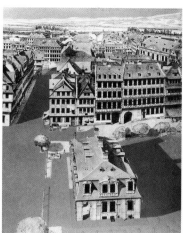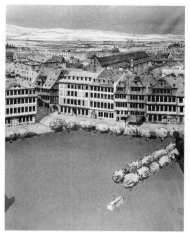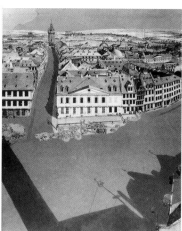

In the United States, New York was for a long time the focus of panoramic production. In 1794, a *Panorama of Westminster and London* went on show, painted by William Winstandley and probably inspired by Barker's sketches. This was followed in 1796 by a *Panorama of Charleston* by the same artist (however, it was relatively small: 6 by 35 metres) and, in 1802, by Alexander Fink's *Panorama of Jerusalem*.

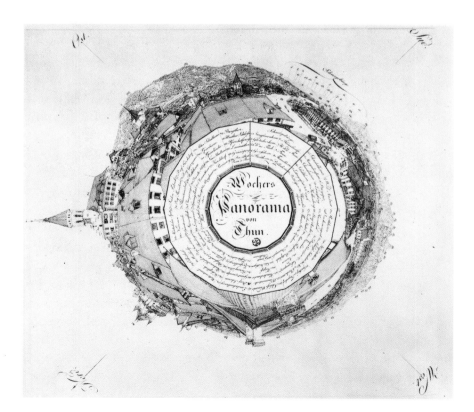

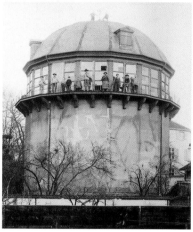

32. Contemporary photograph of the Thun panorama building in Basel, *c.* 1887, shortly before its demolition.

33. Friedrich Meyer (*fl. c.* 1802–34), 'The Panorama-Rotunda in the Sternengässlein, Basel', from *Panorama Depicting the Town of Thun and Surrounding Area. . .*, *c.* 1830, lithograph, 36 × 46 cm. Öffentliche Kunstsammlung, Kupferstichkabinett, Basel.

But it was not until 1804 that the first rotunda specifically built to house panoramas appeared; it was inaugurated with Robert Ker Porter's *Battle of Alexandria*. Over a period of years, Porter exported his panoramas to America once they had been shown in London, thus making them much more profitable.

A second rotunda, also in New York, was erected in 1818 by John Vanderlyn, who for several years had been working on a *Panoramic View of the Palace and Gardens of Versailles*. This panorama was not exhibited until the following year, although the studies had been made as early as 1814, while Vanderlyn had been on extended study leave in France. (As a friend of Robert Fulton, he may have worked as Prévost's assistant for a time.) But it was probably a miscalculation on Vanderlyn's part to concentrate on the artistic rather than the dramatic and illusionistic quality of his work. Moreover, the theme – the return of Louis XVIII – was too European; the only people portrayed were the King of France and the allies who brought Napoleon's reign to an end, Tsar Alexander I and King Frederick William III. The painter continued to work on his canvas after its inauguration, adding figures to a composition that was judged to be cold and empty. As the American public were not interested in the political problems of France, the work was a bitter failure. Barely two months later, it was replaced by a *View of Hell*. Most of the panoramas exhibited subsequently by Vanderlyn in his rotundas (at Philadelphia, Charleston and Montreal) were imported from London: works by Barker and Burford, including a fairly successful *Panorama of Geneva and Its Lake* in 1828 (a tranquil Switzerland proving more attractive than the nationalistic fervour of Franco-English battles).

In the 1830s, the United States produced a variation of the panorama, the 'moving panorama', which was to prove very popular. One traditional rotunda was a great success, however: that opened in New York in the summer of 1838 by the architect, painter and adventurer Frederic Catherwood, opposite Niblo's Garden near Broadway, one of the great attractions of the time. Having travelled in Europe and Africa but before setting off for South America, Catherwood threw himself into this project, no doubt encouraged by Burford, whom he had met in London and who was looking for a new export outlet to America for his productions.

The design of Catherwood's rotunda was based on the principles of Mitchell's first construction in London: two superimposed levels and a double glass roof. The inaugural canvas, *View of Jerusalem*, was a great success. At this point, the entrepreneur went to London to buy three canvases from Burford: *Niagara Falls*, *Lima* and *Thebes*. He then set up networks of outlets in a number of average-sized towns. Unfortunately, as with so many of the wooden rotundas built in the first half of the century, the one in New York burned down in July 1842, and Catherwood, underinsured, lost a substantial amount of money.

Variations: From the Diorama to the 'Moving Panorama'

In *Le Père Goriot*, Balzac has Mme Vauquer's lodgers play with strange linguistic distortions:

> The recent invention of the Diorama, which had carried optical illusion one stage further than the Panorama, had led in some studios to the pleasantry of talking 'rama', and a young painter who frequented the Maison Vauquer had inoculated the boarders there with the disease.

Rama shows were indeed in fashion. They gave Parisians the opportunity to enjoy an *Alporama* in 1819 and then a *Europorama* inaugurated in the Galerie du Baromètre in 1825, this being a collection of 'optical views of a number of capitals of Europe and some of their most beautiful counties'. The arcades were ideal locations for attractions such as these, and in 1832 the Abbot Gazzara hung his *Cosmorama* – the concept for which had existed since 1808 and an example of which had been on view at 29 St James's Street, London, since 1821 – (illus. 34) in the Galerie Vivienne. These were landscapes from all over the world and historical scenes presented in relief through the use of interacting magnifying mirrors. Being a good neighbour, the Galerie Colbert presented a *Georama* that same year. To this list, by no means definitive, we should add Jean-Pierre Alaux's 1827 *Neorama* in the rue St-Fiacre, configured like a classical panorama in as much as it was a circular canvas depicting the interior of a building (St Peter's in Rome, Westminster Abbey).

The Diorama

The panorama's main rival was unquestionably the diorama, launched by Louis-Jacques-Mandé Daguerre and Charles-Marie Bouton, a student of David, on 11 July 1822 at 4 rue Sanson (now rue de la Douane, behind the Place de la République). Both men collaborated with Prévost on several panoramas.

The diorama consisted of a flat or slightly curved canvas measuring 22 by 14 metres. Gradual changes in the lighting were intended to transform the painting in such a way that the same landscape would be seen first by night and then by day (illus. 35, 36). The success of this technique depended on the transparency of the canvas, usually made of fine oiled calico, which would sometimes be illuminated from the front and at other times from the back, not forgetting the

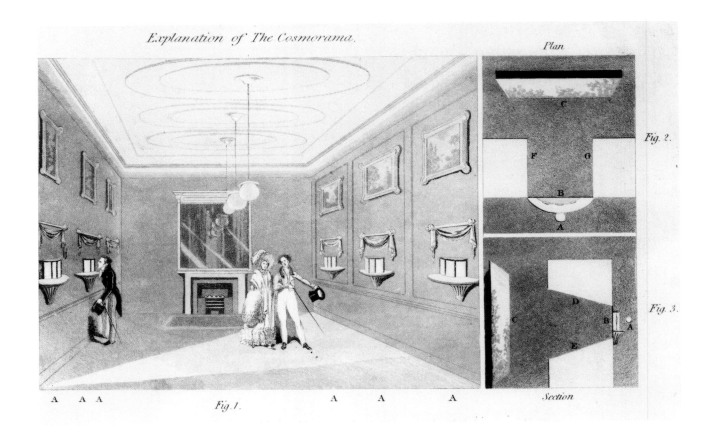

34. 'Explanation of The Cosmorama, 29 St James's', aquatint from *The Beautiful Assembly*, 1 December 1821. Guildhall Library, Corporation of London.

many gradations in between. It also depended on the complementary nature of the colours: filters brought out or suppressed this or that shade, depending on where the light was, thus allowing for the simulation of movement. Daguerre explained the process in his *Description des procédés du daguerréotype et du diorama*:

> Lay two extremely bright colours, one red, the other green, of approximately the same strength on a canvas. Shine a light through so that they are illuminated through a red medium, as through coloured glass; the red pigment will reflect its own rays, and the green will remain black. By replacing the red medium with a green one, the opposite will happen: the red will remain black, whereas the green will reflect the green pigment.

Spectators sat in a hall that could hold 350 people. With the help of a roundabout that could be operated by one man, the hall rotated on itself. Screens were placed on all four sides: two were the focus of the show while the other two were being prepared, thereby allowing the space to be continuously exploited and the canvases regularly renewed (illus. 37). The image was set some 15 metres from the 7-by-4-metre gap so that the machinery of glass, rectifiers, mirrors and deflectors could be hidden between the two screens in

order to facilitate the ingenious interplay of lights and filters. In 1822, the *Miroir des spectacles* referred to the 'supreme charm of the animation' and to a 'new invention, infinitely superior to that of the panorama'.

Each show lasted around fifteen minutes. Early themes were *The Valley of Sarnen* and *Inside Trinity Chapel, Canterbury*: this combination of a spectacular landscape (more often than not Switzerland, especially the Alpine areas, or Biblical scenes such as the Great Flood, or Milton's *Paradise Lost*) and religious architecture was one that would be repeated often. Once the exhibition had finished, the diorama canvases were taken on tour. In 1823, Daguerre's brother-in-law, John Arrowsmith, opened a hall in London, showing Parisian productions at the beginning of each month (illus. 37). John Constable, invited to the preview of the first diorama, communicated his reservations in a letter to a friend:

> I was on Saturday at the private view of the '*Diorama*' – it is a transparency, the spectator in a dark room – it is very pleasing and has great illusion – it is without the pale of Art because its object is deception – Claude's never was – or any other great landscape painter's. The style of the pictures is French, which is decidedly against them.

In Germany, the stage designer C. W. Gropius opened a large rotunda in Berlin in 1827 that exploited not two but three principal scenes simultaneously: the interior of the church of Baccarach, a view of Genoa, and the glacier at Grindelwald. As Roland Recht quite rightly observed in *La Lettre de Humboldt*, they symbolized the stops made along a typical Romantic journey: a Gothic ruin, Italy, some mountains. The Berlin rotunda was active until 1850, and Gropius produced a total of 26 dioramas.

The initial enthusiasm of Parisians for the diorama soon began to wane; people found the huge panorama more appealing. Undeterred, Daguerre sought

35, 36. Louis-Jacques-Mandé Daguerre (1789–1851), Double illustration of the opposite extremes (morning and night) of a diorama depicting an Alpine scene with chalet. Harry Ransom Humanities Research Center, University of Texas at Austin (Gernsheim Collection).

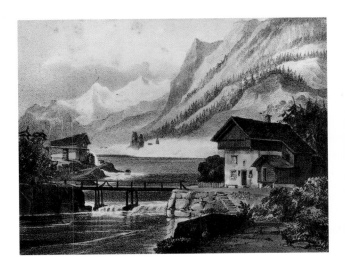
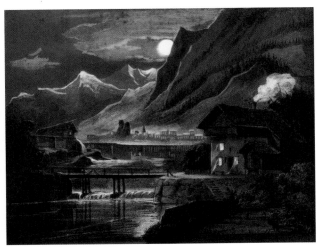

37. Plan and section of 'Arrowsmith's diorama', London, in 1824, drawing, from *Dinglers polytechnisches Journal*.

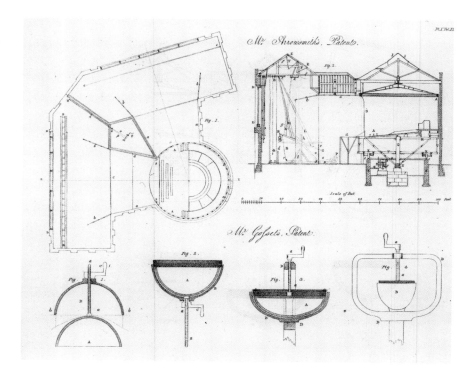

to improve his invention. In 1834, he launched his double-effect diorama. The canvas was painted on the front and back so as to visibly reinforce the illusion of movement by having the superimposition and the complementary nature of the colours interact on the transparency. The results were spectacular and his first canvases a triumph with both the public and the critics. *View of the Port of Gent*, but more particularly *Midnight Mass in St-Etienne-du-Mont*, attracted the following words of praise from the journal *L'Artiste*:

> We have a painting that is not only beautifully painted: the overall effect and the details are extremely accurate, the illusion perfect; but also a scene that is animated: the solemnity of a midnight mass with the congregation, at first absent then gathered in front of the choir, continuously illuminated by the brightness of the lights . . . Everything is painted on the same canvas; the only thing that moves is the light that illuminates the painting.

One success followed another, but in 1839 the rue Sanson rotunda was destroyed by fire. Daguerre's career as a dioramist came to an end (although he painted one more canvas, for the church of Brie-sur-Marne, where he eventually retired). Thanks to the substantial compensation he received from the State, he was able to devote himself to perfecting the daguerreotype, which was to make him a fortune.

Taking over from Daguerre, his colleague Bouton undertook the installation of a hall on the Boulevard Bonne-Nouvelle which opened in 1843. The

following year, Gérard de Nerval went to see a representation inspired by the Great Flood. On 15 September 1844, he wrote an impassioned article in *L'Artiste*, peppered with verbs so as to convey the power of the illusion, seeing in 'this sequence of *scenes* with their surprises, emotions and various angles of interest, a truly dramatic show'. Bouton's rotunda also burned down in 1848.

Despite having been likened to the panorama by the majority of commentators and historians, the diorama in fact had very little in common with it. The diorama did not even really derive from the panorama. One would have to look instead at Franz Niklaus König's 'diaphanoramas' (*c.* 1810–15) to find its prototype (illus. 38, 39). These were oiled and scraped papers that played on the effects of transparency in the semi-darkness of exhibition rooms. A more direct link can probably be made with Philippe-Jacques de Loutherbourg's *Eidophusikon* (illus. 40). In 1781, Loutherbourg put on a show in which he simulated the passage of time and displacement in representation by means of changes in lighting and the movement of certain mechanical sections of the set. This was a small scene, about 2 by 2.5 metres, but in it the principles of the diorama were already established: movable overhead lighting; the use of coloured glass; a canvas painted on both sides to give the effect of transparency. This points to the diorama having its roots in phantasmagoria. The ending -*rama* is deceptive: in the word *panorama*, 'pan' is the constituent that creates the idea of totality, the total vision of a given reality dependent on a circular horizon. Yet the diorama, because it was flat and like a painting (even though the frame was camouflaged), did not contain either the same logic or, more importantly, the same aim. Its main concern was to incorporate the passage of time and movement into a representation whose themes were often connected to the transition from day to night or vice versa, to the changing seasons, to natural disasters. The diorama originated more from magic or enchantment, which is what Baudelaire obviously felt when he wrote his uncompromising chapter on landscapes in his *Salon* of 1859. Having railed

38, 39. Franz Niklaus König (1765–1832), Diaphanoramas of the Rigi-Kulm and William Tell Chapel on the Vierwald-stättersee, *c.* 1810, watercolours on oiled transparent paper, each approx. 84 × 119 cm. Kunstmuseum, Bern.

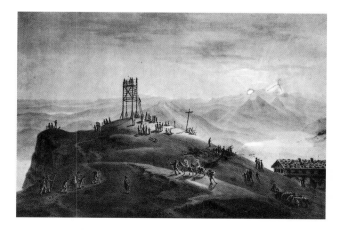

40. Edward Francis Burney (1760–1848), *The Eidophusikon of Philippe Jacques de Loutherburg*, c. 1782, watercolour, 19.5 × 27.3 cm. British Museum, London.

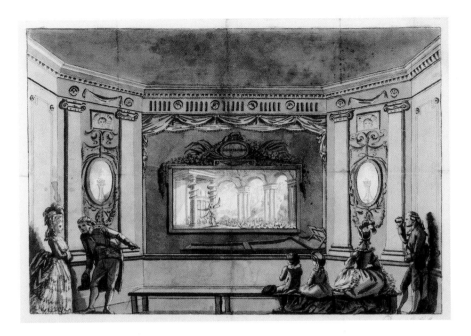

against the diabolical effects of photography, he went on to deplore the fact that the art of composition and the feelings of the artist had been replaced by an obsession with realism, concluding:

> I want to go back and see the dioramas, for their total and far-reaching magic perpetrates an illusion that serves a useful purpose. I prefer to contemplate theatrical sets where I can find my most cherished dreams artistically expressed and tragically concentrated. Because they are false, they are infinitely closer to reality; whereas the majority of our landscape artists are liars, because they have in effect neglected to lie.

Which is no doubt why Walter Benjamin compared the diorama to the magic lantern, for both were arts of projection that would lead to the birth of cinema in 1895.

The 'Moving Panorama'

It is difficult to pinpoint exactly when the 'moving panorama' came into being; the term first appeared in London in 1800 in reference to small movable pieces of scenery used in pantomimes. We could go back to the 'moving transparencies' of Carmontelle, which were sometimes as long as 60 metres. Theatres would also have employed canvases that would have been taken on and off stage like scenery. But the first independent show of this type was probably the *Original Grand New Peristrephic or Moving Panorama* of 1823, depicting the coronation of George IV. Publicity at the time confirmed that it contained 100,000 faces. Representations of a number of Napoleonic battles followed:

Ligny, Trafalgar, Waterloo. Unfortunately, there is very little information available regarding the size of the canvas or, more importantly, its configuration.

We know more about the *Pleorama* exhibited in Breslau in 1831 (it was forced to close during a cholera epidemic and was transferred in August of the following year to Gropius's diorama). The 24 spectators were placed in a boat that moved as though rocked by waves; on each side was a moving canvas. As it dipped to the left or the right, the view was changed to reveal a completely different landscape. In this way, the whole of the Bay of Naples flashed by in an hour. However, this was not a very profitable venture, given that the boat could hold so few people (even though the number was increased to 30 in Berlin) and that there were only four or five shows a day. In November 1832, the Bay of Naples was replaced by the banks of the Rhine. The *Pleorama* was abandoned in October 1833.

The *Padorama* (a moving canvas of about 900 square metres) that opened in London in 1834 was based on a similar principle. The spectators, placed in several carriages, could watch the most interesting sections of the Manchester-to-Liverpool railway, opened a few years earlier, as they flashed past.

The 'moving panorama' that was to be such a resounding success in the United States between 1840 and 1850 was in the main based on this model. An extremely long canvas attached to two cylinders was slowly unreeled in order to simulate a journey that was usually made on water. The shows were held in theatres or reception halls, which meant that they were easy to tour. Local landscapes were chosen, indicating that the creators of 'moving panoramas' had learned from the relative failure of standard panoramas in the United States: the history and wars of Europe were of no interest to a nation keen to learn about itself and create new myths.

In St Louis in May 1848, as though destined to do so by his name, John Adams Hudson presented the simulation of a four-day, three-night journey down the Hudson River by means of a canvas that was over 1,200 metres long. Public response was so favourable that Hudson travelled for ten months, on good days attracting over a thousand spectators, until April 1849, when a fire unfortunately destroyed his canvas.

The most popular theme of the 'moving panoramas' was unquestionably the Mississippi River. John Banvard's *Mississippi from the Mouth of the Missouri to New Orleans* was a triumph. Initially, it consisted of twenty-nine scenes, but when Banvard took it on tour he added twenty-three scenes of the Ohio and fifteen of the Missouri. One advertisement claimed that the canvas measured 6 kilometres. All 'moving panoramas' boasted implausible, by all accounts fraudulent dimensions; Banvard's original panorama could not have measured much more than 400 metres. The painter worked in conjunction with a speaker who provided a commentary on the views from a podium as they passed, spicing them up with anecdotes and information. Inaugurated in Louisville in

1846, this canvas toured Boston and New York before being hung in the Egyptian Hall in London at the end of 1848.

It was not long before a rival came along who attempted to rob Banvard of his following in London, going so far as to challenge him on the accuracy and pictorial quality of his views. That rival's name was John Rowson Smith. His show, the *Original Gigantic American Panorama*, presented a trip down the Mississippi from the St Anthony falls to New Orleans (illus. 41). The London rivalry between Smith and Banvard quickly became polemical. For support, the latter called upon Charles Dickens, who praised his show and commended its educational value. Smith questioned Banvard's ability in the press, condemning him for being self-taught while he, Smith, had been academically trained and had a reputation as a great theatre designer.

Among the many other 'moving panoramas' of the Mississippi we should also mention that of Henry Lewis, which was a resounding success during its two-year tour of America before ending up in Europe; one by Stockwell, which explored lesser-known, more distant regions; that of the French immigrant Léon Pomarède, well researched and with a grand finale that depicted the burning of St Louis; and, finally, one depicting Native American traditions (burial grounds, scalps, etc.) that was designed with an ethnological slant by Dr Dickinson and made by John J. Egan. Painted in tempera, it only weighed around 100 kilos, which made it very easy to transport. Dickinson held his audience spellbound with a commentary that was both anecdotal and scientific.

The fashion for the 'moving panorama' was epitomized by William Burr's depiction of an area that took in the Great Lakes, Niagara Falls and the St Lawrence and Saguenay rivers. This vast expanse was permeated with changing effects of night and day, sun- and moonlight, as well as the seasons and different climatic conditions. Inaugurated in September 1849, it was an unbelievable success; there were 200,000 visitors to the 200 New York shows, while Boston held 1,000 shows that attracted a million spectators. There were two million visitors in all.

Activity in Europe in the area of the 'moving panorama' was largely confined to imports from the United States. Banvard, Smith and Lewis all took their work to London and Paris and toured Germany, each time attracting large numbers of people. Two English productions are worth mentioning. One, in 1849, evoked a trip down the Nile; the other, *Overland Route to India*, the account of a journey from Southampton to Calcutta via Gibraltar, Cairo and Suez in 1850, was a phenomenal success, attracting over 250,000 visitors.

In the 1820s, small, portable 'moving panoramas' also appeared in aquatint. The Englishman Robert Havell was the expert in this field. These were usually river or sea voyages that allowed travellers to identify the outstanding features of the landscape unfolding before their eyes (illus. 42). Sometimes, they showed well-known urban axes such as the Champs-Elysées and the rue de

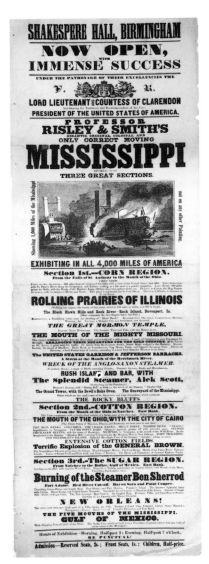

41. Professor Richard Risley (*fl. c.* 1850) and John Rowson Smith (1810–1864), Poster for the Mississippi panorama, *c.* 1863, 74 × 22.5 cm. David Robinson Collection.

Rivoli or the Nevsky Prospekt in St Petersburg; occasionally, they showed horse-races or other sporting events. In general, these were no more than 5.5 metres long and housed in cases into and out of which it was easy to slide them.

The 'moving panorama' – like the diorama though not in the same way – brought about a radical shift in relation to the circular panorama, a shift that involved another logic. What it offered above all was a procession of landscapes, excluding any particular visual configuration, any specially adapted architecture: flatness drawn into a lateral sweep that tied in with the painting. In fact, only Langhans's *Pleorama* was designed along the lines of a panorama, while still giving the illusion of movement, of displacement. Its inability to accommodate many spectators was to be its downfall, and no similar synthesis of totality, globality and mobility was seen until the Great Exhibition of 1900 – and Hugo d'Alési's *Mareorama*.

42. Robert Havell Jr (1793–1878), *Costa Scena, or A Cruise along the Southern Coast of Kent*, portable moving panorama, coloured aquatint in lacquered case, 8.3 × 554 cm. Guildhall Library, Corporation of London.

The New Generation, 1870–1900:
The Great Exhibitions

The Franco-Prussian War of 1870–71 breathed new life into the panorama when it was exploited for propaganda purposes or, later, when it was used during the Great Exhibitions for commercial advertisements. This renewal of interest led to people flocking to the rotundas and very quickly attracted the attention of greedy investors. Limited companies proliferated and international networks were set up, notably the Société des Panoramas Belges, which eventually covered the whole of Europe and beyond (Chicago and Rio de Janeiro, for example). In order to tour the canvases and maximize their profitability, standard sizes were agreed based on those adopted by Hittorff in 1839: a height of 15 metres and an approximate length of 220 metres.

Following the 1870–71 war, there remained one major obstacle to be overcome when it came to touring the canvases: the extremely partisan nature of the different representations. Necessary modifications were made as the need arose. Above all, events took on a mythical dimension and lent themselves to conflicting interpretations: what one observer interpreted as the military might of a besieger was seen by someone else as the heroic resistance of the besieged. A military defeat could be transformed into a moral victory. The Franco-Prussian War was a continual source of inspiration: on the French side alone, the conflict produced eight panoramas.[*] In the space of two years, the Republic revisited its past and exploited the most promising events with a view to kindling national pride. The Germans, albeit later, were not to be outdone. With a willingness to return to certain episodes of the wars with Napoleon I, the conflict between the two countries was kept alive throughout the century.

If we are to believe Oettermann, almost a hundred million spectators visited panoramas between 1870 and the beginning of this century, when they went out of fashion. The financial returns of the various companies testify to their enormous success, despite the fact that it cost a vast amount to produce a canvas, and that this cost somehow had to be covered; an enormous number of visitors was needed before even a small profit could be made. However, as a

[*] *The Defence of Paris* (1872, by Philippoteaux); *The Siege of Belfort* (1881, by Berne-Bellecour); *The Defence of Belfort* (1881, by Castellani); *The Reischoffen Cavalry* (1881, by Poilpot and Jacob); *The Battle of Bapaume* (1882, by Armand-Dumaresq); *The Battle of Champigny* (1892, by Detaille and Deneuville); *The Battle of Rezonville* (1893, by Detaille and Deneuville); and *The Battle of Buzenval* (1883, by Poilpot and Jacob).

genre the panorama had had its day by the time railways and steamships evolved. It became easier to travel; distant lands were no longer so distant. With the advent of photography came an image that was in direct competition with the hyperrealism of panoramic painting. Magazines – cheaper, more flexible and quicker to produce – took over the role of mass media (it should be remembered that despite the heavy costs involved, the panorama for a long while kept to the events that had inspired it, but over time its exploitation of current affairs diminished). Finally, with the birth of cinema in 1895, not to mention various pre-cinematographic shows, the panorama was more or less doomed forever. That said, there was one last and impressive resurgence.

The Paris Rotundas

In the last third of the nineteenth century, Paris was without doubt the capital of the panorama. Rotundas sprang up all over the place, and the Great Exhibitions led to the increased production of shows and attractions.

In 1873, the 'National Panorama' of the Champs-Elysées advertised the *Siege of the Fort of Issy*, otherwise known as the *Siege of Paris*, by Félix Philippoteaux. Such was its success that it remained on show until 1890. The artist was obliged to make two copies of the canvas so that one could tour Europe and the other America. The Société Française des Grands Panoramas saw its shares soar from 100 to 800 francs! As a result, the architect Charles Garnier was taken on to build (in quick succession) the Panorama Français in

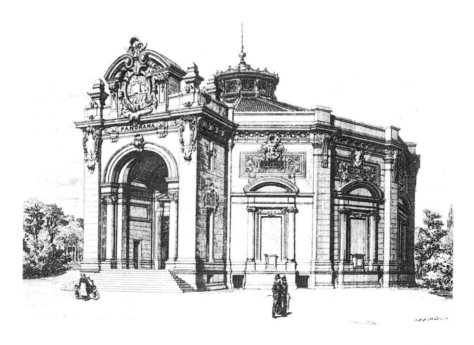

43. Charles Garnier (1825–1892), Marigny Panorama, 1880–82, from *Architektonische Rundschau* (1886).

1880, at 251 rue St-Honoré (to replace the famous Bal Valentino), and the Panorama Marigny in 1882, where the Théâtre Marigny stands today (illus. 43). With a diameter of only 32 metres, the dimensions of the Marigny Rotunda were not in keeping with those recommended by Hittorff in 1839, and it was therefore excluded from the distribution circuits. It opened with Théophile Poilpot's *Battle of Buzenval*. Two years later, Hoffbauer's *Diorama of Paris through the Ages* was shown; flying in the face of conventional design, it consisted of eight dioramas juxtaposed in a circle. Finally, Olivier Pichat's *Panorama of Jerusalem at the Time of Herod* appeared in 1887; five years later, it was hung in a provisional rotunda at 18 rue Larmarck in Montmartre. This was the first panorama to be exhibited away from the great boulevards, where the largest number of attractions and popular shows were concentrated at the time.

There were two new halls in 1880 and 1881, situated next door to one another in rue René-Boulanger and rue du Château-d'Eau, behind the Place de la République. Both were demolished to make way for the Bourse du Travail.

Finally, two rotundas were erected at the two opposite ends of the boulevard belt. The first, the Panorama de la Place d'Austerlitz, opened in 1881 with a *Storm over the Bastille* by Poilpot and Jacob (in 1885, this canvas was transferred to another building on Place Mazas, where it was followed by a *View of Medieval Paris* and then a *Pont Neuf in 1792* before burning down on 27 August 1890). The second was the panorama at 5 rue de Berri, between the Champs-Elysées and Boulevard Haussmann. It opened in May 1882 with the *Battle of Champigny* by Edouard Detaille and Alphonse Deneuville. The two artists shared the latter job, resulting in some extraordinary contrasts, since one was better at drawing and the other with colour. It was nonetheless a great success, and the owner of the company very soon saw his shares increase threefold. A German visitor, quoted in *Meyers Konversationslexikon* (1893), condemned the overt patriotism of this canvas depicting one of the great events of the 1870 war with Prussia: 'How typical of the French to want the whole action to be represented with a pomp and boastfulness that is so French. Wherever you look, the French are victors – see, here they are taking prisoners, there they're about to capture a whole group of Germans.' And yet he praised the illusory effect:

> Despite the obvious weaknesses of the composition, the Panorama of Champigny deserves a place of honour alongside the best that has been produced over the last few years. The relation between the painting and the actual objects has been handled with much finesse and rendered most realistically, so much so that the optical illusion works wonderfully well.

During the first four months, takings for the *Battle of Champigny* were 400,000 francs. The cost of entry was two francs, and attendance averaged out at around sixteen hundred visitors a day.

Germany and Switzerland

The panorama came back into fashion in Germany after the French revival. Stephan Oettermann attributed this to the economic crisis that, paradoxically, hit the victors of the 1870–71 war following the repayment by France of a substantial debt. A spate of bankruptcies was precipitated by inflation, and the middle classes, whose preserve the panorama was, lost all their money. There were no new rotundas until 1880.

The first one to go up was in Frankfurt. The Munich artist Louis Braun produced a *Battle of Sedan* to mark the sixth anniversary of that event on 1 September 1880. The canvas was incredibly popular and remained on show until 1895, when it was replaced by a *Battle of Weissenburg*. In the meantime, a second panorama was built in 1890.

There were also two rival rotundas in Hamburg. The first was built in 1882 and specialized in battle scenes, while the second opened in 1888 and specialized in seascapes. Among the other towns to have their own panoramas were Cologne, Leipzig, Dresden and Hannover. The majority belonged to distribution networks co-ordinated by the large international companies, particularly the Société des Panoramas Belges, which virtually monopolized the market.

It was to counter this cartel that, in 1886, a new, locally funded rotunda was opened in Munich. There had been a tendency in the 1880s to believe that the public only wanted to see battle scenes. So when the promoters selected a *Panorama of Jerusalem with the Crucifixion of Christ*, the response was lukewarm to say the least. (This theme had in fact been tackled a few years earlier by the Belgian artist Julian De Vriendt, but had been a financial disaster.) Contrary to all expectations, the *Crucifixion* panorama, painted by Bruno Piglhein, Karl Hubert Frosch (responsible for the architecture) and Josef Krieger (a landscape artist), was one of the most successful of the century's last decades. Inaugurated on 30 May, it was exhibited in the Munich rotunda until the spring of 1889. Subsequently, it went on show in Berlin, where it remained for more than two years. Its career continued in London, where it was hired by a local company and where a strange event occurred that speaks volumes about the ruthless rivalries of the time.

Although Piglhein was bound by his contract with the sponsors not to make another panorama on the same theme (to the extent that he had to deposit his preparatory drawings and photographic plates at the company's headquarters), his colleagues were free to exercise their talents in the United States and make replicas of the Munich panorama. That is how Frosch came to make three different versions, and how one of these came to be exhibited at Niagara Hall in London in December 1890, near the new rotunda that was being built by the company holding Piglhein's original in order to put it on show a few months later. The two companies ended up in court, but although the case collapsed,

44. Spectators seated at lunettes to view August Fuhrmann's (1844–1925) *Kaiserpanorama* installed in 1883 in the 'Unter den Linden' passage in Berlin, then reproduced in other German towns, print. Landesbildstelle, Berlin.

Frosch's notoriety spread. He continued to work on the Crucifixion theme, first in Amsterdam, then in Milwaukee, Einsiedeln (1893), Stuttgart (1894) and, finally, Aachen (1903). The team of colleagues was particularly efficient, having duplicated the theme so often. A multitude of panoramas of Jerusalem with the Crucifixion followed in the wake of Piglhein's original success; we have counted no fewer than seventeen.

To return to panorama production in Germany, Berlin became the Mecca of the revival that had started in Frankfurt. In all, six rotundas exhibited twenty-four panoramas between 1880 and 1914. The first to open was the National Panorama in 1881. But the highlight was without doubt the new version of the *Battle of Sedan* made by the official court painter Anton von Werner and his team of fourteen. The image chosen was of a half-hour battle in the early afternoon. Whereas in Frankfurt, the Munich artist Louis Braun had focused on the Bavarian battalion, von Werner emphasized the vital role played by the Prussian troops, which in fact came closer to the truth. As for the *Colonial Panorama* that opened in December 1885, it depicted a bloody punitive expedition to the new colony of the Cameroons, thereby backing the State's imperialist and racist campaigns. We should also mention the opening of the *Hohenzollern Gallery* in 1892, an imposing panorama that embraced the 200-year history of that prestigious family. Finally, in 1913, the panorama of *The Rhine Flowing near Caub* illustrated battles between the Allies and Napoleon in 1814. But *The Rhine* arrived too late; the panoramic genre had gone out of fashion, and propaganda was being relayed in other ways.

We should not overlook a variation of the panorama: the *Kaiserpanorama* that started off in Breslau in 1880 and moved to Berlin in 1883. Over a period of

time, the inventor August Fuhrmann set up a network of some 250 venues throughout Germany to which he sold the system and then hired out the pictures. This was not a panorama in the true sense of the term, but a kind of carousel of stereoscopic views depicting remote towns or areas. The carousel rotated while the spectators, standing around the outside of the cylinder, peered through lunettes placed over an opening. They were able to see, one after the other, two cycles of fifty views that were changed twice a week (illus. 44). Fuhrmann sent photographers and artists all over the world and over the years built up quite a collection of stereoscopic pictures, as many as 125,000. Walter Benjamin, in *A Berlin Childhood* (1932–3), praised the show's quaint charm, as did Franz Kafka, in *Journal d'un voyage à Friedland et Reichenberg* (January–February 1911) and Max Brod, in *On the Beauty of Detestable Images* (1913).

It was also in 1880 that panoramas began to be produced in Switzerland. In Zurich, the shoe manufacturer Suret commissioned Louis Braun to make him a panorama measuring 1,000 square metres: *The Battle of Morat, 22 June 1476* (illus. 131). This work was exhibited in a rotunda in the Place Bellevue. That same year, a rotunda was built in Geneva and inaugurated on 24 September with a panorama by Edouard Castres depicting Bourbaki troops marching into Switzerland (illus. 119). The canvas was exhibited for eight years in Geneva before being installed in August 1889 in a rotunda in Lucerne that is still standing today. Finally, the huge, imposing *View from the Summit of the Männlichen*, made under the direction of the Geneva painter August Baud-Bovy, was shown in Paris from 1891 to 1892 before being transferred to the Swiss pavilion of the 1893 Great Exhibition in Chicago, where it was unfortunately destroyed in a fire.

The Great Exhibition of 1889

At least seven panoramas popular with the public were shown at the Great Exhibition of 1889. Some had been funded by industrial companies for publicity purposes. Such was the case with the Compagnie Transatlantique, whose rotunda in the Champ-de-Mars housed Théophile Poilpot's *Petrol Panorama*, where spectators, under the impression that they had boarded a ship sailing from Le Havre, felt as though they were in the middle of the ocean. What was unique to Poilpot's canvas was the fact that it was composed of two semi-circular views, one devoted to 'smiling' Pennsylvania, the other to the barren Caucasus, both oil-producing regions. It garnered unanimous critical approval despite its unusual configuration.

The greatest attraction was undoubtedly *The History of the Century*, painted by Alfred Stevens and Henri Gervex. This work was extremely innovative in that it broke Aristotle's principle of the three unities (one action, one time, one place), which had been respected in the creation of all previous circular representations. Instead, the two painters presented, against a backdrop of

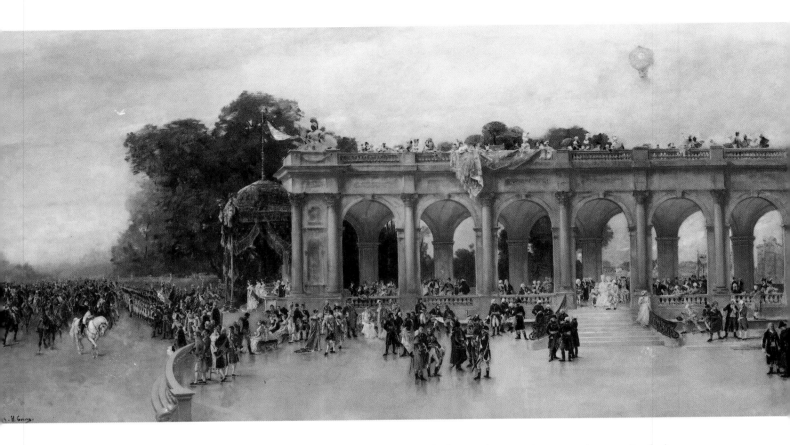

45. Henri Gervex (1852–1929) and Alfred Stevens (1823–1906), Reduced replica of a quarter of the panorama of the *History of the Century*, 1889, oil on canvas, 151 × 302 cm. Musées Royaux des Beaux-Arts de Belgique, Brussels.

the palace and gardens of the Tuileries, almost a thousand of the most prominent people in France from the time of the Revolution into the nineteenth century (illus. 45, 115–16). It was envisaged that a visit would last half an hour. Long hours were spent in library research, mostly under the direction of Hippolyte Taine. The project took two years to prepare and a year of work in the rotunda itself with the help of a large team of colleagues and assistants.

Based on a similar principle but reduced to a strict synchrony was Charles Castellani's painted panorama *All of Paris* for the same exhibition, which collected on the site of the new Opera the principal personalities from the world of art, literature, theatre, politics and society. The canvas was exhibited in the former Panorama National Français in the rue du Château-d'Eau and subsequently transferred and reassembled on the Esplanade des Invalides.

One of the other main attractions in 1889 was *The Battle of Rezonville* by Edouard Detaille and Alphonse Deneuville, hung in the rue de Berri rotunda. This canvas had actually been created in 1883, but *The Battle of Champigny* remained in the rotunda while it continued to be a success, and *Rezonville* was sent to Vienna in the meantime. When the latter work was eventually presented to the Paris public in 1889, it was awarded the Grand Prix d'Honneur.

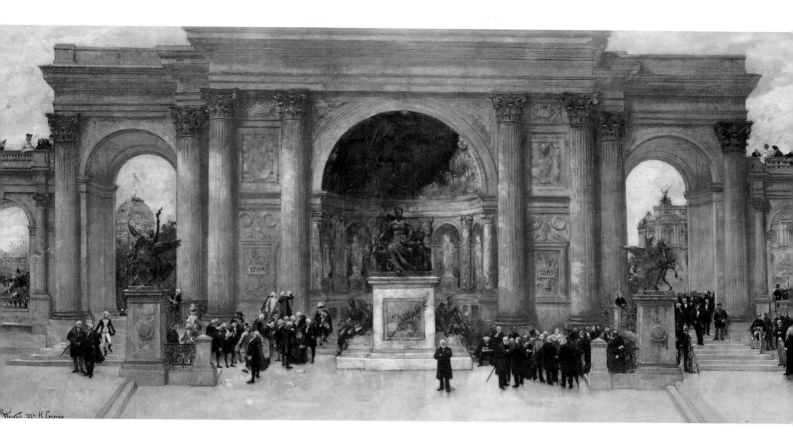

Finally, attention should be drawn to the panorama Pierre Carrier-Belleuse made with his students just in time for the Exhibition. It depicted episodes from the life of Joan of Arc and was housed in a rotunda in the Avenue Bosquet.

Between the Great Exhibitions of 1889 and 1900, one event in particular captured the imagination of the French people; it became the subject of Poilpot's panorama *The Avenger*, hung in Davioud's rotunda in the Champs-Elysées. This work depicted the naval battle in which the French attempted to break the English blockade off the coast of Brest in June 1794. The platform – the actual bridge of a ship – was activated by hydraulic machinery that simulated its pitch and roll so as to maximize the impact of the illusion. *The Avenger* was inaugurated on 26 May 1892 by the President of the Republic. Whilst the event was of interest, the panorama was not, and poor attendance led to the rotunda being converted into a hall of mirrors in 1894.

The 1900 Exhibition

The turn of the century signalled both the apogee and the end of the panorama in France. Indeed, while panoramas had never been so numerous, the two most

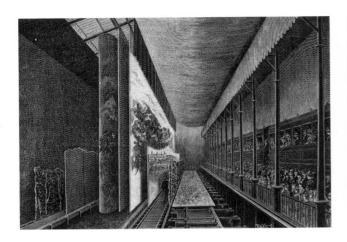

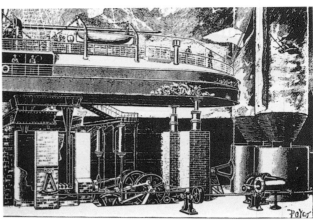

46. *The Trans-Siberian Railway Panorama*, print, from *La Nature* (May 1900). Bibliothèque Nationale de France, Paris.

47. View of Hugo d'Alési's (1856–1906) *Mareorama* installed during the Great Exhibition of 1900, one of two prints, from *La Nature* (June 1900).

spectacular attractions of the 1900 Great Exhibition were closer to the cinema than to panoramas in the strictest sense of the term.

The *Trans-Siberian Railway Panorama* funded by the Compagnie Internationale des Wagons-Lits was a simulation of the most spectacular stages of a journey from Moscow to Beijing. The spectators were installed in three luxurious carriages belonging to the sponsors. Thanks to an ingenious system, they could gaze through the windows as the countryside passed by; each of four successive layers of landscape moved at different speeds (illus. 46). The illusion was impressive, but the horizontal sweep it offered was more in the spirit of the 'moving panorama'. Paul Morand recalled this simulation in 1900.

The *Mareorama* combined the simulation of movement with a genuine panoramic configuration. As with *The Avenger*, the platform (which could accommodate as many as 700 people) was supposed to be that of a transatlantic ship, 70 metres in length, that rested on a universal joint so as to create the illusion of the pitch and roll of a ship. Props were placed at each end of the bridge to conceal the cylinders that supported two gigantic canvases as they were unrolled from port to starboard. Each canvas was 750 metres long and 15 metres high; in other words, there were around 20,000 square metres of painting (illus. 47–9). Spectators were able to see some of the most spectacular landscapes to be found between Marseilles and Yokohama by way of Naples, the Suez Canal, Sri Lanka, Singapore and China. Actors navigated the ship, air blowing through a layer of kelp circulated the sea breeze and imitated its smell, and special lighting created night- and daytime effects. It was an all-inclusive show, a perfect illusion.

The rest of the exhibition included classical panoramas, which, there being nothing new about them, did not arouse much interest, at least as far as the critics were concerned. The works with an overt colonial theme – Algeria, the Congo, Madagascar, trade missions – were obviously there to promote the Third Republic's policy of expansion.

As for the *Round the World* panorama, it was more of a juxtaposition of scenes than an actual circular view covering 360 degrees. Several countries were represented, and – to add a little local colour – each had indigenous people in the foreground – a kind of living imitation terrain. The public flocked to see the illusion of a world placed at their disposal and under their domination.

Finally, the *Stereorama* exhibited in the Algerian pavilion was in effect an inverted panorama. There was a circular canvas at the centre; there were simulated waves in the foreground; spectators were distributed around the outside in a semi-circle. Through 40 windows, people could watch the canvas as it rotated, revealing the whole of the Algerian coast from Bône to Oran.

Without a doubt, the panorama's resurgence in 1900 can be likened to the last gasp of a dying man. The cinema was already beginning to work its magic. What more appropriate symbol could we choose at this stage than Raoul Grimoin-Sanson's *Cineorama*? Using cinematographic techniques, Grimoin-Sanson adapted experiments with fixed projections which had first

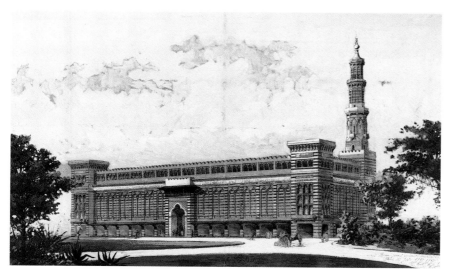

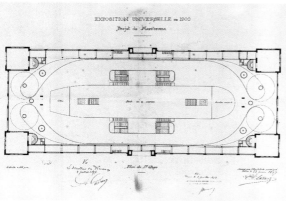

48. Hugo d'Alési, View of the *Mareorama* building, 15 April 1899, gouache on paper, 46.5 × 63.5 cm. Centre Historique des Archives Nationales, Paris.

49. L. C. Lacau, First-floor plan of the *Mareorama* with drawing of its mechanical construction, 23 June 1897, 47.5 × 66.8 cm. Centre Historique des Archives Nationales, Paris.

50. Projected pavilion for Giovanni Segantini's (1858–1899) *Panorama of the Engadine*, 1897, black chalk and conté pencil on paper glued to cardboard, 52 × 53 cm. Musée Segantini, St Moritz.

been undertaken by the American Charles A. Chase and then by Colonel Mossard. These entailed projecting several photographs, one next to the other, onto a circular screen and using filters to tone down the joins. In the *Cineorama*, ten projectors simultaneously threw their images onto as many screens, each measuring approximately 9 by 9 metres; these were arranged so that they covered 360 degrees. The resulting shots were equivalent to ten cameras placed in a circle. As Grimoin-Sanson put it:

> After having been to different countries and shot interesting, lively panoramas with the camera placed on the ground, we decided to take it up in a balloon: it weighs 500 kilos, and its bulk took up most of the nacelle to which it was tied. We lifted off from the Tuileries at the beginning of May on a slightly cloudy day; we started the camera rolling the moment we had 'lift off' and continued to film until we were 400 metres up. The results we obtained in this way were excellent, and any spectator who watches the projection will, on seeing the ground disappear below him, have the sensation of rising up into the air. Since the projector can be reversed, all we have to do is show the film in reverse for the spectator to then feel that he is landing.

However, the heat generated by the projectors created a safety risk, and the attraction was abandoned after an accident during the fourth showing. The cinema's popularity was undiminished, however. Twice a night, the Société Lumière offered free showings on a screen that measured 21 by 18 metres, hung in the former Salle des Machines. In six months, over 1,400,000 spectators went to see this new extravaganza.

The Great Exhibition of 1900 inspired another grandiose enterprise which unfortunately never saw the light of day: the *Panorama of the Engadine*, a project Giovanni Segantini had been working on for a long time in the hope that it would be financed by a committee of local innkeepers and hoteliers, arguing that it would attract numerous tourists to the region (illus. 50, 133–5). Having encountered one difficulty after another with the Paris organizers, the Swiss eventually decided that their region was sufficiently well known not to need additional publicity, particularly as the project would have been so expensive.

There was to be one more large French panorama: the *Pantheon of the War*, painted by Pierre Carrier-Belleuse and Auguste-François Gorguet, exhibited in 1919 and dedicated to the glory and memory of the soldiers who fought in the Great War. On a canvas measuring 14 by 130 metres, 6,000 life-sized characters (sovereigns, political and military leaders, war heroes) were portrayed against a battlefield background stretching from Calais to Belfort. But this was more of a commemoration, a memorial, than an attraction likely to draw a mixed public looking to enjoy simulated reality.

Prefigurations

The panorama, like any invention or breakthrough, like any serious model, had its ancestors and provenance. From the Villa of the Mysteries in Pompeii or even the rock paintings of Lascaux, a line can be traced through the ages to the Bayeux Tapestry and on to the decorative cycles of private and public spaces of which the Renaissance — especially in Italy — was so fond. These came in the shape of the *camera picta* or the *studiolo*, unless they were State rooms where rulers flaunted or registered their humanitarian deeds, their places in history. Such literary and religious decorations subsequently found their way onto Baroque ceilings and into Baroque collections. But obvious comparisons should be avoided. For example, the Baroque, with its *sotto in sù* perspective, was above all signalling its obedience to divine power, while circular perspective was more concerned with human domination of nature. In most instances, decorated rooms, tapestries with scenic motifs, or juxtaposed panels all respected a symbolic convention: this was taken into consideration when the original spaces were being transformed, particularly as they so often were 'interrupted' by windows and doors. Moreover, spectators were free to move around in such spaces; they could go up to the walls, even touch them. On the other hand, the aim of the panoramic configuration was to produce — using all available means — the illusion of another space, so much so that the canvas did not allow its boundary to be seen. The original space (that of the rotunda) was transformed into another space, that of a representation that left no trace of what it really was, becoming the perfect substitute for reality. It is important to remember that in order to arrive at that point, a building was constructed ad hoc: illusory architecture and painting blended and merged to become one configuration that guaranteed circular continuity, limitlessness and a fixed relationship between spectator and canvas.

Another possible line of development was through enlarged views such as those produced in the fourteenth century, Ambrogio Lorenzetti's *Good Government* in Siena for instance. There are numerous examples of paintings that, thanks to their size or proportions, have left their mark on the history of art, encouraging a regular tendency to extend the horizon line. Particular attention should be paid to the famous early eighteenth-century Italian *vedute* (although that genre had its roots in sixteenth-century Flanders), which could be defined as attractive, recognizable representations of natural spots, cities,

squares or streets. Their classical proportions indicated a clear realignment to the horizontal, and their appetite for detail bordered on hyperrealism. It is no secret that the vedute painters (Canaletto, for example) regularly resorted to the camera obscura, mainly to open up space. However, it would be wrong to class the *vedute* with photography, even though they quite clearly prefigured it. Indeed, it is not difficult to pick out the many distortions of the original models which, rather than present themselves as absolutes, allowed themselves to be subjected to compositional and proportional demands. Be that as it may, the enlargement at work in the *vedute* was not enough to destroy their logic or to produce the panorama's continuity and circularity. The similarities so often cited by historians are therefore interesting but questionable. One could offer further examples from the history of art, but they would not necessarily be representative and would only end up reading like a catalogue. We might have to follow a less obvious route in our attempts to establish a genealogy for the panorama and to understand how, at some point in time and as a result of certain shifts in taste and behaviour, it emerged and established itself as a model.

Diderot's *Salons*

It was in his *Salon* of 1763 that the philosopher Denis Diderot (1713–1784), when referring to a painting by Philippe-Jacques de Loutherbourg, first used the technique of integrating or incorporating the spectator into the fictional space of a painting:

> Ah! my friend, how beautiful nature is in this little canton! Let us linger here a while. The heat of the day is becoming oppressive, let us lie down beside these animals . . . And when the weight of the day has lifted, we shall continue on our way, and at some point in the dim and distant future we shall recall this enchanted spot and the delightful hour we have spent here.

One of the consequences of imagining oneself passing into pictorial space was that spectators found themselves *in the middle* of the landscape. Although Diderot systematized such walks in his *Salon* of 1767, in the *Salon* of 1763 he used the same technical ploy twice to formulate the principle. The first instance related to Joseph Vernet:

> Look at the *Port of La Rochelle* [illus. 51] through a glass that embraces the area of the picture and excludes the edges; and then, no longer mindful that you are examining a piece of painting, you will suddenly exclaim, as though you were high up a mountain, a spectator of Nature herself: Oh! what a wonderful view.

The second concerned Jean-Baptiste Greuze's portrait of his wife: 'Position yourself with the stairs between this portrait and you; look at it through a telescope, and you will see Nature herself. I defy you to tell me that this person is not watching you, that she is not alive.'

Illuminating the area in question, reducing the painting to a fragment or

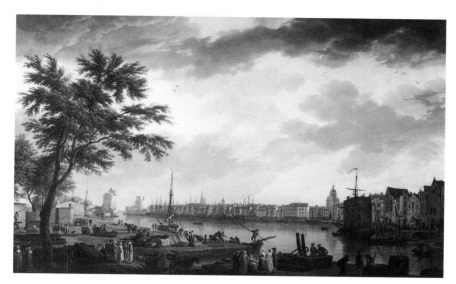

51. Joseph Vernet (1714–1789), *The Port of La Rochelle*, 1763, oil on canvas. Musée du Louvre, Paris.

detail, to a frame, an elevated and commanding position, the perfection of the illusion: the use of an eye-glass produces an unfettered view that looks like reality. By whatever means this occurs, once the imagination intervenes, the representation – presented and considered as straightforward reality – is judged by the viewer's reaction. And the artist is judged by his or her ability to grasp the colourful content of life, taking care to record the transitory rather than take an academic stance. In other words, we could say that the eighteenth century as a whole symbolized the transition from the person of principle to the person of sensitivity. Under the combined influence of Locke and Hume, the well-established notion of Beauty, founded on the acceptance of a set of rules, was challenged or overturned by a notion founded on the emotions and feelings of the subject. In *L'Invention de la liberté, 1700–89*, Jean Starobinski explained that Diderot initiated a new aesthetic. This resulted in the rise of the Picturesque, which, in stark contrast to a beauty that had eliminated all irregularities, was based on the recording of the unexpected, of the imperfect, of variety – very different from the refinement that had been the accepted aesthetic norm. A word of caution, however. With William Gilpin, for example – a proponent of the Picturesque – this approach was not to be regarded as an absolute submission to the natural model: compositional demands sometimes resulted in nature having to be corrected. In his *Three Essays on the Beautiful Picturesque* (1792), Gilpin remarked that 'nature rarely presents us with perfect compositions. Her ideas are too broad to be used by the picturesque eye, and need to be restrained by the laws of art.'

But those laws were no longer the rigid rules of the Classical ideal, forged out of sight of nature. The Picturesque offered itself in all its variety and un-predictability, which had to be captured at the right, the significant, moment. It would find its fullest expression in the notion of the Sublime.

The Sublime

The Sublime was redefined in the eighteenth century. The discovery of wild areas, high mountains and chasms, revealed an intrinsic beauty that was also regarded as being the manifestation of nature's superior purpose. Jean Starobinski explained what lay behind this discovery:

> We enjoy repeating that in the middle of the eighteenth century, mountains ceased to be 'horrible'. But it must be pointed out that mountainous landscapes were originally appealing because the horrible is appealing. Precipices used to be dreadful and of very little interest; these days, they are dreadful, but they attract troubled souls that seek the aesthetic emotion of terror.

In *A Philosophical Enquiry into the Origin of Our Ideas of the Sublime and the Beautiful*, Edmund Burke developed a theory in which the Sublime stood in direct opposition to beauty. The Sublime hinged on the intensity of a passion that bore the hallmark of terror, while ideal beauty (neo-Platonic in origin) was based on the idea of *smoothness*, proportion, harmony. Fear, darkness, immensity, infinity were, according to Burke, some of the attributes of the Sublime. In one form or another, the panorama was based on such attributes: fear, through the theme of war or through simulations that went so far as to make people dizzy or seasick; darkness, which Robert Barker made a prerequisite when entering the rotunda, reinforced by the contrast between the darkened platform and intense lighting that fell from a concealed source onto the canvas; immensity and infinity, at the very heart of the panoramic programme.

The best example of this new attitude can be found in the work of the surprisingly little-known Swiss painter Caspar Wolf. I refer not only to his *Extraordinary Views and Descriptions of Swiss Mountains*, which appeared in 1776 with a preface by von Haller and whose aim it was to remove the burden of travelling and give the amateur the opportunity to enjoy all that the Sublime landscape of the Alps had to offer. In effect, the majority of Wolf's paintings belong to the genre of the Sublime because in them individuals are drawn into environments that both overwhelm and exalt them. In fact, his human figures are more often than not to be found where light meets shade, particularly in the many cave scenes that open onto clearings in the distance. In a gigantic setting that threatens to overwhelm, the penumbra might be seen as taking on the protective role of a refuge. More striking still is *Inside the Bear Cave near Welschenrohr* (illus. 52), in which the artist on his rock is surrounded by an asymmetrical yet circular wall, a lay-out very similar to that of a panorama.

Another aspect of Edmund Burke's work could prompt a comparison of the Sublime and the panorama, and that is the importance he accorded circularity. This is what the philosopher had to say about what, in architecture, encourages a sense of infinity:

52. Caspar Wolf (1735–1783), *Inside the Bear Cave near Welschenrohr*, 1778, oil on canvas, 42.3 × 34.5 cm. Kunstmuseum Solothurn.

. . . only this uninterrupted composition is able to give limited objects the stamp of infinity. In my opinion, it is in this kind of artificial infinity that one must search for the reasons why rotundas produce such an imposing effect: whether it be a building or plantation, one knows not where to fix the limit and, whichever way one turns, the same object would appear to continue, never allowing the imagination to rest.

This is a plausible comparison and could apply to architects such as Boullée (his *Cenotaph to Newton*) or Lequeux (his *Temple of the Earth*). One should be wary of anachronisms, however.

Saussure and Escher von der Linth

Looking at other genres that might have influenced panoramic representation, cartography is probably not the least significant. The Merian family presented oblique views of cities in the fifteenth century, following a procedure that would soon become established. The new sciences of geography and geology would make a major contribution to the replacement of the artistic model by a topographical one that offered a precise and detailed reproduction of terrain.

In his *Voyages dans les Alps*, published in Neuchâtel between 1779 and 1796, Horace-Bénédict de Saussure regularly and prematurely referred to 'panoramic'

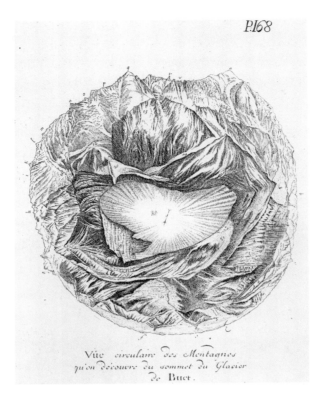

P.168

53. Horace-Bénédict de Saussure (1740–1799), 'Circular View of Mountains Seen from the Top of the Buet Glacier', 1776, from his *Voyages dans les Alpes* (Geneva, 1779).

viewpoints from which the whole of a landscape and journey could be recaptured at a glance. Referring to the Talèfre Glacier, he spoke of 'so open and beautiful a view that words can only begin to describe it'. It should therefore come as no surprise that at the beginning of his book there was a flat, circular representation that could serve as an orientation plan (illus. 53), and that would later be called a horizontal panorama. As he explained in the introduction:

> . . . the idea of a drawing of this kind actually came to me when I was at the top of the Buet in 1776. When I had finished describing the infinite variety of objects I had before my eyes, I realized that if I did not add some drawings it would be impossible to give my readers even the vaguest notion of what I had seen. But were I to have used ordinary *vedute* [views] I should have had to have made a vast quantity, and the more I would have made, the less they would have evoked the unity and sequence of these mountains as seen in Nature . . . But by following the method I have used, the draughtsman makes an exact copy of objects as he sees them by turning the sheet as he himself turns, and anyone wishing to use his work to get an idea of what the object he has drawn looks like must imagine that they are at the centre of the drawing, and with their imagination enlarge on what they see from this centre and, turning the drawing, inspect all these parts. In this way, they will see how, one after another, all the objects are linked together and exactly how they appear to the observer who stands at the top of the mountain.

In 1755, before Saussure, Micheli-du-Crest had made a *Geometric Prospect of the Snow-Covered Mountains Known as Gletscher*, although he had reconstructed neither the view's continuity nor its circularity. Later in the eighteenth century, Hans Conrad Escher von der Linth made panoramic views of the Alps his speciality. Having made a copy of Saussure's horizontal panorama, he then used a different scale and in 1792 designed a *View from Fieudo, One of the Peaks of the St-Gothard to the West of the Convent*, discovered when out for a walk one summer. It measured approximately 10 by 3 metres. In his account, he went so far as to claim (wrongfully) that this idea originated with him:

> In 1792, a time when no one had yet thought of the panorama, I drew a completely circular view from the summit of the Fieudo, which is in the Gothard range; at the time, I did not know how to draw mountain chains on paper and had only the vaguest notion of geographical stratification.

Escher von der Linth subsequently made almost 900 artistically and scientifically precise drawings and plates of his pilgrimages through the Swiss countryside, from Geneva to Zurich, travelling, needless to say, through his favourite subject: the Alps. About a fifth of this output, housed in the Graphische Sammlung of the Federal Polytechnic School of Zurich, belongs — by virtue of its horizontal, oblong format — to the panoramic genre. But none of the images actually emerged as a panorama.

Supporters and Detractors: The Ideal Landscape

In October 1802, the critic from *Monthly Magazine* devoted a long article to the *Eidometropolis*, a view of London painted by Thomas Girtin (illus. 54–6), criticizing the artist for adhering too rigidly to the view from his chosen vantage-point, with the result that the towers of Westminster looked like a compact mass: he should have taken the liberty of adapting reality in such a way as to produce a more poetic and enlightened vision more capable of detaching form from volume.

The tradition of the ideal landscape in fact was based on an art of composition which involved rediscovering a perfection of balance, rhythm and selection thought to be absent from real nature. The elements of a painting had to be organized into a hierarchy, given a function, a structure, in order, no doubt, to elicit what Baudelaire was to call 'the chaos of details'. And yet, as I have already pointed out, a new aesthetic was established during the eighteenth century that was to lead to reality's being recorded objectively and laid out from a predetermined vantage-point, *hic et nunc*.

The pre-eminence of this one and only vantage-point automatically precluded the use of poetic licence. What the painter depicted from a specific spot, viewers should, if they so wished, be able to visit and verify for themselves.

Then, if the painting wanted to claim that it was duplicating such-and-such a reality, it could surrender itself completely to the constraints of the model. It is no coincidence that panoramists always carried out precise and meticulous surveys of terrain: Marquard Wocher went so far as to gather information from a local correspondent on all the modifications undergone by the town of Thun, from the moment he began his preliminary sketches to the moment he had to produce his large-scale work. The panoramist sought to reconstruct material facts without worrying too much about the truth that lay behind them.

The fact that it could be used as documentary evidence meant that a panorama was largely dependent on the choice of vantage-point, which then had to be strictly adhered to. A panorama also had to contain a clearing in the distance and an elevation, so that there would be no awkward obstacles to prevent the most picturesque elements of the circular horizon from being brought together in the most favourable of conditions. The *Journal London und Paris* reproached Thomas Girtin for having chosen, in his *Eidometropolis*, an observation point too far from the interesting monuments of the City of London, resulting in the canvas losing its documentary value (illus. 54–6). Léon Dufourny, in his report for the Institut National des Sciences et des Arts in 1800, drew attention to this issue:

> In order to produce the necessary drawings for the execution of a panorama, the artist must chose a fairly high hill so that he is able to see every part of the horizon and at the same time observe the details to be found at the foot of the elevation on which he is placed; it is imperative that the most interesting, the most picturesque objects on this horizon be seen by him from an advantageous angle and in a position most likely to render their effect stimulating; it is particularly crucial that the foreground be rich in details and that it be as lively as possible.

54–6. Thomas Girtin (1775–1804), three of five drawings for the *Eidometropolis*, 1797–8, watercolours. British Museum, London.

The 'Great Picture of London' painted by Girtin, also known as the *Eidometropolis*, was exhibited in Wigley's Great Room in Spring Gardens from 2 August 1802. The chosen vantage-point from the top of the British Plate Glass Manufacturers building accentuated the modern, industrial character of London. As Ralph Hyde wrote, '. . . the water-colours show the appearance of the Eidometropolis from Lambeth to London Bridge, with a gap for the Blackfriars Bridge to St Paul's section. They can be assumed to be part of the colour model used when the full-scale oil was being painted.'

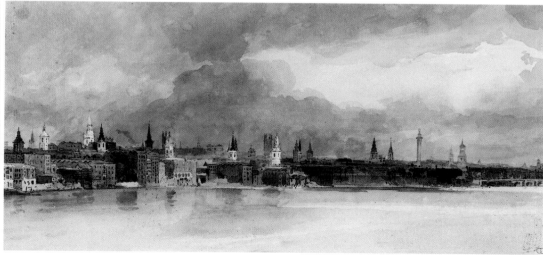

Since licence and correction were no longer allowed, everything depended on where artists positioned themselves in the landscape they wanted to depict. For we should not forget that all vantage-points are partial (in both senses of the word): what they reveal to the eye has involved certain features being transferred from beyond the horizon or concealed, within the horizon, by such and such a feature. We should therefore limit the scope of the term *panorama*. In a circular representation, there are inevitably certain areas that cannot be seen on the level of the depth of field. In truth, only an aerial view would allow every single feature of the terrain to be reconstructed, but this would result in the virtual loss of all verticality through flattening. Not to mention the lack of 'anchorage' conveyed by a landscape that appeared neither inhabited nor alive, but disconnected from any figure or subject that gave it a sense of place.

The panorama therefore had no composition other than that *implied* by the chosen vantage-point. It formed an almost encyclopaedic document of nature and abandoned itself to recording all the multifarious details of reality. It neither knew how to, nor did it want to select. It is therefore not surprising that the criticisms targeted against it were often similar to those made of camera obscuras and, later, those addressed to photography, namely that it was a mechanical, soulless reproduction of the real, devoid of any artistry. In any case, the laws governing the ideal landscape – based on principles of balance, proportion, a foreground opening that did not exceed a width of 12 metres, and a height-to-width ratio of 1:3 – could not be applied to a circular canvas, since it functioned through juxtaposition or continuity, following an unstructured plan that demanded a lateral sweep of the eyes.

If the public responded positively and enthusiastically to panoramic exhibitions, the experts from the world of the Beaux-Arts did not; their opinion was, to say the very least, divided. Aubin-Louis Millin outlined the rift very well in his *Dictionnaire des beaux-arts* (1806):

> The opinions of several harsh critics and connoisseurs were at first not very much in favour of this optical show. All the artists could see was an expensive scrawl amusing to children big and small whose only merit was that the perspective was well observed and that the objects represented were imitated faithfully. Despite the severity of these judgements, Mr Barker's exhibitions drew huge numbers of curious people from all walks of life and were extremely successful in other countries where panoramas were made or toured.

Admittedly, the panorama had its supporters: Sir Joshua Reynolds, Jacques-Louis David and John Ruskin. In 1810, Caspar David Friedrich nurtured the idea of making a panorama himself after a stay in the Riesengebirge. Pierre-Henri Valenciennes, in his *Eléments de perspective pratique à l'usage des artistes* (1800), welcomed 'an interesting show for artists and amateurs', concluding

that 'this new fashion for painting a sweeping view has been missing from art, and can only add to the progress of knowledge'. As for Delacroix, we have seen the enthusiasm with which he defended Charles Langlois to the Paris City Council. John Constable, on the other hand, had reservations. He evidently enjoyed the show, but did not think it belonged in the domain of art 'because its object is deception – which was never the case with Claude Lorrain nor with any other great landscape artist.

Before tackling the subject of illusion, I should like to underline just how much opinions about the panorama, as expressed in the periodicals of the time, corresponded with the friction that existed between the disciples of Academic Neoclassicism on the one hand and Romanticism on the other. An article published in the *Journal des artistes* on 29 May 1831 is extremely revealing in this connection. Essentially, its critic was attacking two reviews whose common cause was their affiliation with the Romantic movement: *Les Débats* and *Le Constitutionnel*. His tract expresses an impassioned Classical creed triggered when the other side claimed that taste should be dictated by the masses, by the crowd rather than by the élite:

> To what role are these gentlemen, these people of talent and intellect now reduced? To that of simply conforming to the changing and fickle taste of the masses; for, try as we might, it will always be necessary to recognize that, by 'opinion of the century' we should understand 'opinion of the masses'; we should, however, do these men of letters and artists the honour of acknowledging that they have more knowledge of their field and more taste than these masses.

He moved on to the newly proclaimed fashion for the panorama:

> Everyone admires a beautiful panorama; all of those who have been trained in the arts, or at least in geometry, appreciate the relationship between the complexity of the lay-out and the magic of the effect. We know that the contours of the landscape and even of the architecture fall in with the game of anamorphoses, but is there anyone who understands that with anamorphoses one can make first-class paintings, historic paintings?

The artistic élite felt threatened by the panorama; they feared that their artistic activities would be snatched away from them, especially as panoramists were about to venture into territory closely guarded by the Academies – that of war and battles – that could be incorporated from near or far away into history painting.

The use of the camera obscura; the rise of the Picturesque; the strict adherence to actual vantage-points with no room left for poetic licence; faithful machine-made records; details meticulously transferred – all came together to rankle the Beaux-Arts. This pattern would be repeated time and again: the condescending attitude towards the panorama, its undeniable technical merit

57. Rotunda housing Hendrik Willem Mesdag's (1831–1915) *Panorama of Scheveningen*. Panorama Mesdag, The Hague.

acknowledged while it continued to be dismissed as being outside the field of art and great painting (it is true that in general the quality of the painting was fairly mediocre). Later in the century, it was reduced to the status of an industrial product. As François Robichon quite rightly pointed out in *Le Mouvement social*, 'In the eyes of the law, the panorama is a curiosity: the reproduction of reality is not an act of artistic creation if it is an industrial product. Painters of panoramas do not own the artistic copyright to their works.' One of the consequences of this was that painters were unable to prevent their canvases from being dismantled or cut into pieces and sold separately once they had been exhibited. It was in fact in order to protect himself from this risk that Poilpot became a shareholder in his own panoramas.

As to the observation Van Gogh allegedly made after having seen Hendrik Willem Mesdag's panorama of the beach at Scheveningen (illus. 57) – often painted by Van Gogh when he stayed at The Hague – '. . . the only fault of this canvas is that it doesn't have one' – no one knows whether this was meant as a compliment or a reproach.

58. Louis Le Masson (1743–1829),
Panorama of Rome, 1779, watercolour and
gouache on paper mounted on canvas,
62 × 456 cm. Private Collection.

In 1779, Louis XVI commissioned Le
Masson to produce a circular view of Rome
to decorate the walls of the dairy in the
château of Rambouillet. Le Masson made
accurate drawings from the terrace of
San Pietro in Montorio, but the full-scale
realization of what appears here to be a
model was prevented by revolutionary
unrest. Some scholars regard this project
as the first panorama before the term was
coined, preceding Robert Barker's by a
decade. But they overlook the fact that
Le Masson did not invent the panoramic
concept (platform with ramp, canopy,
overhead lighting, circular support
structure). What his work did have in
common with true panoramas, of course,
was the desire for an all-encompassing
view.

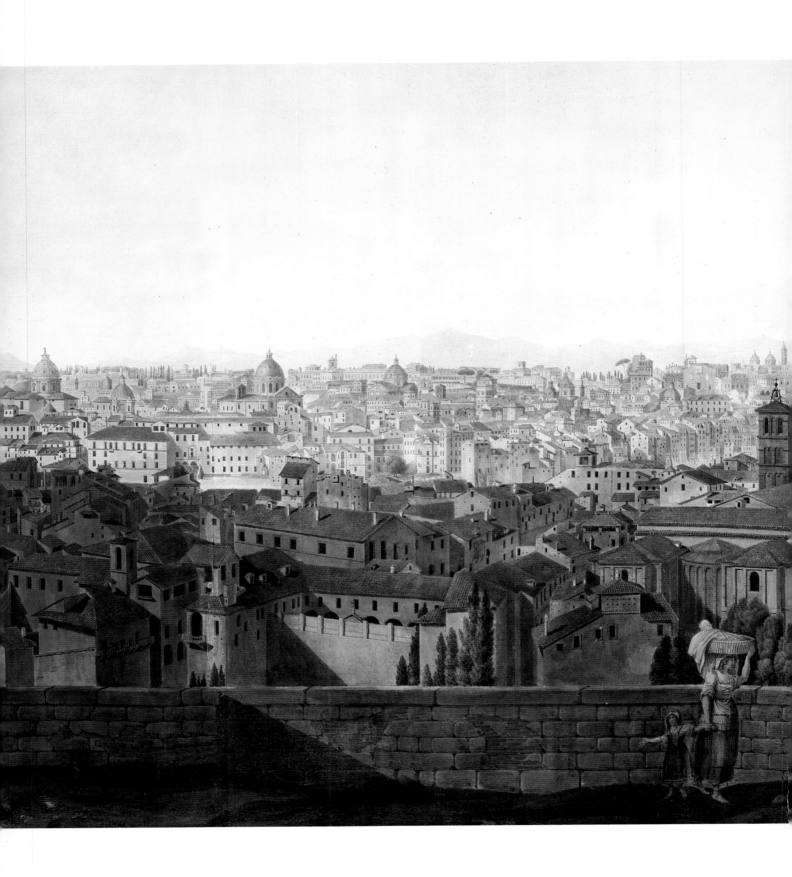

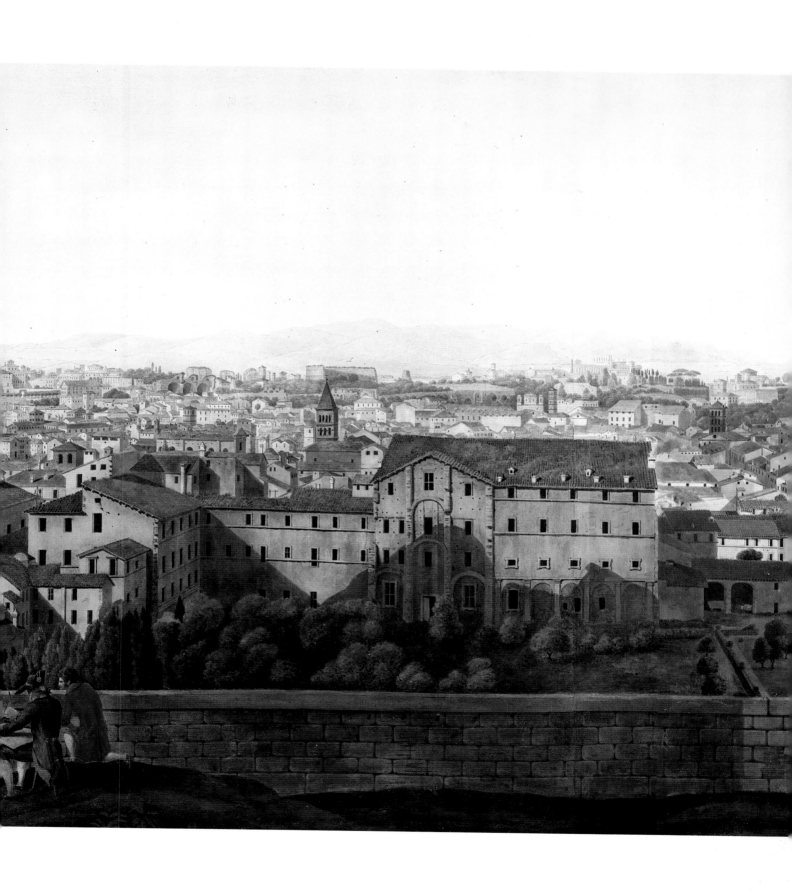

Representation/Illusion: A Theory of the Frame

In his *Handbuch der Aesthetik* (1807), J. A. Eberhardt said some very harsh things about the panorama, criticizing it on four counts. The first three related to faults that hampered the sense of illusion: absence of sound; immobility of the figures and lack of variety in the landscape; the spectator's having to shift from illusion to consciousness of deception. These I shall deal with in the next chapter. First, I wish to concentrate on Eberhardt's fourth criticism.

Having described the terror, vertigo and nausea that could be induced by a panorama, Eberhardt went on to condemn vehemently spectators' lack of freedom, their inability to escape the 'spurious chimera':

> Neither the knowledge that I am nowhere near the vantage-point, nor the daylight, nor the contrast with my immediate environment can rouse me from this ghastly dream, from which I have to wrench myself against my will. One can in this way put an end to the illusion the moment it becomes unpleasant; but the technique is not available to all spectators of the panorama.

In this particular case, the problem was the distinction between representation and illusion. More broadly speaking, however, the passage raises the question of the ethics of such representations. An article published in the *Journal des artistes* in 1830 stipulated that the imitation should respect certain limits, those prescribed by good taste: 'What we do not want to see in artistic productions is a *complete* imitation of nature.' All that was needed to complete the work of the artist was the participation of the viewer: 'It is we who complete his work; it is our imagination that will add movement, that will bring the spark of life to masterpieces of art.' More so than sculpture, painting constructs space, volume, depth through subtle deceptions that require the spectator to consent to being duped; the consent is warranted, but must not be inflicted.

Quatremère de Quincy was probably the most accomplished and systematic voice of a Neoclassicism that, confronted by the advent of a documentary and naturalistic dimension to art, defended the idealistic view of representation. In his *Essai sur la nature, le but et les moyens de l'imitation dans les beaux-arts* (1823), he also developed the idea of an imitation based on the principle of incompleteness where, in comparison to its model, the image was flawed – unlike identical reproductions that were machine-made more often than not and that failed to give pleasure. He compared the 'freedom of imitation' to the

'constraints of the copy'. For, according to Quatremère, aesthetic enjoyment was only possible when there was a difference between the image and the real, and when this difference was evaluated in relation to the likeness. It did not have to be total, but on the other hand it did have to attain perfection within the limits of its art: incompleteness therefore ceased to be a problem in as much as the spectator was no longer really aware of it. From this came Quatremère's law that the greater the apparent difference between the image and the actual subject, the more superior the work of art.

Quatremère's arguments were often specious and revolved mainly around two points. First, if the image was so realistic that it became confused with and supplanted the subject, there was no reason not to prefer the subject itself, all of whose qualities could not in any case be reproduced for the simple reason that the image presented only one angle, to the exclusion of all others. Second, ideal beauty could not be found anywhere, not in any landscape, not in any being; it was up to the artist to create it by competing with nature and by producing a beauty whose model existed only in a scattered state. For art to exist, therefore, it had to identify itself as such through a lack of likeness which the ideal, of which it was the bearer or messenger, would then redress. This entailed condemning outright all forms of art that did no more than record reality as it was, that made illusion an end in itself. At the same time, both the viewer's alleged passivity in the face of total illusion and the mesmerizing effects that deprived him or her of freedom to choose had to be denounced.

The question of illusion is a delicate one. At this point, we must return to Diderot, to whom I attributed such a crucial role in the evolution of the desire *to enter* into a pictorial space that subsequently replaces reality. Diderot expressed a propensity for realism, the Picturesque and anything that resembled reality, so much so that he became a part of it, as a reading of his writings on Chardin will show. What he was after was living presence – in other words, life. Of Chardin's *Skinned Skate*, he said: '. . . the object is disgusting; but it is the actual flesh of the fish. It is the skin. It is his blood; the very sight of the thing would not otherwise fascinate' (*Salon* of 1763). When it came to Vernet, the illusion went so far as to make a spectator hallucinate; he saw the light tremble and shiver on the surface of the sea, watched the men move, 'heard the winds whistle and the waves roar'; he could even hear the sailors call. However, as Jean Starobinski quite rightly observed, '. . . the demiurge landscape artist opens up a natural space for us, but the force that draws us in only receives its reward in full if we know we are in raptures thanks to the perfection of an artifice.' For, dare I say it, we must not loose sight of the fact that we are looking at a painting. For Diderot, illusion was only taken on as an extra and enjoyable aspect of a sustained and constantly maintained awareness of the representation, the artifice, the simulacrum.

On the other hand, the panorama constantly strove to perfect the design and

methods used to eradicate awareness and achieve total illusion. This was done primarily by suppressing the frame. Before tackling this subject, it might be worth defining landscape, and defining the painted landscape.

The traditional definition of a landscape always implies that there is someone looking at it, his or her very gaze giving it form. According to Robert's dictionary, landscape is 'part of a country presented by nature for the eye to look at'. For Littré, it is a 'stretch of a country seen from just one angle'. The landscape is therefore what takes shape in the eye of an individual from the position he or she occupies, extending as far as the horizon. Hence the landscape is only ever one part, one fragment of the world, shaped for and by a subject *hic et nunc*.

Admittedly, it would be a mistake to see a whole painting as a fragment, in as much as paintings did not present themselves – for a long time at least – as fragments of reality (in the way the haruspex cut out a piece of the sky), but as autonomous and self-sufficient compositions. However, paintings cannot ignore the boundaries that give them shape. Let us recall Alberti's famous formula in his *De Pictura*, although it is not unambiguous: 'First of all, I trace on the surface to be painted a quadrilateral of the size I want, made of right angles, and which is for me an open window through which the story can be viewed.' From Alberti's time on, the role of the frame would be to designate the representation, for it was seen as a symbolic agent that defined the area of the image. Pierre-Henri Valenciennes, for example, referred to the 'frame which surrounds the Painting, and which bestows upon it the value of a perspective based on Nature as she is seen through a window whose opening forms an edge, and therefore a limit to the scene we are looking at'. Further on, he described 'the canvas as being the aspect of nature that is circumscribed by the frame, always creating the effect of a window'.

It is therefore the frame that denotes that a work of art is what it is. It could even be used to replace this fundamental and satisfying role, as witness the English tourists Louis Marin referred to in *Des pouvoirs de l'image*,

> who, having found an artistic landscape they liked, and wanting to refine their pleasures and convert those of nature into those of art, turned their backs on them and contemplated them in a slightly tinted mirror, a *Lorrain-glass*; in short, they made of the image in the mirror, of the 'view', of the *prospect*, of the panorama, a painting by Claude.

However, Carl Gustav Carus, in a letter to Friedrich, stated quite clearly what, in his opinion (though it was still an idealist notion), separated a simple reflection from an artistic creation:

> Just try the experiment for yourself: look at a natural landscape in a mirror! You will see it reproduced with all its charms, all its colours and shapes; but if you capture this reflection and compare it to the effect a finished work of art

representing a landscape has on you, what do you notice? – It is obvious that the work of art falls short of the truth; for whatever it is that makes the beautiful natural shapes so charming, the colours so luminous, it is never entirely achieved in the painting. You experience at the same time the feeling that the authentic work of art constitutes a whole, a little world (microcosm) in itself; a reflection in retrospect will always appear to be a fragment, a part of infinite nature, detached from its organic links and circumscribed within its limits from nature.

For a long time, the painting used its composition to naturalize or legitimize its frame in an attempt to escape the fragmentary destiny that so haunted it. There was a rigorous narrowing of the central perspective into the vanishing-point; the original model was modified to aesthetic ends; the gaze, not to be distracted by any detail, had to be concentrated so as to take in the whole of the scene and the scene as a whole; the landscape was presented as the be all and end all, not as a part of the world that intimated a greater totality; anything that could belong to or suggest an external reality was swallowed by the frame so as to nullify the outside-the-field (I use this anachronistic term for the sake of convenience) of the representation.

Alternatively, the painting could return to its fragmentary status and problematize it as though it were an arbitrary element, the product of its own artifice. This is the case, for example, when a figure in a painting is seen to be looking outside the perspective triangle, when index fingers point to an elsewhere, or when elements can be considered to be marginal: feet or hands that rest on the frame, characters that are cut in half, or marginal areas called attention to in other ingenious ways. What we have here is a kind of *in medias res* where the representational field is visibly and explicitly linked to a concealed elsewhere that takes it out of its 'window', beyond the visible.

Lastly, what can we say about some of Friedrich's paintings in which the landscape is *framed* by a window within the painting, as though duplicating as well as exhibiting the arbiter of what has been cut out? If Friedrich was particularly sensitive to this problem, it was probably because he was obsessed with its opposite – that of the all-encompassing representation: 'All that we perceive, whether it is by turning around completely, should be captured within the image, for this is what we would term richness of composition.' Friedrich's problem, extremely well analyzed by Roland Recht, was that the conditions or limits of the painting as a form obliged him to compress into 45 degrees the 100 degrees his eyes took in. From what we understand, Friedrich was attracted to the panorama because he wanted to reconstruct the grandeur of his impressions of the Riesengebirge.

Abolishing the frame was the only way of transcending the limits of traditional representation. Diderot had understood this when he suggested using an eye-glass to eliminate the frame. And if Valenciennes stressed that the

semiotic role of the frame that circumscribed the painting was to define the representation, he did not, as did Quatremère de Quincy, turn this into an ethical factor. On the contrary, he devoted a very commendatory end-of-chapter to the panorama in his *Eléments de perspective*, admitting that an ordinary painting

> can never perfectly present the lie of the land because the space it represents is circumscribed by the frame; and because wherever it is placed, the view is broken and obstructed by other objects that have nothing to do with what the painting depicts; these drawbacks prevent the illusion from being complete.

The proponents of panoramas were to stress this point constantly: any comparative element that might remind the spectator of the illusory nature of the representation, and thereby impede 'the impression of really being there' as promised by Barker, had to be carefully suppressed. Dufourny was to observe: '. . . it is by removing from the eye all elements of *comparison* that we succeed in tricking it to the point where it hesitates between nature and art', before going on to say:

> Paintings, however large they are, are usually enclosed within a frame that right from the start proclaims that these are works of Art. They are placed next to an infinite number of objects that have nothing to do with the subject; despite itself, the eye when it gazes at the paintings takes these objects in, and it is with their help that it can judge sizes, distances and even colour, and since nature is always superior to art, the imitation appears weak, incomplete; the illusion cannot establish itself, or soon vanishes.

In conclusion, he proposed to systematize this kind of representation and apply it to all paintings.

Through its configuration, the panorama was to produce an uninterrupted area of representation with no edges, no break, no exterior. The horizontal arrangement of the circular canvas was uninterrupted since the platform was reached from below; the upper part was concealed by the canopy; finally, the part situated underneath the canvas and the area separating it from the platform was neutralized, first by an oblique canvas sheet and later by imitation terrain, which completed the illusion with the addition of authentic objects and *trompe l'oeil* features, mannequins, silhouettes, etc. Consequently, the panorama could not fail to attract the wrath of Neoclassical academics who condemned the mixture of genres in no uncertain terms. To return to Quatremère de Quincy:

> In whatever way the artist has chosen to comment and bring together, in one and the same work of art, formulae, methods, objects and effects belonging to another form of imitation in his attempts to produce a more authentic likeness, he has distorted the medium, or image, in the hope of achieving a respectable similarity. He wanted to deceive, he deceived in order to please, and from that

moment he lost the right and the means to please those who expect from the arts the charm of imitation and not the deception of counterfeit. Let him address those who are more than willing to be duped or who deserve to be – that is to say, the ignorant.

The mixing of authentic objects with pictorial representation attracted much criticism, at times harsh, from the corridors of academia. Jules Claretie, in *La Vie à Paris* (1881), wrote: '... the combination of the morgue and the Musée de Luxembourg, the Salon de Peinture and the Galerie Tussaud will make this panorama fashionable where fixtures, twisted rifles, broken helmets and shell bursts represent Naturalism, while the actual background of the painting, the landscape, sky, the sweeping lines represent Art.'

Be that as it may, the effectiveness of the invention was not in question; spectators forgot the real world outside and were transported to different places which they took to be reality. One should of course make allowances for exaggeration, but the effectiveness of the subterfuge is borne out by many anecdotes. I have already mentioned the seasickness experienced by Princess Charlotte. In the first article to appear in Germany on the subject of the panorama exhibited in Hamburg, the author had his reservations when it came to the nervous disposition of the ladies, who were, in the circumstances, associated with *Stutzer* – in other words, fops. Eberhardt himself, in his *Handbuch*

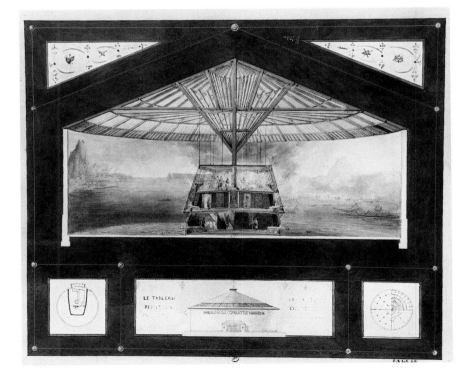

59. Charles Langlois (1789–1870), Cross-section, elevation and plans of the panorama of the *Naval Battle of Navarino*, 1831, hand-coloured drawing, 28.2 × 33 cm. Musée Carnavalet, Paris.

Langlois, a former Napoleonic officer, inaugurated his first panorama in 1831 with a *Naval Battle of Navarino*. For the first time, the spectators' platform contributed to the overall illusion, consisting as it did of the poop deck of the frigate *Scipion*, which had taken part in the actual battle. The artificial terrain beween the circular canvas and the platform was improved subsequently, in that objects related to the panorama's theme were scattered around. There was nothing in the visual field to remind spectators of the spectacle's mimetic nature.

der Aesthetik, expressed his regret at not having had the opportunity to observe the effects of a panorama on a woman of his acquaintance, but he was concerned as to how it might affect feminine sensitivities when he saw 'the terrible effect it had on the solid nerves of a man'. And we should not forget the dog who, when taken into a rotunda, was fooled into thinking that the water was real; it looked so natural that he threw himself in for a swim. Probably fictitious or at the very least elaborated, this report appeared in *Le Cabinet de lecture* for 24 January 1831. A most unusual document on the subject, it also contains a young woman's account of how she had a genuine attack of hysteria when she visited Langlois's panorama of the *Naval Battle of Navarino* (illus. 59). It was of course not insignificant that these reactions were almost exclusively attributed to women; they are connected to what Georges Didi-Huberman, when referring to Charcot, so charmingly called 'the invention of hysteria'.

The nineteenth century was particularly fond of stories in which a representation was pushed so far that simulation almost became incarnation. In *The Oval Portrait*, a short story in the form of an apologue, Edgar Allan Poe seemed to want to attack illusion and its mortiferous qualities when these took the form of a portrait. Wanting to paint his wife's portrait, a young man got her to sit for him. But the life was gradually sucked out of the wife's body and transferred to the canvas. In his near rapturous state, the painter put the finishing touches to his painting and the woman died: 'He did not *want* to see that the colours he was applying to the canvas were being *drained* from the cheeks of the one seated next to him.' We shall see how the configuration Poe chose for the sitting – rotundity, lighting – was not so far removed from the panorama: 'She sat quietly over those long weeks in the dark lofty room of the tower where the only light to filter onto the pale canvas came from the ceiling.' A light that Poe also said 'fell so lugubriously into this isolated tower'.

The Limits of Illusion

This is how the *Journal des théâtres* for 12 August 1821 concluded the article on Pierre Prévost's *Panorama of Athens*: 'The eye is so deceived that forgetting I was in front of a Panorama, I often stood on tiptoe to gaze at the countryside beyond the buildings in front of me and took my lorgnette so as to see the gorges through which the ways of Providence flowed.' We have seen how a specific idea of representation – let us call it ethical – rebelled against the principle of an illusion that, through wanting to be mistaken for reality, not only lost all artistic merit, but – even worse – inflicted its effects on spectators. Some criticisms or reservations, on the other hand, accepted the concept of orthodox illusion while mourning its incompleteness, its imperfection.

This is why Kleist's account is particularly interesting. In August 1800, when Johann Adam Breysig's *Panorama of Rome from the Palatine Hill* was hung in Berlin, he wrote one of his famous *Lettres à la fiancée* declaring that the show 'was famous only because it was a novelty'. The idea of a representation in the round was attractive, but in Kleist's opinion it was 'possible to achieve much greater perfection'. Rather than have a canopy covering the platform, he would have preferred 'a tree under whose spreading leafy branches we could find shade'. As to the thick pine planks that covered the ground, he observed ironically that they 'looked nothing like Carrara marble'. Having praised Breysig's canvas, in which he had found 'a great quality in the detail, an abundance of beautiful things and parts, each of which would have been enough to make a place worthy of interest', Kleist returned to the installation as a whole to make his final objection: 'But no breeze from the west came to cool the ruins where we stood; the heat was so overwhelming in the outskirts of Rome that I was keen to return to Berlin.'

Here lies the ambiguity of the panorama. From the moment that it no longer subscribed to the classical logic that relied upon spectators participating in the game of the imagination for it to be complete, it gave in to the demands of totalization to the extent that it culminated in the mixing of genres for the satisfaction of all the senses – touch, sight, sound and (why not?) smell. In Hugo d'Alési's *Mareorama* (illus. 47), air passed through a filter of algae and kelp and was made 'fragrant'; as for Segantini, he wanted to introduce different Alpine plants so as to recreate a perfect ecosystem.

The two most common criticisms aimed at the panorama were the absence

of wind and lack of sound. Eberhardt, for example, spoke of the unease he had felt when confronted with a view of London, a large bustling city, weighed down by a 'melancholic silence'. Some critics, however, only mentioned this without really expressing regret. For example, the article in *La Nature* (15 June 1889) devoted to the *Panorama of the Transatlantic Company* noted:

> What the illusion lacks is a light breeze, floating pavilions, the sound of the lapping of waves, orders being shouted from a megaphone. It might then be possible to believe, so perfect would the imitation be, that the visitors, transformed into passengers, did indeed feel seasick.

The *Journal des artistes*, referring to Langlois's *Naval Battle of Navarino*, went even further:

> It is true that we do not have the advantage of hearing these honourable exclamations, for everything here is for the eyes and not for the ears: this vast horizon bursting with light, these blue mountains, the bay and city of Navarino, the Island of Sphagia and, in the middle of it all, five or six fleets battling it out; the noise must have been tremendous, but fortunately we were left to imagine it, to work it out for ourselves.

This judgement comes as no surprise, since it emanated from a journal with Neoclassical leanings ready to defend the idea of the incompleteness of art being supplemented by the viewer's imagination.

In his 'Explication déduite de l'expérience de plusieurs phénomènes de vision concernant la perspective', presented at the Académie des Sciences on 28 March 1859, Michel-Eugène Chevreul also listed a number of what he considered to be faults in the panoramic configuration that not only spoiled the illusion but were also at variance with what a spectator would have seen in a real landscape. The central circular platform was the same from canvas to canvas, and was too regular to prevent people from getting bored; the sky could only be seen as a cylindrical area, whereas in the outside world the spectator would be able to see the whole of the celestial vault. What he mentioned at the end comes as a surprise, however. The platform to which he referred was apparently divided into three levels separated by ramps (as is the case in the modern rotunda built in Thun to house the Wocher panorama; illus. 60). By placing himself on the lower level and turning to look at the most distant part of the panorama situated beyond the platform, sections of the canvas appeared to be cut off by the vertical bars of the ramp and the supporting circle. Through this rather comical adulteration of the lay-out, Chevreul ended up discovering that it was possible to gain aesthetic pleasure exclusively from the effect . . . of framing!

At the centre of the debate surrounding the panorama was how movement was represented and whether or not it was possible to introduce supposedly mobile elements into something that professed to be the perfect illusion.

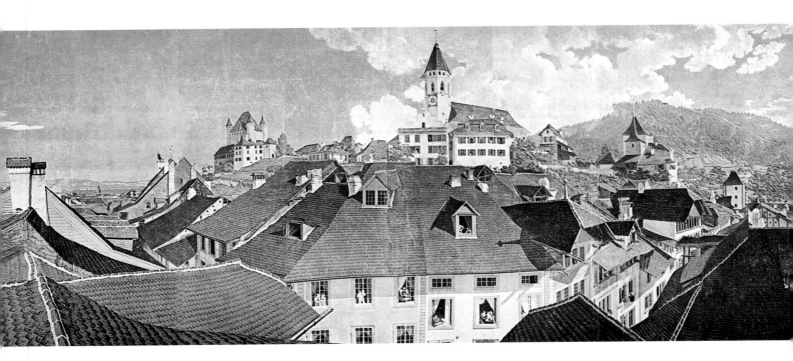

As early as 1806, Millin was already advising caution. He drew attention to the fact that the transitory moment was only suited to history painting, in which it was idealized and absolutely essential. Hence the conclusion that 'the true domain of the panorama is completely inanimate nature', or animate nature in repose. Millin did make a few concessions, however:

> It is quite acceptable for the artist to put boats on a lake in the background of the painting as long as they are a long way away from the spectator so that the movement is so slow as to be almost imperceptible, and so that the permanent scene he has before his eyes cannot destroy the illusion.

Millin went on to permit waterfalls as long as they were far enough away to appear stationary, and fires as long as they were far enough away for their flames not to be seen to flicker; it struck him as absurd to want a panorama to portray 'the frenzy of a land or sea battle, as Mr Barker advises'. When it came to the representations of towns, these were only acceptable if they were a mass in the distance with no moving figures, carriages, men on foot or on horse-back: 'On finding himself surrounded by such representations, the spectator might think he had been transported to a fairyland where by the wave of a magic wand everything had been plunged into a profound lethargy, rooted to the spot by a magician's spell.' Eberhardt was to take up this argument and apply it to the whole of nature, whose endless variety – nuances and changing interactions of light and shade, scudding clouds, atmospheric variations, transformations of the landscape as the sun journeys through the sky – the panorama was incapable of reconstructing.

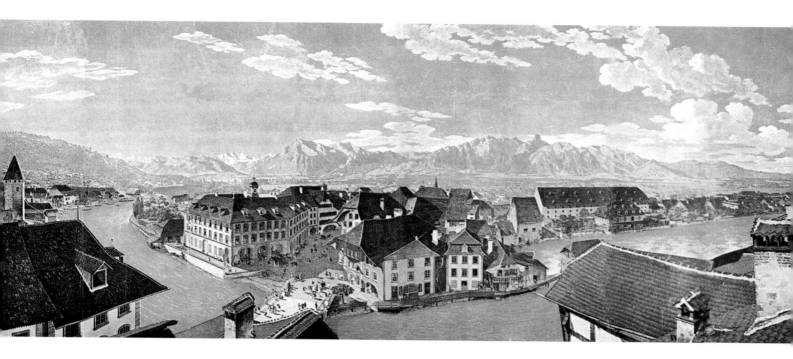

Canon Meyer, however, an early visitor to Prévost's panoramas of Lyon on show in Paris, did not turn his nose up at it; anyone reading him would get the impression of a spectacle of movement:

> On the distant horizon, clear and exposed, stand the snow-covered peaks of Switzerland. Below, bathed in sunlight, spreads a plain through which flows the Rhone. The dark clouds of an imminent storm hang over the town. Small clouds flee before the storm as though reaching out towards us. There is no greater illusion than this column of clouds over Lyon and the shadows cast by the sun over parts of the city. We hear the thunder rumble in the distance, feel the first shock of the impending storm: we have an urge to run for cover below the nearby towers of the castle before it breaks.

Is it necessary to draw attention to the proliferation of verbs? Fired up, the imagination generously completes the illusion. But on the whole, commentators, critics, even the staunchest advocates of the panorama suggested that movement should be banned from the representational field. Yet it was quite rare to find a canvas that did not include a person or vehicle in motion.

Another major problem painters had to deal with was that of temporality, which was by definition virtually incompatible with the effect of synchronicity the panorama wanted to achieve. In urban views, it is possible to achieve a fluidity in the portrayal of everyday life, of the commonplace and its symbols. But to represent a battle, a painter has to choose from a sequence of events and favour a specific moment. A particular story emerges instantly and with it the outline of an interpretation of the events and how they were linked.

60. Marquard Fidelis Wocher (1760–1830), *Panorama of Thun*, 1814, oil on canvas transferred onto panels, 750 × 3,830 cm. Kunstmuseum Thun.

This is the oldest surviving panorama. No fewer than 360 figures are shown in a composition depicting the humdrum life in a small Swiss town at the time of Biedermeier. The panorama's artistic merits are clearly evident despite its relatively small size. Originally exhibited in Basel, it was rediscovered in the 1950s and eventually hung in a rotunda in Thun. Unfortunately, the rotunda, inaugurated in 1961, does not meet all of the traditional requirements. The panorama is shown in daylight, and it is reached by a platform composed of three concentric concrete levels, the largest of which brings the spectator too close to the canvas. Moreover, there is no canopy to screen the light source, and the circular glass panel in the conical roof has been replaced by an opaque glass dome that fails to produce the appropriate lighting effects. Marquard Wocher, was a 'minor master' of his time who from early childhood was fascinated by Switzerland and the Alpine landscape. He returned to Thun in 1804, and it was probably not much later, whilst in Paris, that he had the idea of painting a panorama.

Lessing came up with an admirable theory that he called the *fruchtbare Augenblick*, the pregnant or fertile moment, freighted with both what had happened before and what was to follow. A harmonious space unified by perspective cannot accommodate two different moments in the *storia*. This pregnant moment is the product of a trick of composition which allows tension to be introduced and the duration of the action to be condensed into a gesture, a situation. But such compression is unlikely in a representation that is circular, continuous and without a centre or frame.

The panorama would have to find a different system. One solution was to go back to distributing a guide to viewers that gave background information on the scene and explained the whole situation and the events that had led up to and followed on from what they were about to see. Another, later solution consisted in choosing a pivotal half-hour episode from the event that coincided with the length of time it took to 'read' the circular canvas and the actions connected to it. For the panorama showing the Battle of Sedan in Berlin (1882), the platform accommodating the spectators rotated slowly, taking 20 or 25 minutes to complete one turn. But such a solution involved losing the space that existed in the synchronized totality, making it more of a pictorial cycle than a panorama. Because a linear reading was required, because the image unfolded, it broke the spell of a fictional horizon falsely presented as being real.

Only Alési's *Mareorama* succeeded in combining panoramic configuration, simulation of movement and narration or a sense of time. But the lengths he had to go to in order to achieve this consigned his work to oblivion in favour of the nascent cinema. We should, however, avoid too heavy a focus on history. In his fascinating anthology *Panorama, Diorama, Photographie*, Heinz Buddemeier regarded the panorama's inability to reproduce movement as the first frustration the spectator had to suffer and as a failure to achieve the total illusion it wanted to create. And yet there is nothing *a priori* that makes the cinema a *terminus ad quem* of nineteenth-century representation, and if movement was a problem for the panorama, then at worst it was something to be avoided and not a deficiency to be redressed. There were three possible solutions:

— to eliminate any element considered to be mobile or moving, and risk being accused of only being concerned with static nature;

— to allow the spectacle to unfold, although most of the time it would have a flatness that removed it from strict panoramic logic, as was the case with most of the 'moving panoramas';

— to organize a story, with a direction and a linear narrative, sacrificing panoramism in the strictest sense to an altogether relative movement: one might 'move' through the event, but its protagonists would not themselves be moving.

Most of the time, panoramists were happy to depict movement fixed in place, requiring the involvement of spectators' imaginations or forbearance. Millin's 'magicians who rooted people to the spot' might not necessarily have been a vexation after all.

From Near/From Far Away

In his *De Pictura*, in many respects a seminal text, Alberti stressed how important it was for the painter to select a suitable vantage-point: 'The artists themselves prove that this is so when they distance themselves from what they are painting and, guided by nature, position themselves further away so that they can find the spot from which . . . they can see everything more clearly.' Such a technique is dependent on visibility, since 'no painted thing can appear equal to the real thing, unless it is viewed from a specific distance.' The position of the spectator is therefore determined by the painting itself:

> Using lines and colours, the task of the artist is to record and paint on a surface all the figures presented in such a way that, from a predetermined distance and from a point determined by the central field, all that you see painted produces the same relief and has the same aspect as the figures that are presented.

From the outset, therefore, the logic of perspective dictated the distance from which the spectator should view a painting so that the full impact of the figuration could be appreciated and it was impossible to see how it had been made. In his *Cours de peinture par principes*, Roger de Piles, amongst others, demanded that every painting should have 'a point of distance from which it should be viewed'. Daniel Arasse, in his book *Le Détail*, gave an admirable demonstration of how the whole history of imitative painting was nevertheless imbued with a desire to go and take a closer look. There is a basic conflict between the pleasure of the image as a whole and the enjoyment of the image close up. For the comings and goings of spectators as they pass in front of a painting, move before it, result in the form sometimes vanishing, sometimes reappearing.

In the eighteenth century, the question of distance was the focus of much attention. William Gilpin defined this in his *Three Essays on the Beautiful Picturesque*:

> Painting is not an *imitative* art but rather a *deceptive* art . . . by assembling and spreading colours in a particular way, the artist can obtain an imitation of nature which when viewed from a distance resembles it, but which is quite different when viewed from close up.

Diderot carried out the same experiment and declared apropos of Chardin: 'Move closer and everything becomes blurred and flat and vanishes. Move away and everything comes together is and reproduced' (*Salon* of 1763).

Of course, things become more complicated if we position ourselves too far away, as Baudelaire suggested when, in his *Salon* of 1846, he wrote that 'the best way of finding out if a painting is harmonious is to view it from fairly far away so that neither the subject nor the lines are recognizable.' But as a general rule, the corruption of configuration takes place between the ideal viewing position and the painting. In his *Discussions on the Theory and History of the Figurative Arts* (1827, quoted by Roland Recht), A.W. Schlegel appeared to create dislocations that would be capable of producing in this 'between-state' a fitting criterion to describe great art. The passage must be quoted in its entirety:

> Denner, a famous copyist of nature, painted faces on which you could see, with the help of a magnifying glass, the pores and hairs of the skin, tears in the eyes; from a certain distance, however, the one normally taken for the viewing of paintings, this painstaking skill could not normally be seen. On the other hand, when you contemplate from close up, with the naked eye, not with a magnifying glass, a painting by Titian, you can see the disintegration of the shapes and colours, and it is only from an appropriate distance that the masterly hand of the artist, whom we rank well above the one previously mentioned, then becomes visible. The painter must not represent what actually exists but only its reflection. This principle must be respected by the portrait and history painter, but the landscape artist should also adhere to it. If it were solely a question of producing an illusion, then optical boxes, panoramas and dioramas would be of greater artistic import than a landscape by someone like Ruisdael or Claude Lorrain . . .

There is another problem connected with distance, and that is its relationship to the elements represented. For the overview has a tendency to immobilize individual elements, whereas the close-up view teems with life, with details. Pascal referred to this in his *Pensées*: 'A town, a landscape are when seen from afar a town and a landscape; but as one gets nearer, there are houses, trees, tiles, leaves, grasses, ants, legs of ants and so on to infinity. All this is subsumed under the name of landscape.' We often find this optical phenomenon being observed in literature. For example, we have only to recall Mme Bovary's journey to Rouen: 'Seen thus from above, the entire landscape looked inert, like a painting,' but later the city wakes and is seen to be teeming, humming with life, 'like a Babylon'. Moreover, in travel accounts it became a topos to contrast the panoramic view taken from a summit with the disconnected and incomplete sensations of displacement experienced on the ground. Roland Barthes, in his *Michelet*, described the physiology of the Romantic journey and spoke of 'two reactions that involved the whole of a man's body: travel sickness or panoramic euphoria'. A similar switch appeared in a more modern project, Michel Leiris's *L'Afrique fantôme*, in which the author experienced, on more than one occasion, the need for a broader vantage-point that would allow him to recapture at a glance the journey he had undertaken, including its many

pitfalls, as well as the one he had yet to make, which would bring him despair, hope and yearning.

The near–far paradigm can be applied at all levels. An exchange takes place between two experiences and two realities that would seem to be mutually exclusive: one is the distant image that enables the countryside (*landscape* and *townscape*) to be embraced in its totality, although it will look static and the areas in the distance will disappear; the other is the close-up image that restricts itself to fragments but leaves nothing out. However, these two pleasurable experiences are linked, as Carl Gustav Carus, Friedrich's friend quoted here by Daniel Arasse, pointed out: 'The pleasure of contemplating from a mountain top the winding valleys we have just travelled is not dampened, and we get a fairly powerful impression of the whole, for the pleasure experienced in certain places returns and is in a way repeated.' Be that as it may, the panorama was to establish a new order and guarantee the effectiveness of the illusion it wanted to embrace: for the first time in the history of mimetic representation (frontal representation, that is; otherwise we would have to include frescoed ceilings in our discussion, particularly Baroque ones), viewers were allocated a predetermined distance from which they should not stray.

In his patent, Robert Barker specified: 'There must be an inclosure with the said circular building or framing, which shall prevent an observer going too near the drawing or painting, so as it may, from all parts it can be viewed, have its proper effect.' Consequently, if the panorama aspired to create the illusion of reality, then it had to secure the permanence of the landscape, which inevitably relied upon the fixedness of the spectator. Without this, the landscape would probably have betrayed its artifice, for it would have been unable to adapt to the new coordinates imposed by the individual changing position – because, as we have seen, a reality is always delineated and constructed in the *here and now* and in harmony with the subject. If the position of the individual is fixed, strictly defined by the platform, there is no reason for the horizon to alter, and the illusion is guaranteed.

For the panorama consists of several vantage-points at one and the same time: it is the bringing together of all that can be seen by pivoting on the spot, that central point occupied by a viewer who with his or her eyes sweeps around the painted circle from a steady distance. In his *Précis d'un traité de peinture* (1828), Delécluze gave a germane analysis of the repercussions for the representational scheme of removing the frame:

> The continuity of the apparent horizon line is the main thing that distinguishes the *panorama* painting from the framed painting. All we see in the latter is the portion of the horizontal line that is embraced by the angle of vision; moreover, there is only ever one vantage-point. With the *panorama*, whose surface is circular, we proceed from angle of vision to angle of vision – in other words, from vantage-point to vantage-point. As the spectator takes his gaze from one

61. Thomas Hornor
(c. 1800–1844), *View of
the Observatory erected over
the Cross of St Paul's
Cathedral, from which a
Panoramic View of London
and its Environs was
executed by Thomas Hornor
in the Summer of 1821,
with a Sketch of St Paul's
shewing its elevation with
respect to the neighbouring
buildings*, from the
prospectus for the
Colosseum, 1823,
lithograph, 25.8 × 16.5 cm.
Guildhall Library,
Corporation of London.

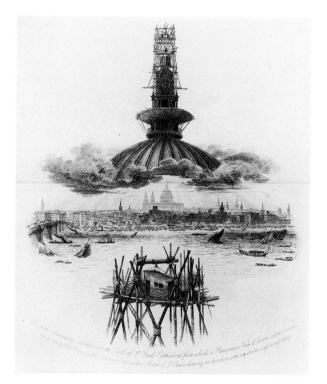

side to the other, his eyes, through the proliferation of vantage-points, is subjected one after another to the optical phenomena that belong to each angle of vision.

Having had his place – his point of view – imposed on him, the spectator deserved some recompense or reward. Which was why the panorama stream-lined the fundamental figurative precision of the distant as well as the near. It would of course have been necessary to choose one's position carefully so that the most interesting features were in the foreground where visibility and read-ability were at their best. But the features furthest away would not have been neglected for all that. At times, this was at the expense of aerial perspective, which was not always compatible with the desire to completely reconstruct all the tiny details of the original. However, the panorama was able to combine what could be seen up close with what could be seen in the distance through a conflation of the gaze which rendered the spectator's movement towards the painting unnecessary – it was a pointless movement since there was nothing to be gained by it.

The most striking example of a panorama offering this type of double focus was without a doubt Hornor's view of London exhibited at the Colosseum. As we have seen, the painter erected scaffolding and a small wooden hut at the top of the main tower of St Paul's Cathedral (illus. 61). Hornor often slept up there so that he could get up at dawn before factory smoke and smog clouded

the atmosphere and get a better view of the surrounding but distant country-side. But that was not all: the sketches from a distance, from the top of the cathedral, were subsequently checked out on the spot by the painter. He roamed the streets and squares, examined buildings, studied the way they had been decorated, inspected each tiny detail, collected details invisible to the naked eye – but not to the camera obscura – from the vantage-point he had chosen for himself. In the Colosseum, the combination of views from near and far common to, though not always consistent with, the panoramic genre found an unusual complement: telescopes 'arranged so as to make it easier to discern the objects in the far distance that are painted in such great detail'. This feature was reported in the *Journal des artistes*, which did not subscribe to the innovation, however:

> As regards this final point, we are not of the same opinion as the journalists of London, who admire it. If these distant objects are painted as they should be, the use of the telescope, by bringing things closer, can produce nothing other than an unnatural effect; for it would be unable, for example, to suppress the atmospheric effects which the painter had to take account of when observing the laws of aerial perspective; on the other hand, if he did not take account of it, the tiny details they say can be seen with the help of the telescope must, to a certain extent, be visible to the naked eye, assuming the rotunda has a radius of 30 feet.

Needless to say, the misunderstanding was fairly widespread, and from their particular point of view, those who inhabited the world of the Beaux-Arts – those, that is, with the greatest Classical or Neoclassical leanings – could only censure a practice that turned their world's most established principles upside down. For whom, then, was the panorama destined and what were its aims?

What Public?

The first panorama made by Barker in Edinburgh was, without a doubt, as was all artistic output at the time, aimed at connoisseurs. But there were not enough of them to make the show-painting a viable financial proposition, given that the initial investment was so high. Moreover, there was a need to open up access to other social classes, particularly the middle class. The initial entrance charge soon came down from three to two shillings, and then to one not long after Barker had installed his panorama in London. This was because the panorama was, right from the start, a self-financing venture that had to rely on as wide as possible an audience, a paying public that was the key to success and that sometimes found itself to be an extremely remunerative operations base.

All manner of things were done to bring in the crowds. Tielker, for example, agreed to substantial reductions on Saturdays and Sundays; he also toured his canvases from town to town to make them more profitable. The majority of rotundas adopted a policy of reduced rates at certain times for those of more modest means. The rest of the time, when the normal rate was in operation, they were less crowded, thereby guaranteeing the wealthier spectator a better view and conditions more suited to aesthetic contemplation. On occasion, though rarely, two platforms were superimposed: the lower, crowded one was cheaper, the visibility poor, the vantage-point too low, the perspective out of true and the illusion not as convincing; above it was the 'aristocratic' platform, the central vantage-point, where places were limited so everyone could relax at their leisure.

As a general rule, however, visitors mingled. In 1889, an article appeared in *La Nature* that spoke of 'peasants and labourers who have never seen the sea, the bourgeoisie and tradespeople who have been raised in their small communities or over the shop, diplomats who dream of representing France abroad, nature lovers who hanker for virgin forests'. François Robichon (in *Le Mouvement social*) worked out what the attendance figures had been over the century. Between 1800 and 1820, the annual turnover varied from 30,000 to 50,000 visitors. From 1800 to 1860, the average dropped to 15,000. But the second-generation panoramas proved to be a tremendous success, with an annual average of 90,000 between 1860 and 1865, 110,000 between 1865 and 1870, and at least 200,000 between 1872 and 1885.

Rotundas were usually located in urban areas traditionally reserved for

entertainment, enjoyment, family walks or just passing time. In Paris, they were situated along the belt of the great boulevards where there was also a profusion of variety theatres and where people from different social classes mingled. However, these different tiers of the population were drawn to the panoramas for very different reasons. The educated classes were interested in the images and the originality of the representations. The populace were attracted by the strength of an illusion that transported them to a reality so very different from their own, that miraculously offered them a visual escape to places they had only ever been to in their dreams. As for the middle classes, particularly the lower middle classes, they came to savour the novelty, to experience a show that had a wealth of emotions to offer and encyclopaedism on the cheap; feeding off the new, the innovative, a culture developed on a grand scale which was no longer judged according to accepted ideals or references accumulated over time, but according to personal feelings and the degree of audience participation in the emotions and magic of the surroundings. Expert opinion was no longer relevant; what mattered was that the crowd enjoyed itself. With profound condescension, a commentary like Quatremère de Quincy's could be applied point by point to those who regularly attended the panoramas:

> The imitation employed in the domain most circumscribed by reality is the one that lends itself the most to the kind of pleasure we have termed the pleasure of the senses, the only one, in truth, that vulgar people demand of the arts and, moreover, the only one that they receive. By vulgar, one means all those whose minds have received no cultural education, all those who have not been educated in this genre, as well as those in whom the sensual holds sway over the other faculties. This explains the popularity of these shows to which the vulgar of whom I have just spoken run in search of all manner of sensations so close to those of reality that there is almost no comparison to be made.

It must be admitted that panorama painting originated in a meticulous and compliant hyperrealism that was not far removed from its model. With a few rare exceptions, it derived from a popular academicism that would remain quite impervious to the innovations and artistic experiments of the nineteenth century. But this in no way devalues the phenomenon from a historical point of view, for it was not only new to the world but also represented a shift away from art which had until then belonged to an élite of connoisseurs who had laid down their own rules as to how it should be exploited and evaluated.

This is why the extremely heterogeneous public who frequented the panoramas comprised a particularly valuable sociological entity, a manifestation of the desires and fantasies of an era as well as its disaffections. In the course of the 1800s, the emergence of an image that could be reproduced was to transform a collective space that was gradually being invaded by all kinds of

advertisements and propaganda. Individual imagination and private fantasies were replaced or contaminated by a collective imagination made up of stereo-types and clichés. By depicting wars, the past and nearby or faraway places, the panorama had a major contribution to make to the construction and dissemina-tion of an imagination that was in this case all the more collective because it was based on simple instincts and reflexes flattered by painters and business-men on the lookout for clients.

For all these reasons and for others that will become apparent in the next two chapters, the panorama exercised a complex hold upon a society of which it was to some extent the privileged mouthpiece, and in much the same way as television is today the focus for desires, frustrations and inanities. The comparison is all the more tempting because like television, the panorama was a mixture of art, technology and commerce, and because its principle driving force was enchantment or magic. Nothing was spared, and techniques were constantly being improved so as to please an eclectic but lazy public. Further-more, commercial considerations were as far as possible carefully concealed behind an educational role – the two were compatible when the objectives of both spectacle and publicity were in harmony. This was the case, for example, with some of the panoramas in the Great Exhibition of 1889, one of which was Poilpot's *Petrol Panorama*. This is what an article in *La Nature* (12 October) had to say about it:

> Visitors who wish to educate themselves have only to go down to the Champ-de-Mars area on the banks of the Seine near the Pont d'Iéna: there they will be given an excellent *general science* lesson which has the advantage, what is more, as regards exhibitions, of being free.

What praiseworthy objectives, what generosity ... Technology and commerce came along, and panoramas were either administered by limited companies or commissioned by big industry.

It is a fact, however, that at the beginning, before considerations of com-mercial viability took over, the panorama did nurture educational objectives to inform and educate, if not cultivate, the public at large. In 1801, when the *Panorama of Constantinople* was exhibited in London, the Barker family hit on the idea of having a small booklet on sale that gave historical facts and topo-graphical explanations, even though people had until then been quite happy with a simple horizontal panorama as an orientation plan. From 1804 in Paris, tickets for the best places actually included an explanatory booklet and a print (illus. 62). The guides and booklets published when different views went on show were often quite amusing to read. They were written in a tone that was both scholarly and biased, with the intention not simply to inform but also to influence what people saw and how they interpreted it. As for the 'commenta-tors' who organized guided tours, these were few and far between until 1830,

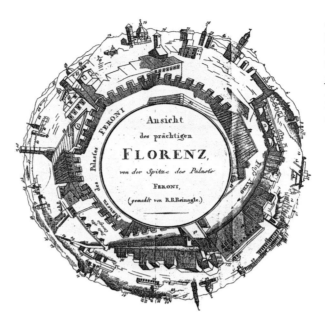

62. Engraving of Ramsay Richard Reinagle's (1775–1862) panorama of the *Panorama of Florence from the Top of Palazzo Feroni*, shown in the Strand, London, 1806, from *Journal des Luxus und der Moden*.

when the extreme, all-embracing synchronicity of the circular canvas began to lose its space in favour of a more narrative form.

The size but more particularly the educational potential of the panorama had not escaped the notice of the more informed commentators of the time, just as Napoleon was soon to see its potential as a propaganda tool. At the end of a very positive review of the view of London exhibited by Prévost in the Boulevard des Capucines, Miel, in his *Essai sur le Salon de 1817*, described a project in which panoramas of towns – both entertaining and educational – would be sited in areas around Paris depending on their theme: commercial centres of commerce would be near the Bourse, centres of culture near the Louvre, great battles near the Invalides, etc.

Dickens also recognized the panorama's educational and moral worth, for by revealing to simple spectators realities they would otherwise never have discovered, and by broadening their horizons, it widened their 'range of reflection, information, sympathy and interest. The more man knows of man, the better for the brotherhood among us all' (*Some Account of an Extraordinary Traveller*). Ruskin joined the chorus of celebrated projects. Describing Burford's panorama, he praised 'an educational institution of the highest and purest value, which ought to have been supported by the government as one of the most beneficial instruments of scholarship in London'. As for the scientific didacticism propounded by Alexander von Humboldt in his *Cosmos*, he went on a metaphysical, almost religious tour on which we can feel the idea dawn that humanity can only better itself, improve itself, by looking at nature and the unfamiliar world.

Later in the century, a decidedly more scholarly course was adopted. The panorama was considered to be:

the excellent and compulsory companion of an education that is today liberally spread through most of the civilized States; it sets before the eyes of populations greedy for knowledge the striking, almost tangible representation of the events with which this century has enriched their minds, and the places they have read about and to which they are suddenly transported as though by a miracle.

Thus wrote François Robichon, who quoted this text by Germain Bapst in *Le Correspondant* on 10 September 1890. Flourishing in the Third Republic, the panorama became 'the ideal accessory of the laity: a lesson in history and geography'.

When all is said and done, the panorama was in a constant state of flux between entertainment at any price and education in spite of everything, set against a commercial background. In keeping with a trajectory that became progressively more like that of television, it became as much a tool of alienation as of emancipation. It downgraded élitist culture without producing a culture that it could call its own. If it touched the public at large, this was because it rejected the prerogatives of art in order to flatter not only a facile taste for the new and sensational but also intellectual naïvety and laziness.

63. Pierre Prévost (1764–1823), Preliminary canvas for the *Panorama of Constantinople*, 1818, oil on canvas, 68 × 856 cm. Musée du Louvre, Paris.

In 1816, faced with the necessity of finding new themes for panoramas to engage a public grown weary of battle scenes following the defeat of Napoleon, Prévost undertook a long journey that took him to Athens, Jerusalem and, finally, Constantinople. The panoramas he created of the two first towns were incredibly successful. But he died before producing the large-scale version of the sketch he had brought back from Constantinople. One of his former pupils, Frédéric Ronmy, and his brother, Jean Prévost, took over, but apparently the results were unconvincing and the public's reaction lukewarm when the panoramic canvas was exhibited in the rotunda in the Boulevard des Capucines. Sections of the preliminary canvas are in very bad condition due to damage in transit or from overhandling while the large-scale version was being produced.

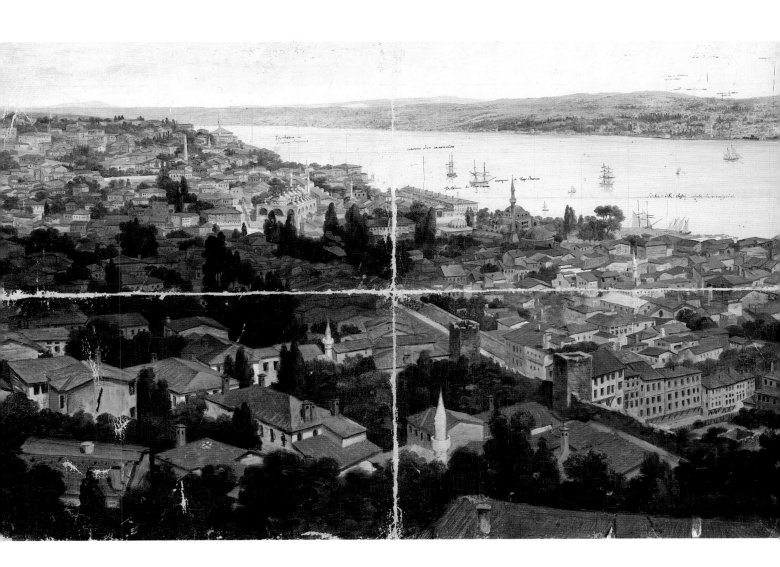

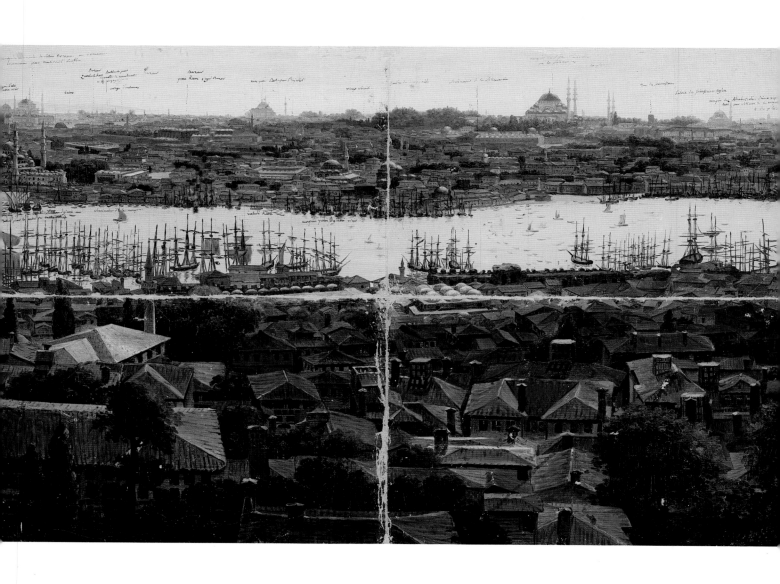

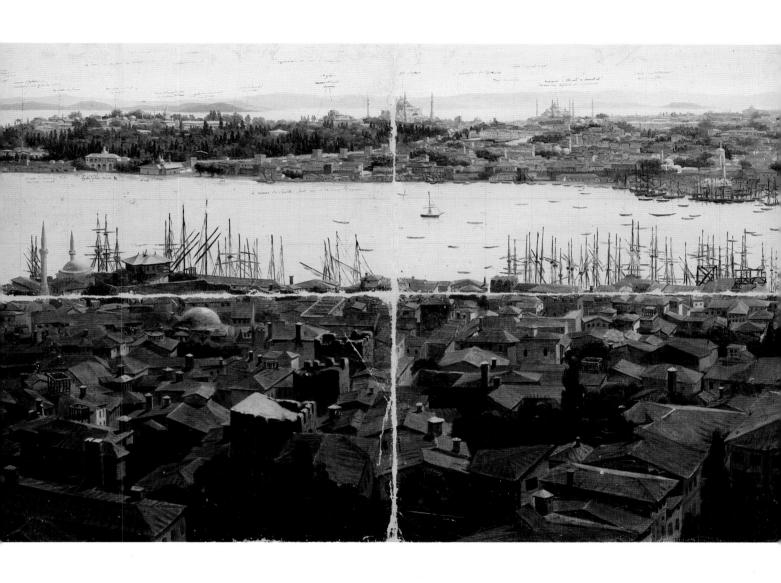

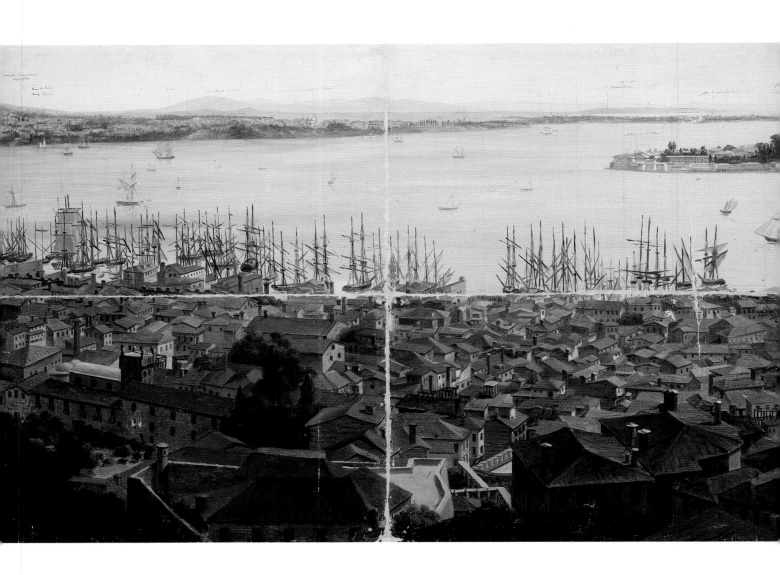

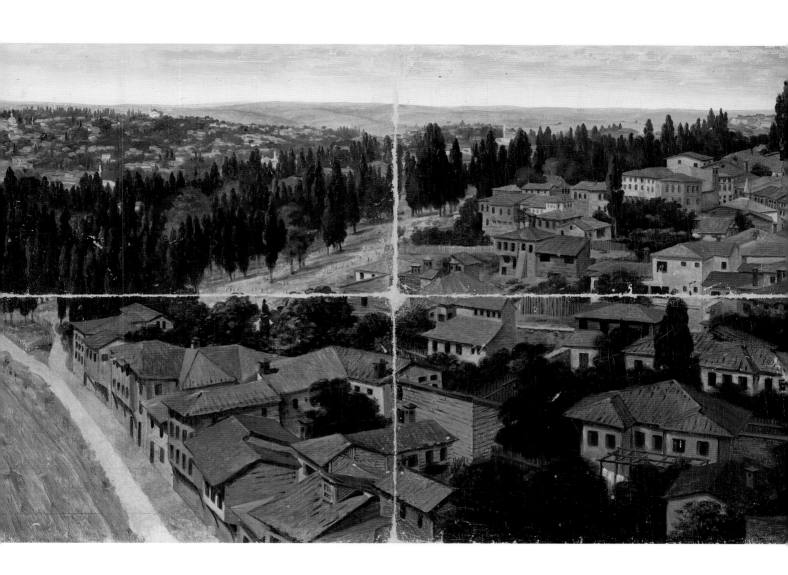

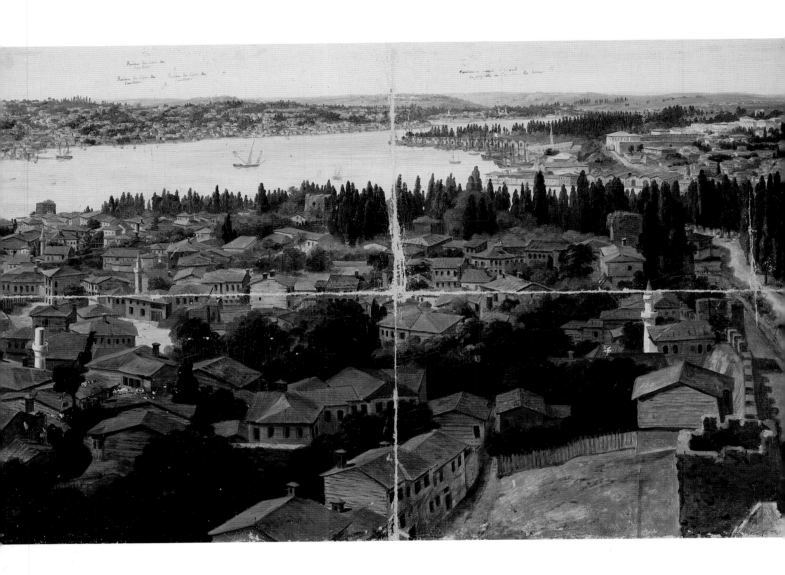

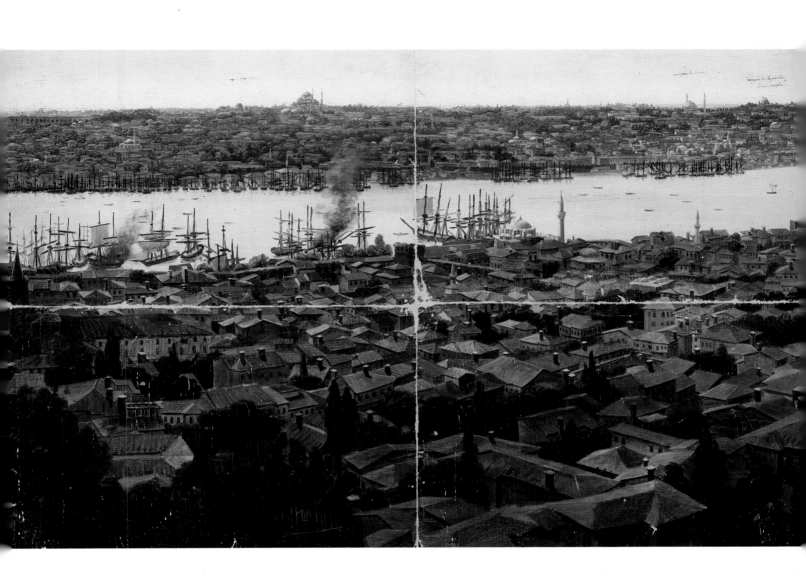

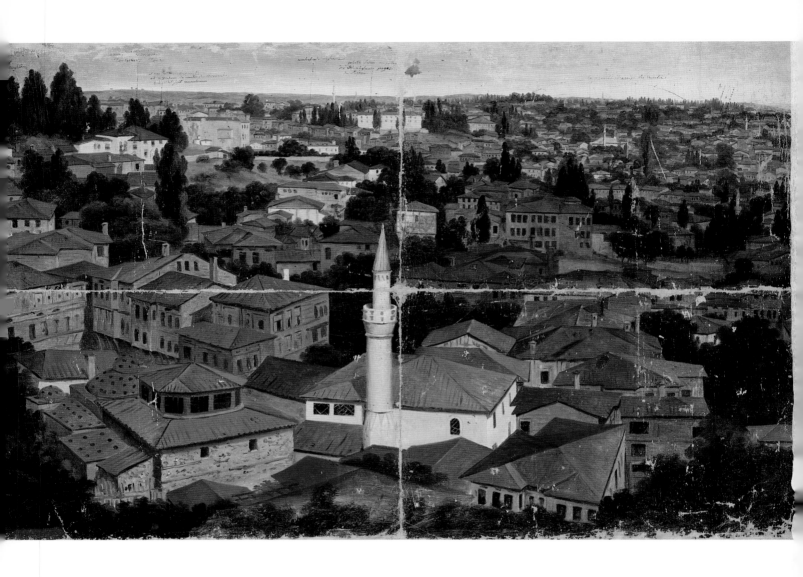

Memory Created: Experience Replaced

When Robert Barker exhibited his first panorama in London, that of the city of Edinburgh, he was careful to tell the public that he had made it on the spot so that they would know it was absolutely genuine. He need not have bothered. Some critics accused him of distorting the truth so that his version would be more attractive. And so the painter asked the Provost of Edinburgh to supply him with a statement and an affidavit to certify that his work was a 'perfectly fair and accurate representation of the city and its surroundings as far as the horizon and in all directions'. From the outset, therefore, the panorama wanted to and did rely on sources that confirmed its authenticity. Wishing to replace reality, it had to be able to guarantee that it conformed to its model.

Subsequently, advertisements as well as the booklets or guides distributed to spectators continued to stress the fact that studies and sketches had been made at the actual locations being represented, with panoramists spending much of their time on the spot during a preparatory phase that was indispensable if their canvases were to be credible. Henry Aston Barker, Robert Burford and Pierre Prévost went on study trips and returned with enough material for several panoramas. Breysig visited the ruins of Rome and drew the views he would convert into a panorama several years later.

When it came to battles, first the artists visited the sites so that they could make topographical studies and sketch the different landscapes. Then they would go in search of witnesses who had participated in the events: officers and soldiers from both camps (this was what H. A. Barker did for his *Battle of Waterloo*). Some of these eye-witness accounts were reproduced in the explanatory booklets. Once the panorama had become a well-known phenomenon, travellers and military men took the initiative and made drawings or research notes in order to sell them to entrepreneurs on their return.

If it was crucial to conform to reality, this was also because those who had taken part in the events depicted used to come along to check them and relive their experiences. It was not uncommon to see an old soldier turn up at a panorama with family and friends so that he could show them in situ, or almost, his contribution to a battle (illus. 64). We should remember how Miel suggested that the canvases of great battles be hung near the Invalides, arguing that 'soldiers wounded fighting for their country could, without danger but not without pride, see the arenas of their glory once again'. As for Nelson, he was

64. A war veteran wearing a medal explains the *National Panorama of Berlin* to a crowd of visitors.

The circumstances recall those described by Pliny the Elder in Book XXXV of his *Natural History*: 'L. Hostilius Mancinus, who was the first to set foot in Carthage, displayed in the forum a painting replicating the location of the city and the stages of the siege; he was himself seated next to it as he gave the crowd a detailed explanation, a kindness that secured him the consulship at the forthcoming agricultural meeting.'

not beyond being moved on seeing just how strongly a panorama evoked his nation's glory; he thanked Henry Aston Barker for this when the two men met in Palermo in 1799: 'I was introduced by Sir William Hamilton to Lord Nelson, who took me by the hand, saying he was indebted to me for keeping up the fame of his victory in the battle of the Nile for a year longer than it would have lasted in the public estimation.'

However, travellers were also in a position to challenge depictions if they were too garish or liberties had been taken. For Chateaubriand, visiting Prévost's panorama of Jerusalem was an ordeal, as he explained in the foreword to *Itinéraire de Paris à Jérusalem*, published in his *Oeuvres complètes*:

> The *Panorama* of Jerusalem and Athens is in Paris; the illusion was perfect; I immediately recognized the monuments and places I had described. Never was a traveller subjected to so terrible an ordeal; I had not expected Jerusalem and Athens to be transported to Paris so that I could check them for accuracies and inaccuracies. My encounters with spectators were favourable: my precision was such that the fragments of the *Itinéraire* made up a popular programme and explanation to the paintings of the *Panoramas*.

In this instance, the panorama functioned not as a representation whose accuracy needed to be corroborated, but as a source of truth, a guarantee of reality. John Ruskin's experience was quite different when, reaching the roof of Milan Cathedral, he compared image to reality:

> I had been partly prepared for this view by the admirable presentation of it in London, a year or two before, in an exhibition of which the demise has been of late a great loss to me – Burford's panorama in Leicester Square. There I had seen, exquisitely painted, the view from the roof of Milan Cathedral, when I had no hope of ever seeing the reality, but with the deepest joy and wonder – and now that I am indeed there, my profound wonder has become fathomless.

It was as something altogether different that the panorama claimed its principle role, however. It was not repeating an experience that had already taken place; it was replacing it. In 1800, Valenciennes anticipated the different possibilities:

> What had been missing from art was this new way of painting a general view that could contribute to the acquisition of knowledge. It is certain that a succession of paintings of this kind would be very intriguing and would enable thousands of people to discover, without having to travel, the most celebrated cities, the major seaports and the most interesting countries not only in Europe but also in other areas of the world.

The image was therefore a valid experience, permitting people to realize a dream that had been prevalent since the beginning of the nineteenth century: to travel without having to move (illus. 65).

In his *Salon* of 1817 already quoted at length, Miel never tired of eulogies, especially when it came to the panorama of London, whose documentary excellence he praised: 'If I were to say: whoever has seen the panorama of London has been to London, I could be accused of exaggeration; but I only speak the truth when I say: whoever has seen the panorama of London will find his way around London.' And further on, in the passage already quoted, he referred politely to 'Parisians who like to travel without having to leave home'. This ironic reference to a characteristic peculiar to Parisians can be found in other commentaries, for example the *Journal de Paris et des départements*, which ended its introduction to Daguerre's diorama with the following: 'We cannot urge Parisians too much, those who enjoy pleasure without fatigue, to make the journey to Switzerland or England without leaving the capital.' Later, in relation to the long-awaited reopening of Bouton's diorama, *The Artist* (1843) took up the refrain:

> It was a terrible loss for these gentlemen, for the artists and for the Parisians who, without having to cross borders, without being exposed to excesses, thirst, hunger, cold, heat and above all danger, could, from the comfort of their well-stuffed seats, see pass in front of them all five continents of the known world. These are the kinds of journeys the Paris bourgeoisie love to make. For the price of four pennies on the bus, they were able to witness a landslide in the Valley of the Goldau that made them tremble with fear.

As far as representations of journeys were concerned, for a time the great favourites were the diorama and then the 'moving panorama'. The public was probably attracted by the simulation of movement, which was more in keeping

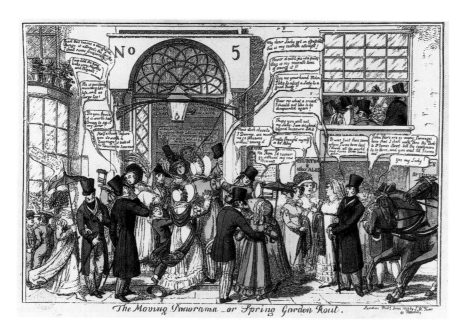

65. *The Moving Panorama, or Spring Garden Rout*, 1823, caricature drawing.

with the idea of going to a foreign country than was motionless contemplation. With regard to the *Pleorama* of the Bay of Naples hung in Berlin, one critic advised 'lovers of natural beauty to spare themselves the bother of a long and costly trip', for it was better to see a show that provided a comfortable alternative, saved a lot of time and created the illusion of being there. Dickens used the same argument in an article he wrote for the *Examiner* devoted to the 'moving panoramas' of the Mississippi and Missouri rivers. Having taken the precaution of excluding them from the realm of art, he defined them as being 'easy means of travelling, night and day, without any inconvenience from climate, company on board . . . or fatigue'.

The case for substitution was far from limited to representations of movement. The traditional panorama took it over completely, and Robert Burford, whose principle themes were famous towns or faraway lands, made it his favourite publicity slogan.

The yearning for other countries, other places, for changes of scene, developed considerably during the nineteenth century; newspapers flourished after the Revolution, and a thirst for discovery, for knowledge, was born, not to mention the imperialistic and colonial policies that heightened people's interest in faraway lands. Moreover, the Romantic movement focused public attention on the events which were shaking Greece. Journeys to the East had a mysterious appeal. And we should not forget the railways and improved methods of transport which gave everyone the hope that they too would soon be able to explore different horizons. In reality, of course, travelling was complicated, onerous and more often than not dangerous and unpredictable; it remained the exclusive domain of a privileged class and an élite of artists and writers, soldiers and officers. This was why the panorama and diorama filled the gap so efficiently, meeting a growing need to escape, before the means to actually do so had become available.

Themes were not limited to travel, however. If you went to a diorama or panorama, you could 'experience' catastrophes and battles, navigate through storms at sea – safe from danger and free from inconvenience. A comfortable fear without risks is how we might describe the feeling being offered the visitor. A miracle would take place, to render present in and through the illusion what was in fact far away in space or time. Experience of the world and of reality had been replaced by their simulacra.

It was therefore impossible not to see in the panorama and diorama the beginnings of a new logic, that of the surrogate experience that was to culminate much later in what Guy Debord referred to as *the society of spectacle*. This is neither the time nor the place to reiterate theories or analyses; let us simply recall the beginning of his book, since it touches upon the problem we are dealing with here: 'The whole life of a society which is controlled by modern manufacturing methods is presented as a vast accumulation of

spectacles. Everything that was actually experienced became distanced in its representation.' The dispossession of individuals and their alienation from the collective imagination replacing knowledge and life began there in a simulation carried to a degree of completeness in which the image was valued over reality, in which it replaced it.

If the here is equal to the elsewhere, if the elsewhere *is* here, a new logic emerges, in an embryonic state admittedly, but this does not change the fact that the impact of this 'inertia' is what Paul Virilio sees as one of the driving forces behind the analysis of contemporary telecommunication. As a brief introduction to further reflections, I should like to borrow an expression from his book *L'Inertie polaire* that summarizes well the issues with which I am trying to engage: 'From then on, everything happens without it being necessary to leave.'

The Individual in the Town: Compensation and Control

In the previous chapter, I spoke of journeys and battles, of how illusionistic spectacle replaced the need to travel to other localities, thus eliminating the dangers, exhaustion, cost and time involved. A more surprising theme was that represented by the first panoramas to be hung in Europe: the representation of the actual towns in which rotundas had been built. This was the case with Barker's first panorama of Edinburgh (1788); his view of London from Albion Mills (1792); Prévost's Paris as seen from the roof of the Tuileries (1799); London again, with Girtin's *Eidometropolis* (1802); Tielker's Berlin (1801); Janscha and Postl's Vienna (1804); Taragnola's Hamburg (1805) and finally Morgenstern's Frankfurt (1817). After that, we find fewer examples, for war, the exotic, and historic cities became more attractive as themes. We should not forget Sattler's Salzburg (1829) and, above all, Thomas Hornor's London at the Colosseum.

From where did this somewhat unusual desire spring to represent the town in the town? To duplicate a present reality in its representation, which was moreover an illusion? To what fear, what need, what fantasy did this type of image respond? We can only hazard a few guesses.

At the end of the eighteenth century, public spaces and, consequently, the individual's relationship with his or her environment were completely transformed in the wake of a double revolution, political and industrial. This was very much the case with towns that turned into sprawling masses as a result of huge influxes of people and frequently haphazard expansion. In the introduction to his *Tableau de Paris*, Louis-Sébastien Mercier compared the filth of the great city with the healthiness of the Alps. After having described 'our boulevards, so pleasant to walk along because they bring a feeling of the countryside to the city centre and because the greenery cheers the view', he confessed to a feeling of despondency when confronted by the sight of a city that stretched out all over the place: 'We are on the tenth map of Paris; but it continues to spill over the edges; its boundaries have not yet been fixed, and never will be. I stray, I loose my way in this huge city; the new areas are completely foreign to me.'

Did Lucien de Rubempré, in Balzac's *Les Illusions perdues*, not feel himself to be shrinking? Dickens gave the same impression of London, as did Engels when, in *The Condition of the Working Classes in England*, he wrote: 'A city like London where you can walk for hours without even reaching the beginning of

the end, without ever coming across the smallest sign to indicate that you might be approaching the countryside, is really something quite unique.'

So much for the horizontal growth of the great capitals. They were also growing vertically. Tall buildings quickly shot up everywhere, and the tiny stitches that made up the urban fabric grew alongside the larger developments (it is a fact that one of the early functions of alleyways and arcades – particularly in Paris – was to allow faster, sheltered pedestrian access to the great boulevards in the city centre, the Palais-Royal for example). This led to people losing sight of the city; it became a mysterious place, in the words of Roger Caillois 'a wonderfully illuminated but too *normal* stage set, where the stagehands never show themselves, and which conceals another Paris, the real Paris, the phantom, nocturnal, illusive Paris, all the more potent because it is so secret'. This feeling of mystery was reinforced by the loss of distinguishing features amongst the population, a loss echoed and bemoaned by several writers at the beginning of the nineteenth century. In London in 1822, for example, Chateaubriand wrote: 'There was no longer any variety in the clothes people wore; the old world was disappearing; they had donned the uniform mantle of the new world, a mantle which was nothing but the latest vestment of the future condemned.' Balzac wrote in his preface to *Une fille d'Eve*: 'In the old days, the individual took on the physiognomy of the caste; these days, the individual gets his physiognomy only from himself.' And in *Physiologie de la toilette*, he observed:

> Under the *Ancien Régime*, each social class had its uniform; the lord, the bourgeois, the artisan could be recognized by the clothes he wore . . . Eventually, the French gained both legal and sartorial equality, and differences in the quality and cut of their dress no longer distinguished the different levels of society. How is a man to recognize who he is in all this uniformity?

There are numerous quotations from the early years of the century that could be cited, all expressing a great nostalgia for the distinct and clearly marked semiology of the *Ancien Régime*.

The reaction to this general loss of 'readability' in and of urban space was twofold: *induction* and *panoramism*. Both would become heuristic models. By induction, I mean the belief, inherited from Gall and Lavater, that it is possible to discover what exists inside by examining external features; an example is the physiognomy championed by Balzac in *La Comédie humaine*. But Edgar Allan Poe felt this happy semiology should have limits imposed on it, and in a very strange and disturbing text, *Man of the People*, he highlighted a possible weakness that was to have a marked effect on Baudelaire and then on Walter Benjamin. The narrator is seated in a café in a busy town, and with that keen sense of observation peculiar to convalescents, he studies people as they walk past the window. He is drawing up a definitive list of the various categories of

passers-by, based on irrefutable signs that enable him firmly to classify individuals into characteristic types. He is feeling happy with his system of classification when suddenly an enigmatic figure appears, a strange old man impossible to categorize. The narrator follows him all night as he wanders aimlessly in and around London. At dawn, still unable to solve the problem, he gives up: 'In the end I decided that this old man was a genuine and typical criminal . . . It would be useless to follow him for I would learn nothing more, neither from him nor from his actions . . . He would not let himself be read.' By having introduced a check into the deciphering of passers-by, Poe established the ingredients of a fundamental paradigm, that of individuals' ability or inability to read and understand the public space that surrounds them.

The second reaction took the form of panoramic representations of cities and their surroundings. The heterogeneous and mostly working-class public who visited the rotundas were not seeking aesthetic gratification or even the simulation of movement – this came much later. They were there to experience the eminently more precious illusion that they were masters of the world, of collective space; in the panorama, a city was a calm configuration arranged around the spectators; they thus were able to re-appropriate the town which, when they were in it, always gave them the impression that they were lost.

By adopting a commanding vantage-point, by placing themselves in a central position (illus. 66), individuals were able to see the town anew and read

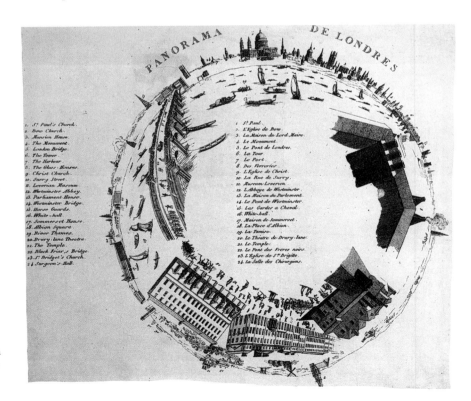

66. Orientation plan for the panorama of London, 1802, print, approx. 32 × 40 cm. London Library, St Paul's Cathedral Depot, Corporation of London.

The first truly circular canvas made by Robert Barker and his son Henry Aston was exhibited in Hamburg, Leipzig, Vienna, Paris and Amsterdam. This is the orientation plan handed out to visitors so that they could locate the principal monuments depicted in the panorama. Certain typical aspects of British life, like soldiers marching across Blackfriars Bridge and street boxers fighting in Albion Square, were added in Hamburg to attract more Continental visitors.

and understand it as a whole. But if that was the case, why not just climb to the top of Notre-Dame or Montmartre – like the property developer Saccard in Zola's *La Curée*, who, gazing at Paris at his feet, dreamed of the money he would make from property transactions when work started in Boulevard Haussmann? On this point, I am quite happy to go along with Heinz Buddemeier's analysis that there were several benefits to be had from these representations: the choice of vantage-point allowed one to recapture the very best image of the town; nature, in comparison, was noticeably downgraded.

Indeed, the two main consequences of the Industrial Revolution were that factories made towns look ugly and that the link between town and country-side was lost because of the rapid expansion of suburbs. Despite its claims to objectivity and to being an accurate record of reality, the panorama in fact idealized it. Panoramas were trying to save the situation by highlighting the green spaces *intra muros* and giving the surrounding countryside an impor-tance and proximity that it lacked in the daily life of the citizen.

Barker's first panorama of London presented the capital as seen from Albion Mills, a symbol of urban industrialization which featured in the fore-ground (illus. 66). But he took care to surround the background with a band of countryside which reinstated a balance with nature. By inference, the panorama disclaimed or rejected the inhumanity and imbalance of the great metropolises. By linking what was close up with what could be seen in the distance, by working in unusual conditions (Hornor rose at dawn before the factories started belching out their smoke) or picking an advantageous vantage-point (Prévost worked from the roof of the Tuileries), the panorama presented not only a better and broader view, but an idealized scene that compensated for the crowd's feeling of alienation while reinforcing that alien-ation by creating illusions that were false. Miel, in his 1817 description of Prévost's panorama exhibited in Paris, drew attention to the evidence of nature in the town, referring to 'the streets, the public squares decorated with lawns and plants to improve them, the promenades', and, further on, 'the surrounding countryside covered in greenery, the huge horizon'. Engels's account would be less bucolic.

Added to which the panoramic representation transformed the town into a landscape, into an object to be contemplated and enjoyed. Walter Benjamin made an admirable study of this in *Paris, capitale du XIXe siècle*:

> Panoramas are the expression of a new feeling about life. The citizen, whose supremacy over the countryside has been claimed a thousand times in the course of the century, has attempted to bring the countryside into the town. In panoramas, the town takes on the same dimensions as the landscape in much the same way as it does, though more subtly, for the *flâneur*.

The compensatory or atoning role of the urban panorama was really only valid in London and Paris, the only true metropolises of the era to experience

extraordinary demographic and territorial explosions. It was not to be the same elsewhere, where no urge to repossess, no fantasies of supremacy prevailed: attendance remained low when exhibitions did not end in complete failure. In Berlin in 1801, the evidence is that the inhabitants believed they knew their town well enough not to need to pay to see an image of it. There was a similar response in Hamburg in 1805 to a panorama of the town painted by Taragnola; this was echoed by the critic from the *Morgenblatt für Leser* (whose headquarters were in Frankfurt), who wondered why citizens might feel compelled to go to a rotunda in order to gaze at a view they could quite easily see from their kitchens. The still modest dimensions of German towns did not justify the duplicating of a reality that was neither traumatic nor in any way deficient. As for Sattler's view of Salzburg, it was successful and above all profitable only when he took it on a tour of Europe, counting on its appeal as a tourist attraction.

It would be wrong to reduce the panorama to a logic of compensation and rediscovered superiority, however. Admittedly, the centrality of the spectators and their dominant viewing positions could give them the demiurgic feeling that the world was organized around and in relation to them. They could be deluded into thinking that nothing escaped them, that nothing would ever again be inaccessible to their gaze.

But the panorama was just as much an all-encompassing, totalizing place that on occasion made individuals lose their bearings and dissolve into the surrounding space and its false reality. Witness the seasickness and vertigo experienced by so many spectators, the distress, the unreality. A more contemporary parallel can be found in Goethe, when, during his journey in Italy (30 March), he found himself on the open sea, with no fixed point of reference, drowning in the immensity of the ocean:

> And we could see no land; all around us the horizon was surrounded by water, the night was serene, the moonlight beautiful. I could only however enjoy for a few moments these wondrous sights, for I very soon felt seasick. I repaired to my cabin where I adopted the horizontal position.

And a few days later, on 3 April: 'When you have not found yourself surrounded on all sides by the sea, you have no conception of the world or of your relationship with it. As a landscape artist this great and simple line inspired in me completely new thoughts.' For many, the fascination with the panorama doubtless sprang from this mixture of humanism and ecstasy, from an exquisite switching from feelings of dominance to those of dissolution, of loss. Wanting to reduce it to one or the other of these two extremes would be to forget its complexity, its indefinable and quaint charm, which can be experienced in the few rotundas that are still with us today.

Panoramism and Panopticism

The panorama can quite justifiably be considered one of the foremost characteristics of the nineteenth century, expressing its fantasies, fears and aspirations. It offered the spectator a reality that could be taken in at a glance, in its all-encompassing totality. But the notion of the *Rundblick*, the circular gaze, cannot be reduced to a single model invented and patented by Barker. Certain concomitants and enlargements allow one to speak of a grander, broader phenomenon that swept first here and then there through the whole of the century and that went by the name of panoramism.

At this point, we should recall the architectural plans drawn up by Claude-Nicolas Ledoux for the Salines Royals d'Arc-et-Senans and the city of Chaux, which borrow from the circle or sphere in order to assert a symbolic system that represents power, order and control ('placed at the centre of the spokes, frame, nothing escapes surveillance'). And the strange print by this same Ledoux in which the project for a theatre is engraved in the pupil and iris of an eye representing both the source and the mirror of a place shaped around and by him (illus. 67). Etienne-Louis Boullée also springs to mind; commenting on his *Cenotaph to Newton* (designed *c.* 1784; illus. 68), he said of the imagined spectator: '. . . he is obliged, as though by a hundred great forces, to stay in the place assigned to him, which, occupying the centre, keeps him at a distance that favours the illusion. He can enjoy it *without coming to any harm* by going too close out of desire to satisfy a vain curiosity.' Copies of the *Cenotaph* were made in the nineteenth century, for example the *Georama* Delanglard installed in Paris in 1826. This was a sphere with a radius of 5 metres, the interior of which was approached by a double spiral staircase leading to a central platform. This was situated level with the equator in relation to the surface of the earth depicted on the walls, like a globe turned outside-in. The principle was taken up again in 1851 by James Wyld in London with his *Great Globe* (illus. 69): a little larger, its 'inverted' ball could be viewed from several platforms linked by staircases in such a way that people could gaze at the earth's crust in its totality and in all its details (all the volcanoes were depicted in full eruption, for example).

We have to go back to Jeremy Bentham's *Panopticon* for another example (illus. 70). Wanting to make a genuine historical mutation out of it, Michel Foucault put it forward in his *Surveiller et punir*: from the logic of spectacle

67. Claude-Nicolas Ledoux (1736–1806),
'*Coup d'Oeil du Théâtre de Besançon*', from
*L'Architecture considerée sous le rapport de
l'art, des moeurs et de la législation* (Paris,
1804), engraving, 25.7 × 38.7 cm.
Bibliothèque Nationale de France, Paris
(Cabinet des Estampes).
 Ledoux's title recalls Barker's for his
original patent, *La Nature à Coup d'Oeil*.

passed down to us from Antiquity (temples, theatres, circuses where 'the inspection of a small number of objects is made available to a multitude of men') we arrive at modern logic, in which, at the other extreme, it is a question of 'procuring for a small number of people, or just one person, the simultaneous view of a great multitude'. Foucault had stated earlier that 'to the reasons why circular architecture was so prestigious during the latter half of the eighteenth century, we should perhaps add this one: it was the expression of a particular political utopia'.

Ledoux worked on his plans between 1772 and 1779, Boullée designed his *Cenotaph* in the 1780s, the *Panopticon* dates from 1791, and Barker's patent goes back to 1787. This is not a question of establishing influences or sources; it is more as a striking concomitance that we record these similar and dissimilar manifestations of the placing of the individual in a central position, in much the same way that the world of reality is served up in the *Rundblick*, the circular gaze that embraces the whole horizon in one, or almost one, go. But the status

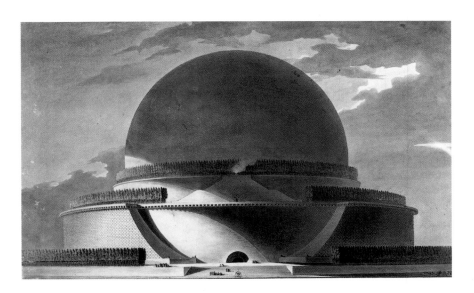

68. Etienne-Louis Boullée (1728–1799),
Elevation of the *Cenotaph to Newton*,
c. 1784, drawing. Bibliothèque Nationale
de France, Paris.

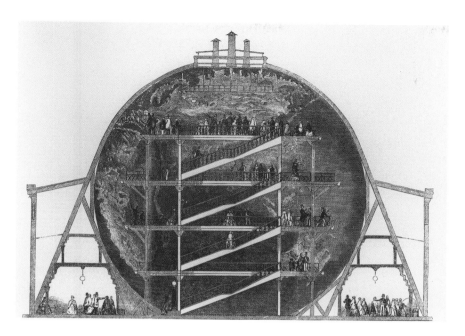

69. *Mr Wyld's Model of the Earth —
Sectional View*, from *Illustrated London
News*, 7 June 1851, wood engraving.
Guildhall Library, Corporation of
London.

of the individual then becomes paradoxical because the dominance he or she
craves presupposes personal annihilation and the loss of real space in order to
hold on to the fictional space of the representation. In the panorama, this
ellipse is the prerequisite of both the illusion and its total effectiveness; in the
panopticon, a principle of surveillance is established due to which the prisoner
has the feeling he is always being watched although he can never be sure of
this, and can never see the eye that watches him.

The word *panorama* was soon used to designate an elevated, overarching posi-
tion. The notion of the *Rundblick* was extended or passed on to that of the
Überblick, the gaze from above. The year 1783 saw the first flight in a hot-air
balloon; it was to have a profound effect on how the individual perceived the
world. Furthermore, there was a reversal in the fortunes of towers: they were
no longer or not only awesome symbols of God's power, but became raised
vantage-points. The appearance of vertiginous towers allowed individuals to
discover a territorial totality of which they had nothing but a fragmented idea
from the ground. We are referring, of course, to the Eiffel Tower. A report
published in *La Construction moderne* on 20 April 1889 related the feeling
created by the 'three-hundred-metre tower':

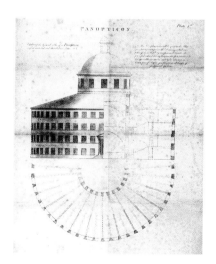

70. Jeremy Bentham (1748–1832), Plan
and cross-section for the *Panopticon*, 1791.
University College London Library.

> The panorama develops the higher you climb. What you see at first are the
> hills that surround Paris, then the view drops back to a distance of around 70
> kilometres . . . At last, you arrive at the final platform, situated 280 metres above
> the ground . . . Paris and the surrounding area look detached as on a map; you
> would think you were in a balloon, with the wind to contend with as well, and at
> this height it is really quite strong.

Lastly, panoramism took on a third meaning that was in the nature of a synthesis, either through the bringing together of things that were isolated or scattered around an area too vast to be perceived in one go (for example, the frescoes in the ticket office at the Gare de Lyon in Paris, which brought into visual continuity the towns and stages that punctuated the journey from the capital to Marseilles), or through the spatialization of what is normally spread out in time (for example, the 'paintings' in Michelet's *Histoire de la France*, which, according to Roland Barthes, placed the artist 'more or less in the position of God whose great power is precisely to hold together in a simultaneous perception, moments, events, men and causes that are humanly dispersed through time, space and other orders').

In various ways, therefore, all of which relate to panoramism, individuals placed themselves in a dominant position in relation to the surrounding area and on the double axis of time and distance. This all-knowing and all-seeing fantasy also emerged in literature, particularly in Balzac's *La Comédie humaine*. Totalization operated on a level that was logical (everything is revealed, causes as well as effects), topological (the town and countryside) and chronological (saturation of time and eras). In Balzac, it is this *intuition* that leads to global perception; in *Seraphità*, he spoke of 'this inner view whose fleet perceptions alternately convey to the soul, as to the canvas, the most diverse landscapes of the globe'. To this we should add the search for the *type*, 'a character who embraces all the characteristic traits of those who more or less resemble him'. The synthetic formula appears in the introduction to Balzac's *Etudes de moeurs*: 'The purpose of art is to select the scattered elements of nature, the details of truth, in order to make of them a homogenous whole, a complete unity.' In a register that is extremely visual, there is an abundance of panoramic descriptions that all relate to a sense of euphoria and possession – whether it be Rastignac at the end of *Le Père Goriot*, gazing at Paris at his feet, or the views of landscapes too numerous to mention, in Touraine, near Le Havre and so on.

But we cannot credit literary panoramism to Balzac. Chateaubriand, in his *Mémoires d'outre-tombe*, often resorted to using it when he wanted to describe a landscape, an image or the actual empire of his mind. And what should we say of the 'bird's-eye view of Paris' in Victor Hugo's *The Hunchback of Notre Dame*, when the author, dominating the city from the top of one of the towers, gives us a synchronic and historic description of it: 'And a very beautiful painting it was that unfolded at one and the same time from every place that we could see.' And we should not forget Edgar Allan Poe's amazing *Landscaped Garden*, a piece that imparted its perfection not from the human point of view, but from God's, or from a vantage-point high above the world: 'As if we could imagine the scene viewed *as a whole* from some point way above the heavens'. And Zola with his proliferation of overarching images, who closed

his *Rougon-Macquart* with an admirable *mise-en-abyme* in the form of a genealogical table of the two branches of the family, with all its defects, temperaments and inheritance, all summarized in a few pages of *Docteur Pascal*.

This euphoric vein of an all-knowing and all-seeing narrator was of course destined to last; for two centuries, it has sustained ordinary fictional output. But when we consider what it entails – great literary works formulated like cosmologies – a radical reversal takes place when it comes to Proust's *A la recherche du temps perdu*. The panoramic vision is of course suggested or promised on more than one occasion, but for the narrator-hero it is always the occasion for failure; he neither visits nor experiences any of the elevated sites (the church tower in Combray, the terrace that overhangs the Verdurin in Balbec, etc.) that would have given him a view of the whole expanse from a fixed, anchored position. Does this come as any surprise? Not really, for if the opposite had occurred, it would have ruined the crucial two-sided construction (Tansonville and Guermantes) as well as the general aesthetic that constantly challenged the individual's perception and understanding of the world and how these functioned in relation to how movement had been recorded and the world depicted. From then on, the latter was presented in an incomplete, variable and contradictory way, through the accumulation of points of view that shifted and sometimes inverted themselves, in a kind of dance that knew no other truth than that of juxtaposition in time.

In conclusion, as we have seen, painting was also to feed off panoramism.

The very dimensions of some paintings made them look like panoramas, either because of their horizontal stretch or because of their great size. It is

71. Caspar David Friedrich (1774–1840), *Wanderer above a Sea of Fog*, c. 1818, 95 × 75 cm. Kunsthalle, Hamburg.

72. Caspar David Friedrich, *The Great Reserve near Dresden*, c. 1832, oil on canvas, 73.5 × 102.5 cm. Gemäldegalerie Alte Meister, Dresden.

73. Cross-section of the architect Louis Bonnier's project for a pavilion to be built at the Hôtel Biron (now Musée Rodin) and intended to house Monet's gift to the French nation of his *Waterlilies*, December 1920, 75 × 108 cm. Centre Historique des Archives Nationales, Paris.

interesting to note that Géricault's *Raft of the Medusa* was taken on a tour of England before being exhibited at sites traditionally reserved for panoramas and dioramas.

In the case of Friedrich, it is undeniable that the enlargement of the visual field produced a panoramic effect. It was not unusual to find one or two characters situated in the centre of a natural vista that stretched out into infinity. We could say that he was depicting both the panorama and its spectator (in the famous *Wanderer above a Sea of Fog* [illus. 71] the subject is in fact in a central, elevated position and isolated from the landscape, two characteristics of the panoramic device). Moreover, and several critics have drawn attention to this, the strange luminosity that typifies Friedrich's work is reminiscent of the zenithal lighting of rotundas on rainy days (illus. 72).

However, the correlation between panorama and painting is delicate. Some Romantic artists (Turner, Cozens) were happy to exploit vast dimensions, ruptures of scale, plunging views, distortions of perspective and curvilinear horizons, but this was essentially to destabilize their viewers, to make them loose their bearings, to destructure the background so that they could be sucked into the vertigo of the image, to be as it were immersed in the forces of nature and the painting. In chapter 14, I stated that the panorama was a mixture of humanism and ecstasy, of dominance and dissolution. Whenever painting touched panoramism from near or from afar, it was more likely motivated by the second of these possibilities.

The relationship was never as explicit or as blatant as in Monet's *Waterlilies*, nor was the difference as marked. When he wanted to bequeath to the State the series he had created at Giverny, the artist demanded that a rotunda be

constructed to accommodate his work so that it could be seen at its best in a completely uninterrupted visual circularity. In 1910, Monet explained:

> I was tempted to use the waterlily theme to decorate a drawing-room: carried around the walls, drawing them into its unity, it would have produced the illusion of a whole without end, of a wave without a horizon and without a shore; and under the soothing influence of these still waters, the overworked nerves would have been able to relax; moreover, to whomever lived there, this room would have offered a haven for quiet meditation at the centre of a flower-filled aquarium.

What we have here is an internal and external inversion accentuated by the loss of the horizon and the infinity of the space created. Initially, the plan was to build a circular pavilion modelled on the panorama and designed in 1920 by the architect Louis Bonnier, in the gardens of the Hôtel Biron (illus. 73). Rejected on the grounds that it would be too costly, this was followed by plans for the present building, the Orangerie, although they did not meet with the approval of the artist, since the continuity of the gaze was interrupted by doors and corridors. Monet was obviously not happy with this solution, since he demanded that the site not be opened until after his death.

II

PANORAMAS

IN DETAIL

Views Including Rotundas

Because of the size and circularity of panoramic canvases, specially designed rotundas were built to accommodate them. Initially fairly basic and simple in design, these buildings became increasingly more substantial and ornate. In order to facilitate the circulation of the canvases, during the second half of the nineteenth century the different international panorama companies laid down certain requirements governing their size. Thus rotunda architecture became more uniform even though each country managed to retain its own individual style.

More often than not, rotundas were built in urban areas set aside for specialist (theatres and variety theatres) or more general entertainment (cabarets, fairs, markets and amusement parks). They provided cheap thrills rather than an educational experience.

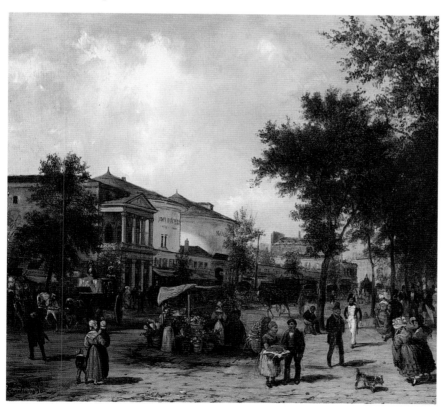

74. Detail of Giuseppe Canella, *Vue des Grands Boulevards de jour*, 1830, oil on millboard, 22.1 × 31.6 cm. Galerie Kugel, Paris.

Panoramic rotundas were instantly recognizable by their shape and size. The subjects of the canvases within were blazoned in large painted letters on the rotundas' façades. Here we see the two rotundas that stood at either side of the entrance to the Passage des Panoramas, on Boulevard Montmartre, next to the Théâtre des Variétés, just within the perimeter of the famous boulevard theatres. Built by James Thayer between 1800 and 1801, these were amongst the Meccas of panorama paintings in Paris, mostly exhibiting circular canvases by the master of panoramas, Pierre Prévost. These included the panoramas of Athens and Jerusalem that were so successful around 1820 and that were much admired by Chateaubriand. Representations of Napoleon's great battles were hung there; it was on seeing these, particularly the one showing the Battle of Wagram, that the Emperor had the idea to build several rotundas on the Champs-Elysées for propaganda purposes – a project that was never realized.

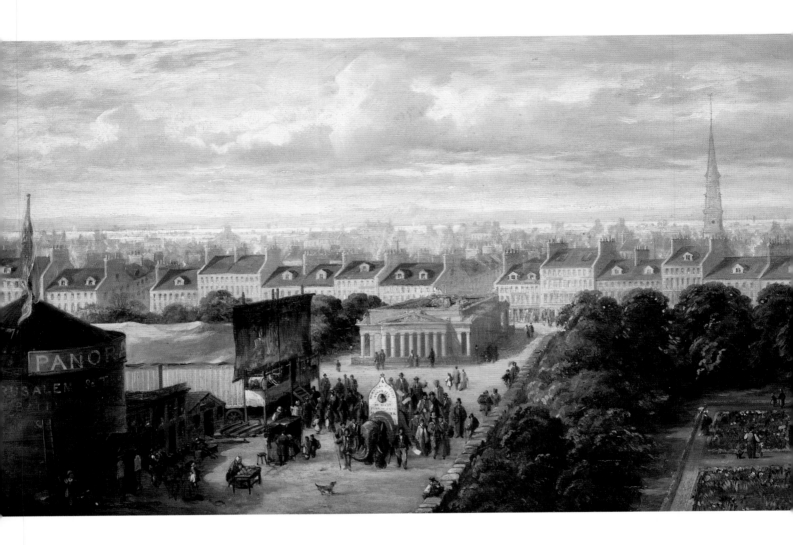

75. Charles Halkerston, *View of Princes Street from the Mound, Edinburgh*, 1843, oil on canvas, 28 × 47.3 cm. City Art Centre, Edinburgh.

The Mound of Edinburgh had the charm of a funfair, with an elephant-drawn menagerie advertising a fireworks display in the Botanical Garden, as well as a variety of permanent attractions, and with a rotunda that housed Marshall's panoramas of Jerusalem and Thebes and the Battle of Waterloo. There is no indication, however, that these canvases were exhibited at the same time.

76. Laurenz Janscha (1749–1812), *View of the panorama at the entrance to the Prater*, *c.* 1810 (?), colour print, 31 × 34 cm. Hessische Landes- und Hochschul-Bibliothek Kartensammlung, Darmstadt.

There is some doubt as to the date of this document, since the rotunda depicted was destroyed in 1809 during the French occupation. Initially a temporary wooden structure built to house Barker's view of London in 1801, the Prater building then exhibited a *View of Vienna from the Catherine Tower* by Janscha and Carl Postl. The panorama painter William Barton, who was involved in managing the site, had the idea to tour this canvas around Europe, from Dresden to St Petersburg and from London to Budapest, before exhibiting it again in Vienna in 1817, in the permanent rotunda built on the same spot in 1811. It was there that Prévost's no doubt updated and corrected panorama of Paris had been hung in the Pavillon de Flore (see illus. 16) in 1814. Barton's rotunda was destroyed in 1871.

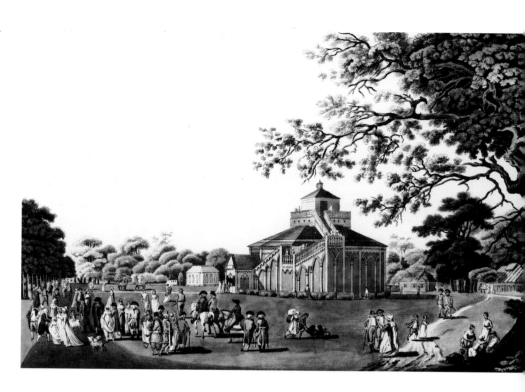

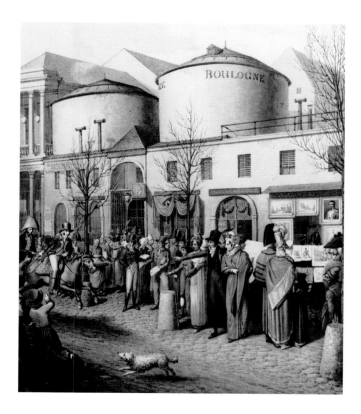

77. Panorama rotundas in Boulevard Montmartre, Paris, in 1814, engraving. Bibliothèque Nationale de France, Paris.

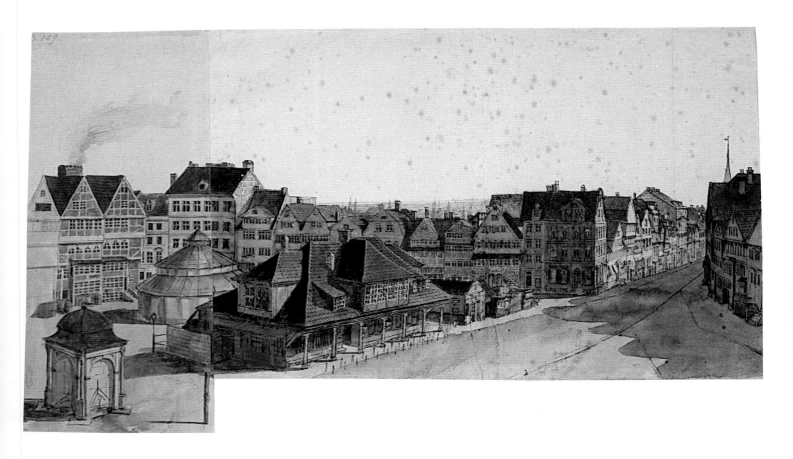

78. Hubert Sattler (1817–1904), *Johann Michael Sattler's Panorama Rotunda in the New Market Square, Hamburg, c.* 1833, watercolour, 31.8 × 54 cm. Museum Carolino Augusteum, Salzburg.

In 1824, Johann Michael Sattler began work on his panoramic view of Salzburg, which he exhibited in 1829. Despite the great number of visitors, the public soon tired of the attraction. Sattler had designed a portable rotunda which he toured around Europe. This watercolour produced by his son Hubert, then aged sixteen, confirms that the Sattler family passed through Hamburg in 1833. It should be noted that their show was intended for a mass audience rather than as an artistic event for connoisseurs.

79. Michael Zeno Diemer (1867–1939) and others, *Panorama of the Struggle for Tyrolean Independance in 1809*, 1896, 1,000 × 10,000 cm. Innsbruck.

The third Battle of Bergisel (13 August 1809) involved 15,000 inadequately armed but valiant Tyrolean peasants under the command of Andreas Hofer and 16,000 mainly Bavarian soldiers from Napoleon's army under the command of Marshall Lefebvre. Once defeated, the latter left the Valley of the Inn, and the Tyrol regained its independence with the signing of the Peace of Pressburg in December 1805. Diemer cycled through the Tyrol in order to familiarize himself with the area and its traditional costumes, many of which can be seen in this canvas. Having spent months preparing, sketching and planning in his Munich studio, whilst at the same time working on his panorama of Bazeilles (illus. 132), he completed this panoramic canvas in only three months with the help of a team which worked day and night towards the end. The panorama was inaugurated in June 1896. The rotunda that now houses it was rebuilt in 1924, after the panorama had been on tour a few times and changed owner.

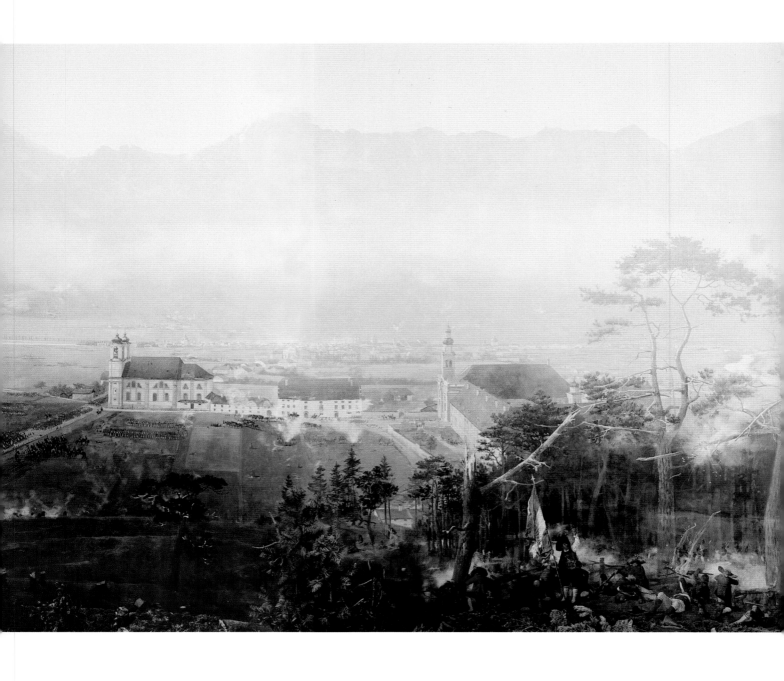

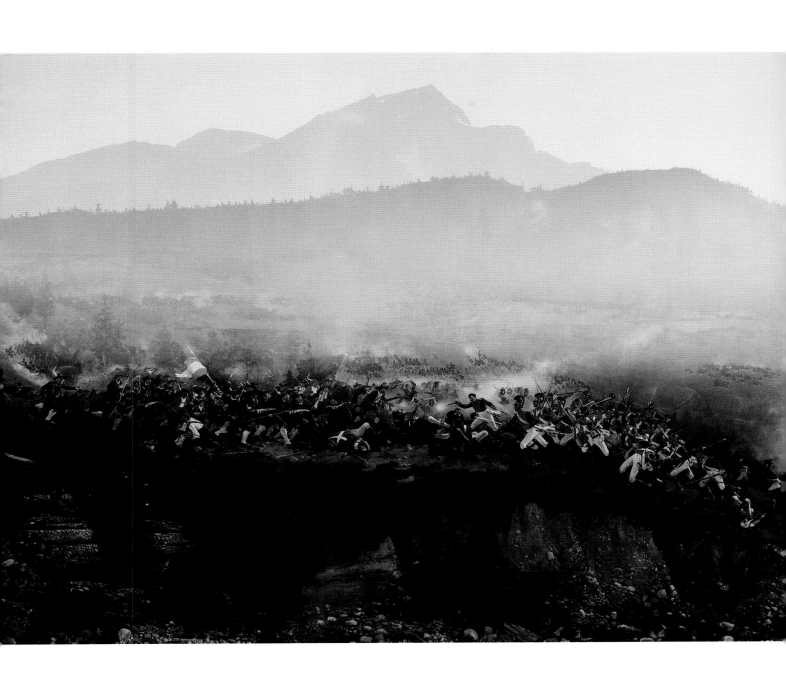

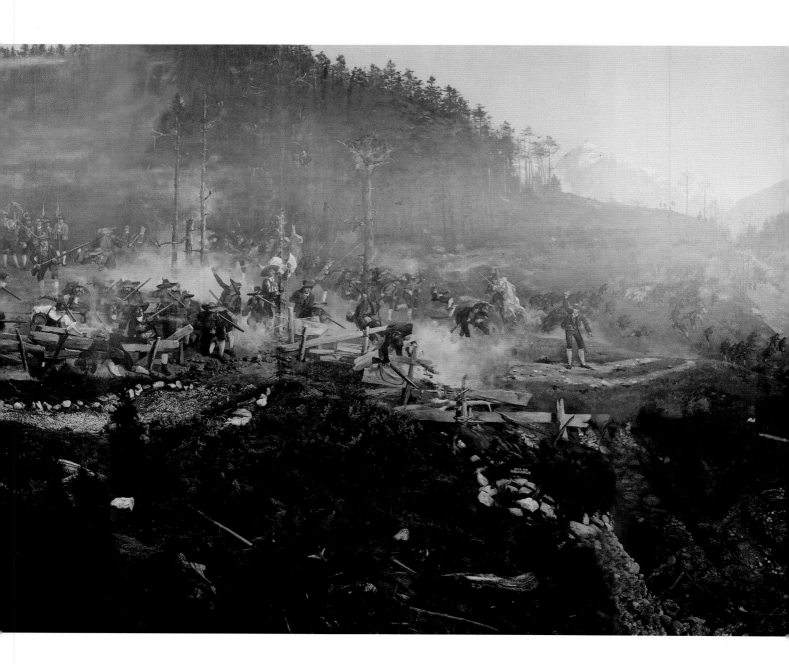

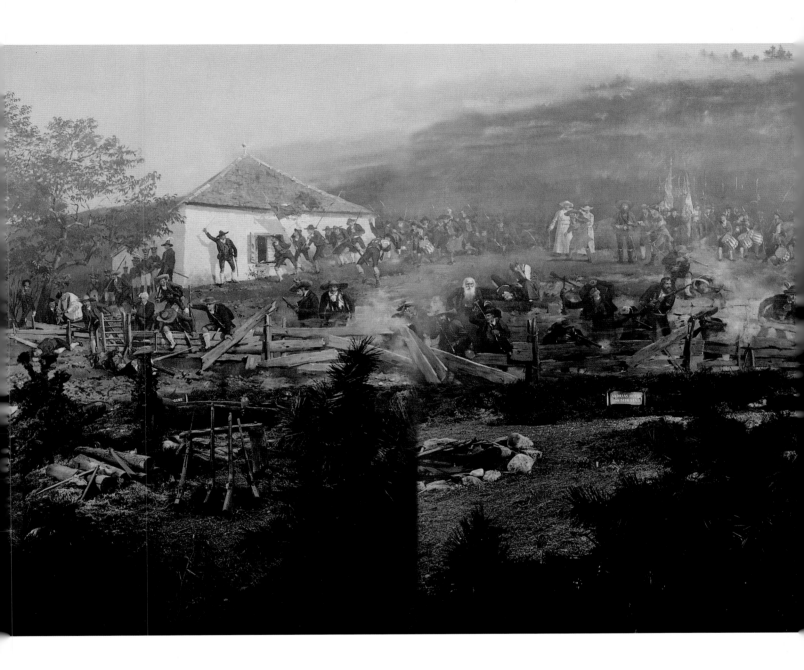

Cross-sections, Elevations, Orientation Plans and Advertisements

To gain access to a panoramic canvas, the spectator had to walk along a darkened corridor so as to forget the reality of the world outside and so that the effect of being plunged into the total illusion of the representation would have more impact. Viewers were confined to an observation platform and could not approach the canvas. A canopy concealed the overhead lighting that entered from behind a glass panel.

Visitors were provided with orientation plans so that, when faced with the vastness of the spectacle (urban or exotic landscape, battle scene), they would be able to identity the main buildings, sites or events depicted.

80. Robert Mitchell (*fl.* 1792–*c.* 1809), 'Section of the Rotonda, Leicester Square, in which is exhibited the Panorama', from his *Plans and Views in Perspective, with Descriptions of Buildings Erected in England and Scotland* (London, 1801), coloured aquatint, 28.5 × 44.5 cm. British Museum, London.

Mitchell built the first panoramic rotunda in London for Robert Barker, basing it on descriptions in the latter's patent. Inaugurated on 25 May 1793, Mitchell's rotunda was in constant use until 1864.

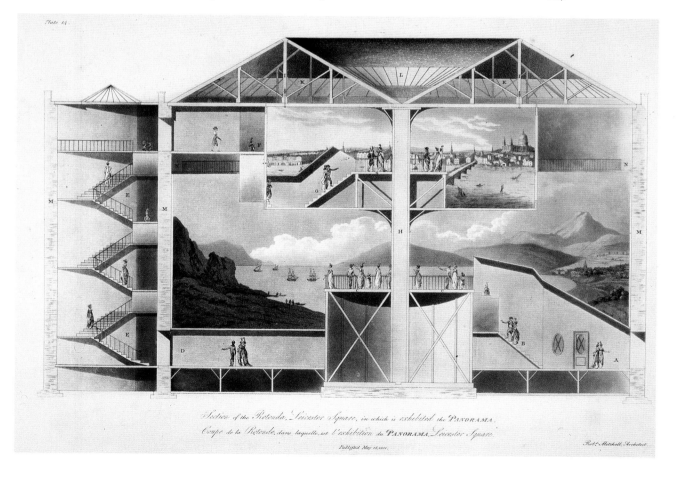

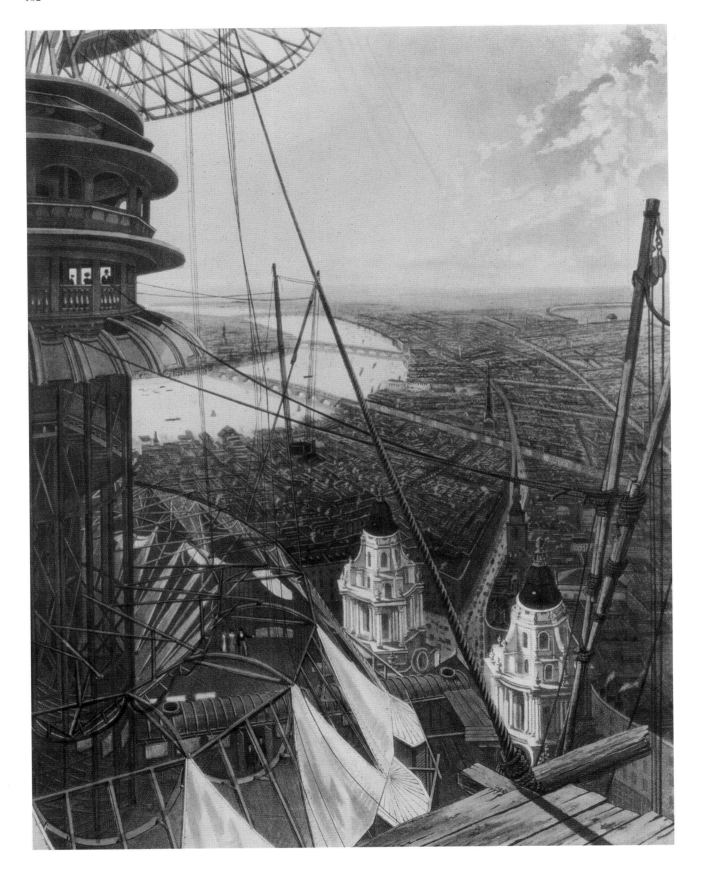

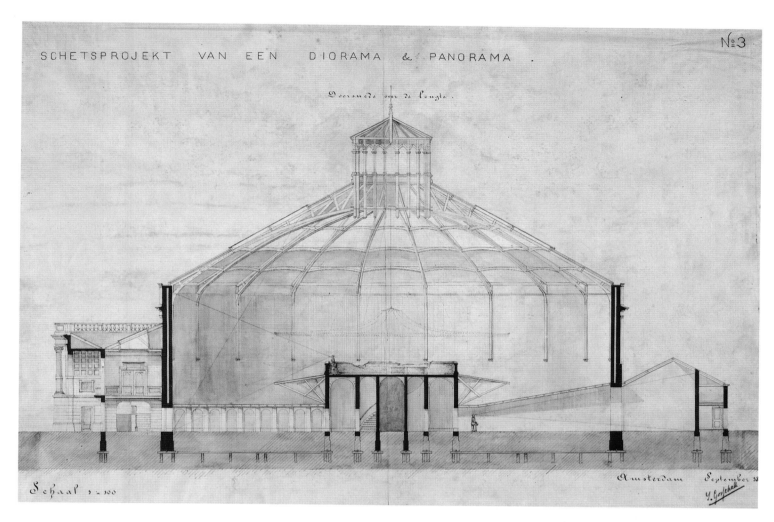

SCHETSPROJEKT VAN EEN DIORAMA & PANORAMA.

Nº3

82. Jakob Gosschalk (1840–1893), Sketch for a projected panorama and diorama, September 1877, watercolour and ink on transparent paper, 49 × 68.5 cm. Netherlands Architecture Institute, Rotterdam [pf. 1].

Following Daguerre's invention of the diorama in 1822, it was not unusual to find dioramas exhibited in rotundas designed to show panoramas. Such was the case with this project for a new building in Amsterdam. The space required for a diorama was of course far smaller than that required to display a circular canvas and was, more often than not, similar in structure to a small theatre. The two forms of illusion were clearly aimed at a single public.

81. *Bird's-eye View from the Stair-case & the upper part of the Pavilion in the Colosseum, Regent's Park*, 1829, coloured aquatint published by R. Ackermann & Co., London. Guildhall Library, Corporation of London.

Between 1822 and 1824, Thomas Hornor took advantage of the restoration work being carried out on the belfry of St Paul's Cathedral to install a small observation hut from which he was able to make sketches and drawings. The resulting panorama was exhibited at the Colosseum in Regent's Park; for financial reasons, it had to be opened to the public before being completed on 29 November 1829. Part of the portable scaffolding used by the panorama painters is visible in the foreground of this print. Below the first public observation platform is a reproduction of St Paul's Cathedral. The twin towers painted on the canvas were so perfect an illusion that spectators thought they were three-dimensional. To perfect the illusion, the Colosseum itself was represented on the canvas, thus leading viewers to believe that they were at the top of the cathedral and not in a panorama.

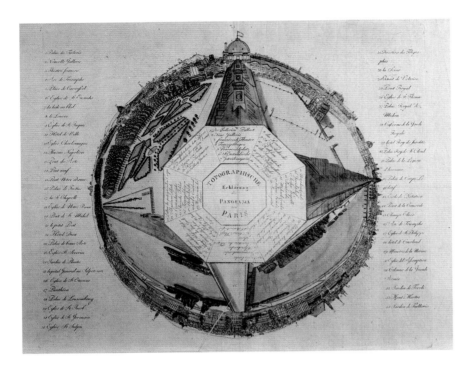

83. Topographical explanation of the panorama of Paris, *c.* 1814, print with watercolour highlights, 29.8 × 34 cm. Museum für Kunst- und Kulturgeschichte der Hansestadt Lübeck.

Contrary to what has been claimed in some catalogues (illus. 16), this print cannot possibly date from 1805, but must date from 1814. It was meant as a guide to the *View of Paris from the Pavillon de Flore* which Pierre Prévost produced, or planned to produce, between 1802 and 1804, and which was exhibited in Barton's rotunda in Vienna in 1814, before touring a number of major cities (in Germany, as is confirmed by this orientation plan, and in St Petersburg, since there is a version with captions in Russian).

84. Poster for a panorama painted by Louis Braun (1836–1916) and Edmund Berninger (1843–*c.* 1896) of the Battle of Champigny, 1896, lithograph, 123 × 67 cm. Historisches Museum, Frankfurt am Main.

During the last third of the nineteenth century, panoramas took on strong nationalistic, indeed propagandistic, overtones thanks to Napoleon, who instinctively understood the advantages to be gleaned from gigantic canvases that depicted his major victories – until his flight from Russia forced him to abandon such projects. This poster advertises a panorama portraying the Siege of Paris during the Franco-Prussian War. Created by Braun, a specialist in the genre, in 1889, it offered the German view of a battle which in France, in a panorama by Alphonse Deneuville and Eugène Detaille, praised the valour of the French troops. First exhibited in Stuttgart, this panorama was displayed in Frankfurt station in 1896 next to a depiction of the Battle of Sedan to raise the spirits of the populace.

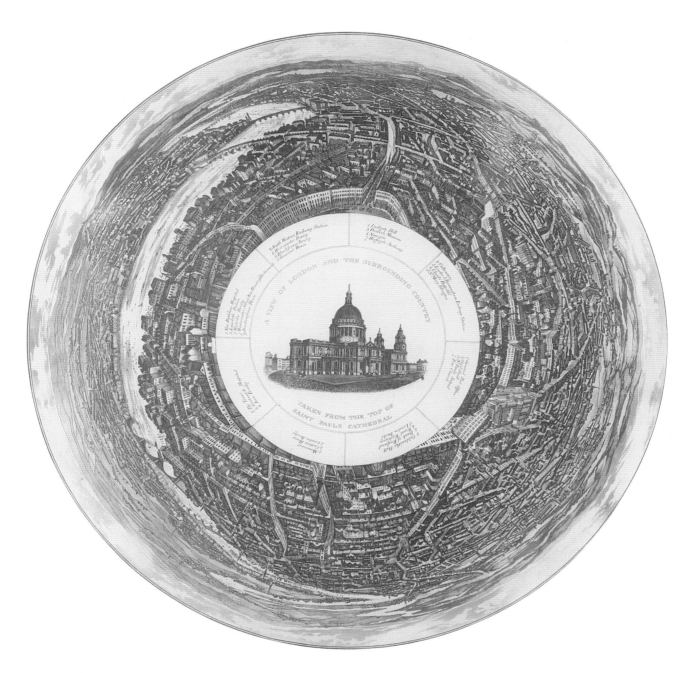

85. *A View of London and the Surrounding Country Taken from the Top of St Paul's Cathedral*, c. 1845, horizontal panorama, highlighted aquatint, diam. 75.5 cm. Jacqueline and Jonathan Gestetner Collection, London.

This anamorphic representation of London from the top of St Paul's Cathedral was probably produced for the reopening of the Colosseum in 1845. Ralph Hyde observed that certain transformations the city had undergone, which are not shown in the version painted by Thomas Hornor between 1822 and 1829, could be seen here: 'The new Houses of Parliament, started in 1840, are referenced in the centre of the print though only the foundations are shown in the image. The third Royal Exchange, opened by Queen Victoria in 1844, is shown.' One of the biggest problems facing the creators of panoramas was the rapidity with which towns were changing. The orientation documents produced to aid viewers were of course much easier to update.

Evolution and Variations

For a hundred years or so, the panorama continued to evolve so as to create an ever-greater illusion. Real objects were brought into the 'artificial terrain' that separated the canvas from the observation platform. Moreover, this platform was perfected and integrated into the reality that was represented, often going so far as to create movement (the pitch and roll of a boat, for example).

There were two major variations of the panorama. The first was the *diorama*, invented by Daguerre, which, through the combined effect of transparency, lighting and complementary colours, created a sense of movement. The second was the *moving panorama*, a long canvas that was unrolled in front of stationary spectators. Hugo d'Alési's *Mareorama* was the creation that most perfectly combined all of these characteristics, as well as circularity and a lack of boundaries.

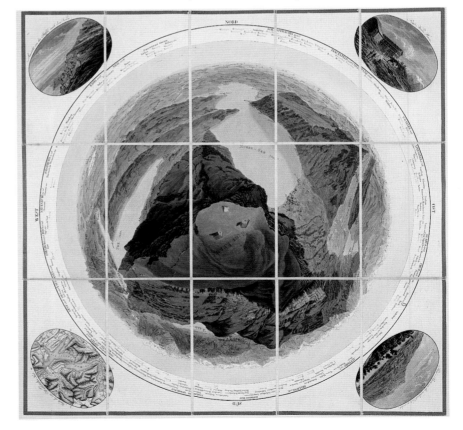

86. Augustin Schmid (1770–1837) after Franz Ludwig Pfyffer von Wyher (1716–1802), *Panorama or circular view sketched from the Rigi-Berg to the Kulm*, 1815–16, print and coloured aquatint, 55.1 × 55.5 cm. Zentralbibliothek, Zurich.

Inaugurated in 1779 by Marc-Théodore Bourrit with his *Circular View of Mountains Seen from the Top of the Buet Glacier*, this type of 360-degree anamorphosed representation was to become known as the 'horizontal panorama' – an apt description given the similarity between the two types of representation. But whereas the true panorama aspired to total illusion, the circular view was above all a response to the notion of totality as perceived from a particular vantage-point. What we have here is an Alpine panorama seen from the top of the Rigi near Lucerne. This type of representation was most frequently used for Alpine vistas and in orientation plans aimed at visitors to the panoramic rotundas.

87. Detail of Jean-Pierre Alaux (1783–1858),
Neorama of the Interior of St Peter's in Rome, 1827,
oil on canvas, approx. 1,700 × 5,400 cm. Musée
du Louvre, Paris (in store).

88. Detail of Jean-Pierre Alaux, *Neorama of the
Interior of Westminster Abbey*, 1830, oil on canvas,
approx. 1,900 × 6,600 cm. Musée du Louvre,
Paris (in store).

Alaux produced two panorama-style canvases
but in a much smaller format than was usual at
the time. Moreover, the manner in which they
were exhibited varied, in as much as spectators
were not limited to a viewing platform but could
walk around the space circumscribed by the
canvas. Alaux called his invention the 'neorama'.
The first one was exhibited in 1827 in the rue
St-Fiacre in Paris (in two blocks of houses in the
Passage des Panoramas). The *Neorama of the
Interior of St Peter's in Rome* depicted the Pope at
prayer, surrounded by his entourage and a crowd
of the faithful. For reasons of perspective, it was
probably wider at the top and narrower at the
base. In 1830, a second, much larger canvas was
exhibited, the *Neorama of the Interior of
Westminster Abbey*. In 1832, on the heels of a
recession and a cholera epidemic, Alaux went
bankrupt. Stored for many years in the Louvre,
his neoramas were rediscovered in 1989. Due to
lack of funds for restoration and exhibition
space, they remain unknown to the public.

89, 90. Hugo d'Alési (1856–1906), *Naples* and *Constantinople*, 1899, two preliminary hand-coloured lithographs for his *Mareorama*, each 15 × 71.4 cm. Museo Nazionale del Cinema, Turin.

Commissioned by the major transport companies to produce artistic posters of the most famous tourist attractions, d'Alési undertook to travel from Marseilles to Yokohama over more than a year to bring back sketches and preliminary documents for his colossal *Mareorama*. This spectacle featured in the colonial section of the 1900 Great Exhibition in Paris. On each side of a platform capable of holding 700 visitors and meant to be a steamer of the Messageries Maritimes, two canvases were unfurled to create the illusion that the spectators were travelling along a coastline. To recreate the smell of the open sea, a light kelp-scented breeze blew through airshafts. A variety of sound effects completed this somewhat excessive simulation. Here we have two prints by d'Alési, a view of the Bay of Naples, with Vesuvius in the background and a view of Constantinople.

91, 92. Max Brückner (1836–1919) and
Gotthold Brückner (1844–1892), *Diorama of
Rome*, c. 1880, back-cloth for Christian
Dietrich Grabbe's 'Don Juan und Faust',
consisting of two images showing day and
night, distemper on canvas, 450 × 610 cm.
Theatermuseum, Meiningen.

Through the manipulation of canvases by
means of back or front lighting and a careful
use of colours, dioramas became the first
representations to allow for the simulation of
movement. Daguerre, their inventor, was
therefore much more a precursor of the
cinema than the revivers of the panorama,
since he never adopted the principle of circular
construction. In a way, his flat canvas was a
screen before the term even existed. The
theatrical effects that resulted from allowing
certain features on the canvas to appear or
disappear, or manipulating the atmosphere
and varying the light, did not fail to attract
the attention of theatre and opera directors.

93–7. John J. Egan (1810–1882), *Panorama of the Monumental Grandeur of the Mississippi Valley*, *c.* 1850, tempera on muslin, five segments of a moving panorama, 228 × 10,607 cm. St Louis Art Museum, Eliza McMillan Fund.

Towards the middle of the nineteenth century, a large number of moving panoramas depicting the valley of the Mississippi River were produced. This is the only one to have survived. The artist would appear to have been inspired by studies made by the anthropologist Dr Montroville to restore features of Native American culture, most notably burial mounds. In fact, the moving panorama had a didactic purpose, for – in addition to depicting a journey down a river – it paraded a wide range of cultural characteristics before its viewers. The subjects illustrated are: Circleville, Ohio, which took its name from the burial earthworks; a cliff with pictographs on the Scioto River; one of many burial grounds, seen here in the snow; the attack of Fort Rosalie in 1729; and the early excavation of a burial mound.

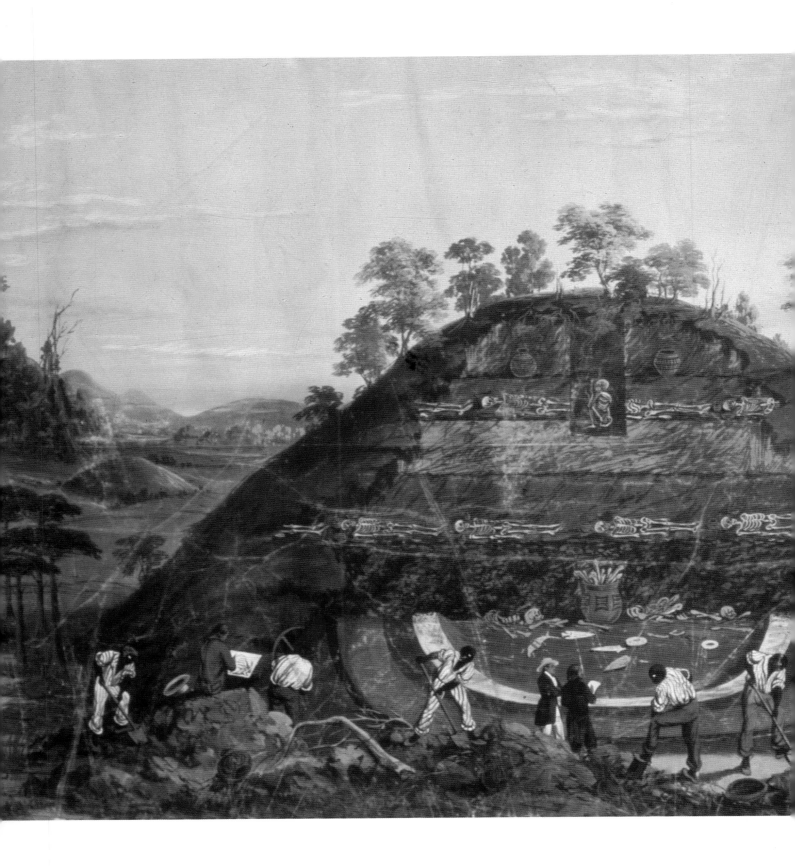

98–101. Franz Schmid (1796–1851),
Zurich from Karlsturm to Großmünsters,
1825, watercolour over pen and pencil,
360-degree panorama consisting of four
sheets, each 57 × 88 cm. Zentralbibliothek,
Zurich.

Once the panoramic paradigm had
been established, many painters became
interested in overlapping views that could
produce 360-degree panoramic landscapes,
although the size of these remained
modest in comparison to that of the
canvases exhibited in rotundas. Schmid
specialized in these types of views,
creating Swiss landscapes and also
producing panoramas of Naples,
Strasbourg and, apparently, Paris.

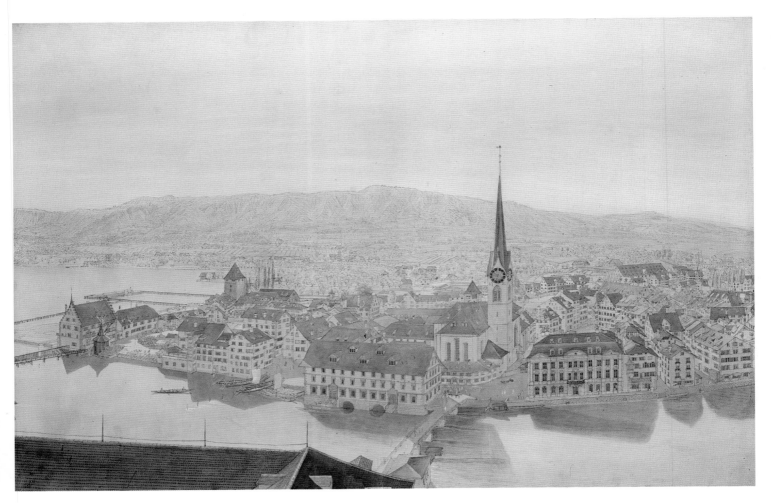

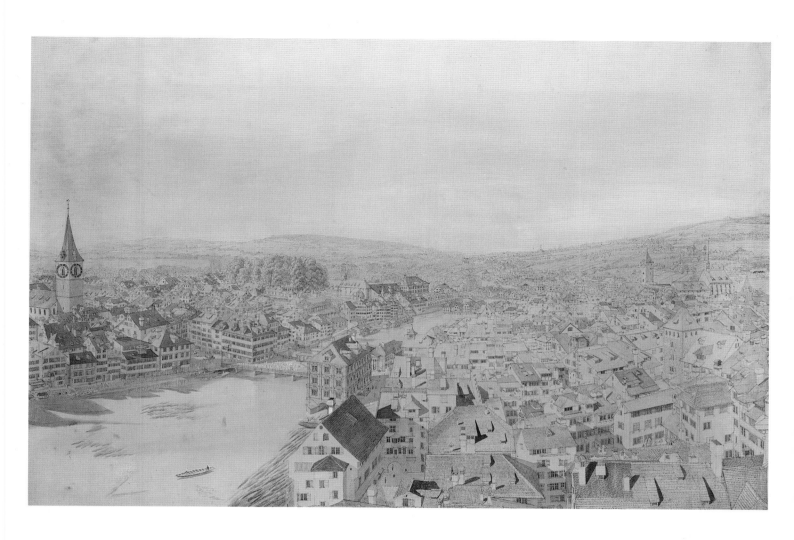

Panoramic Canvases, Drawings, Studies and Prints

Panorama painters worked on site, where they would make all kinds of relief plans and sketches, combining detailed distant and close-up views, and often making written notes. Before embarking on actual panorama canvases, they would make either drawn or painted preliminary drafts. They used 'normal'-sized paintings to help them perfect their compositions. They would then begin work on the full-scale reproduction of the scene they had chosen. Each painter would work with his team, made up chiefly of specialists who dealt only with particular aspects (landscapes, people, skies, buildings, etc.). As a result, the panoramist soon took on the role of project manager whose task it

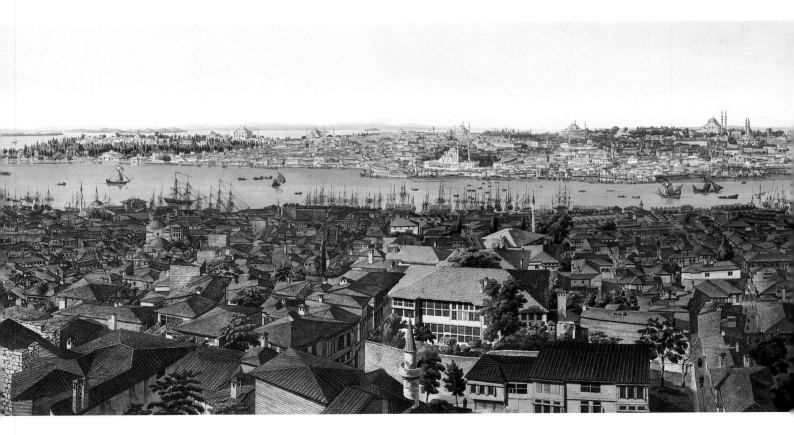

was to oversee the pictorial coherence of the whole and the unity of the perspective.

Amongst the documents included in this section are some reproductions of gigantic canvases. To look at them properly, it is crucial to visualize the enormity of their dimensions and their circularity, without which it is impossible to imagine the unreal, 'wrap-around' effect that was experienced inside a rotunda.

102. Henry Aston Barker (1774–1856) and others, *Panorama of The Celebrated City of Constantinople, and its Environs, Taken from the Town of Galata...*, 1803, coloured aquatint, four of eight double sheets, each 49.5 × 99.5 cm. Jacqueline and Jonathan Gestetner Collection.

Painters of panoramas often returned from long journeys with two or three different views of towns they had visited. That is how Henry Aston Barker came to bring back two preliminary drawings of Constantinople, this one made from the suburb of Galata, and another made from the Leander Tower. Both became panoramas that were shown in the rotunda in Leicester Square, one in the upper room and the other, of which a section is reproduced here, in the large lower room.

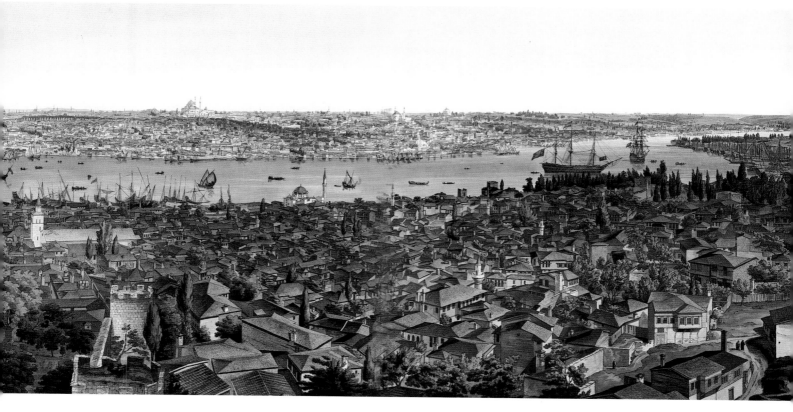

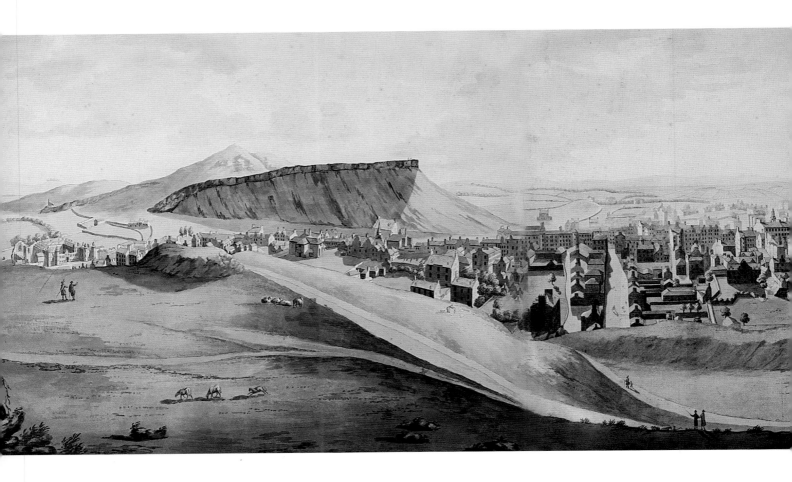

103. J. Wells (*fl.* 1789/90) after Robert Barker
(1739–1806), *Panorama of Edinburgh from
the Calton Hill, c.* 1800, aquatint, six sheets,
42.5 × 331.5 cm. Huntley House Museum,
Edinburgh.

What we are have here is the first panorama
in draft form – hence its crudeness and
imperfections. Moreover, this version was only
semi-circular. The fact that the quality of the
larger canvas showed no great improvement
would account for its lukewarm reception.
This is nonetheless a founding document.
Barker and his son returned to this view,
transforming it to give it the dimensions of a
true panorama, painted in oil, which was
exhibited in the upper room of the Leicester
Square Rotunda in January 1804.

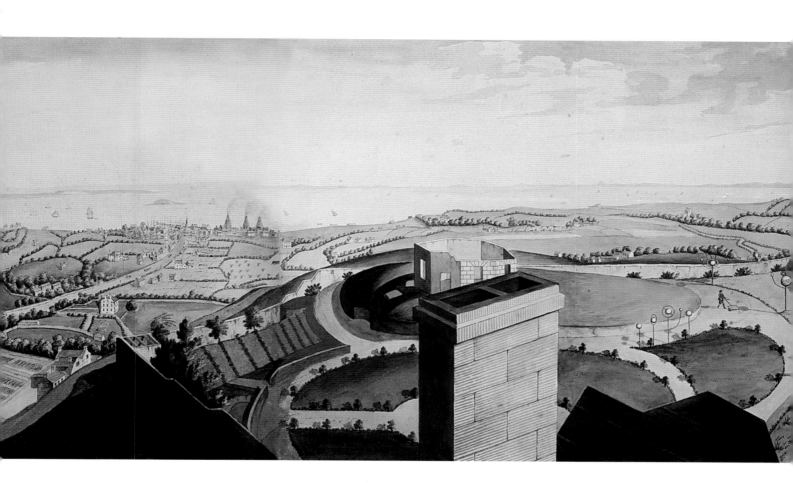

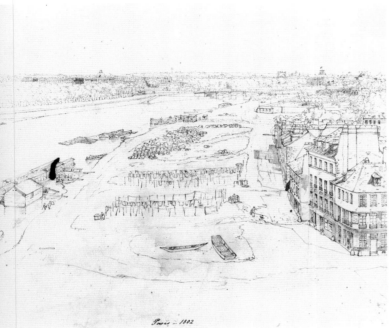
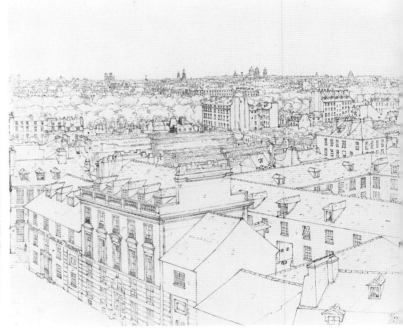

Paris – 1802

104. Henry Aston Barker (1774–1856), Preliminary drawing for the *Panorama of Paris between the Pont-Neuf and the Louvre*, 1802, pencil with red, blue and white high-lights, eight sheets, 36.5 × 426.5 cm. Victoria and Albert Museum, London.

Having recently returned from a long journey to Constantinople, and taking advantage of the Peace of Amiens, Barker went to Paris, where he met Napoleon and made two preliminary drawings for panoramas of the French capital, this being one of them. The vantage-point was close to that chosen by Prévost around the same time, but from the other side of the Seine and with a somewhat surprising lack of precision. The resulting panoramic canvas was exhibited in the upper room at Leicester Square from 15 August 1803 to 30 May 1804.

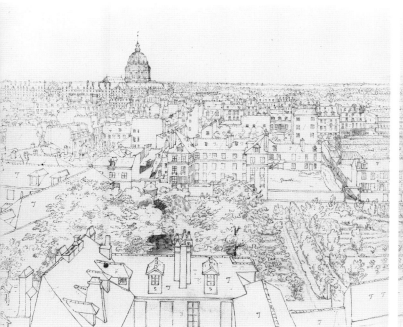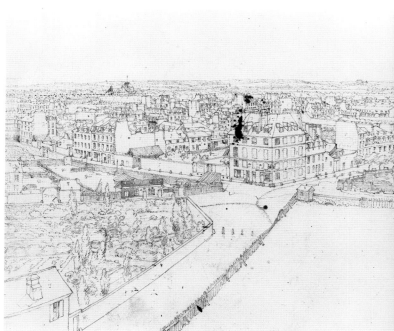

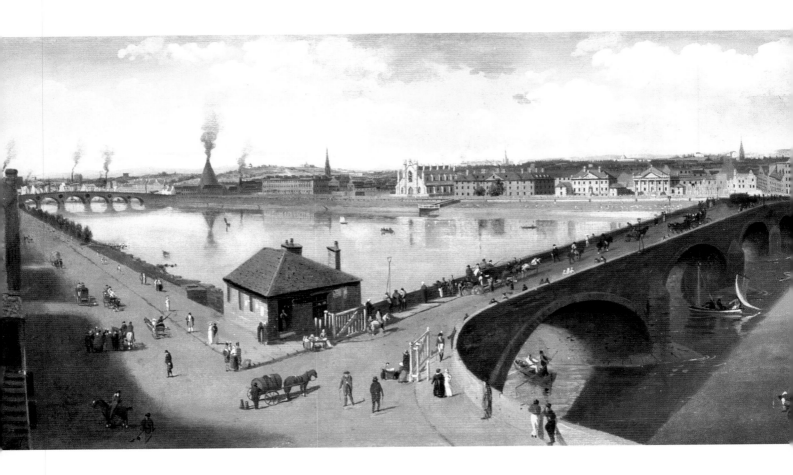

105. John Knox (1778–1845), *Panorama of the City of Glasgow*, 1809, oil on canvas, semi-circular panorama, 31 × 120 cm. People's Palace Museum, Glasgow.

Knox created several panoramas, including views of Dublin, Moscow and Gibraltar, in addition to this semicircular view of Glasgow, which was exhibited in that city in 1809 before being shown in Edinburgh and London. On 8 February 1809, the *Glasgow Herald* had this to say about the canvas: 'The view of this celebrated and beautiful City is taken from an elevated situation at the south end of the Old Bridge, and embraces the whole range of the City, with three bridges . . . A very happy subject for the pencil, and submitted to the public, as a correct view, painted on a seal of magnitude occupying about 3000 square feet of canvas.' The present painting must be a smaller, updated reproduction of the original, since St Andrew's Cathedral, which can be seen in the centre, was not completed until 1819.

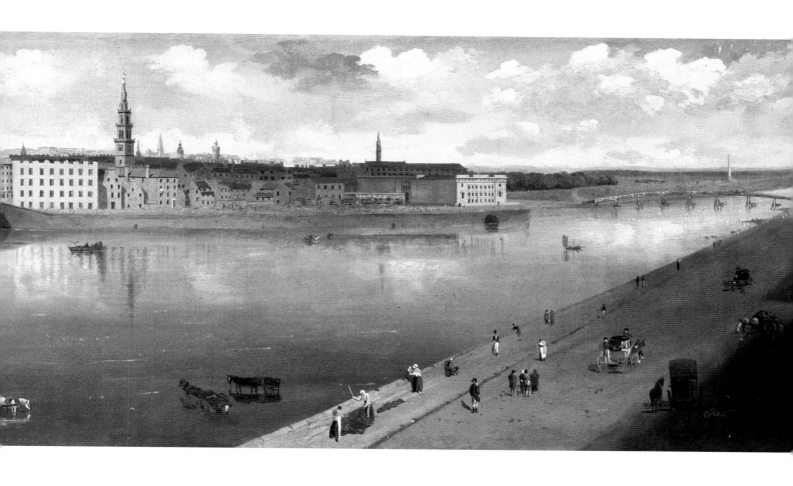

OVERLEAF

106. The so-called, 'Rhinebeck' panorama of London, c. 1810, watercolour, two of four sheets, 71.1 × 261.6 cm. Museum of London.

Discovered in a house on the Hudson River in New York State, these sheets may have been prepared by three separate artists, each a specialist in different aspects of rendering landscapes. They served as a model for a panoramic view of London by Robert Havell Jr.

107–10. Four details of Ludovico
Caracciolo, *Panorama of Rome*, 1824,
panoramic canvas, 170 × 1,340 cm. Victoria
and Albert Museum, London.

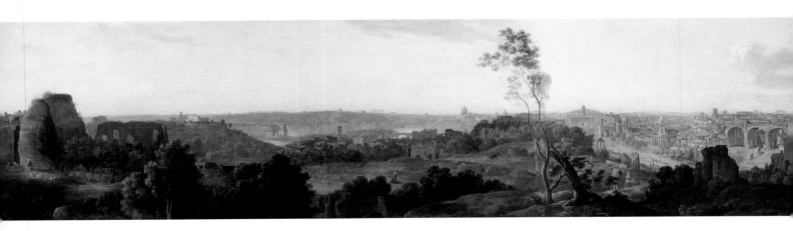

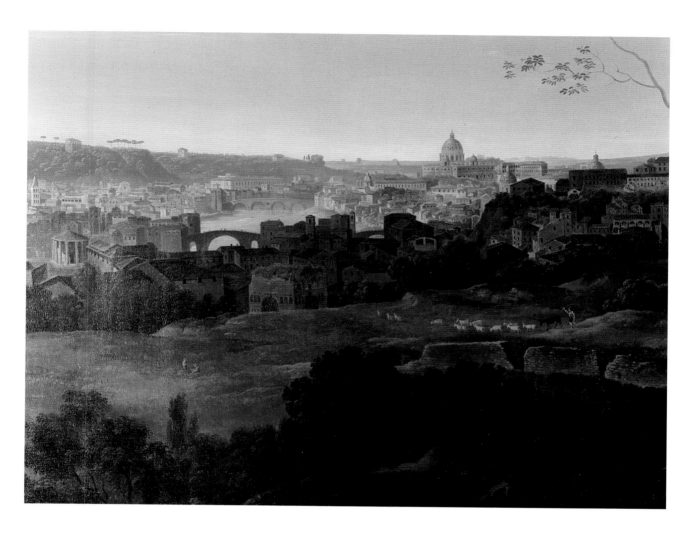

111. Ludovico Caracciolo, Study for *Panorama of Rome*, oil on paper laid down on canvas, 44.5 × 394 cm. Dover Street Gallery, London.

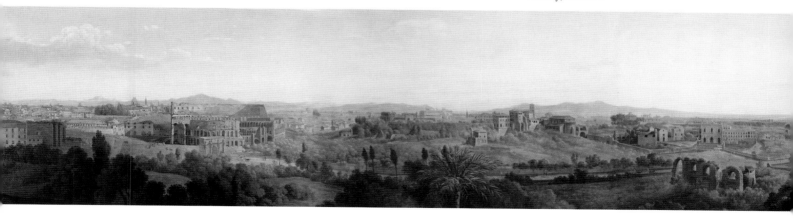

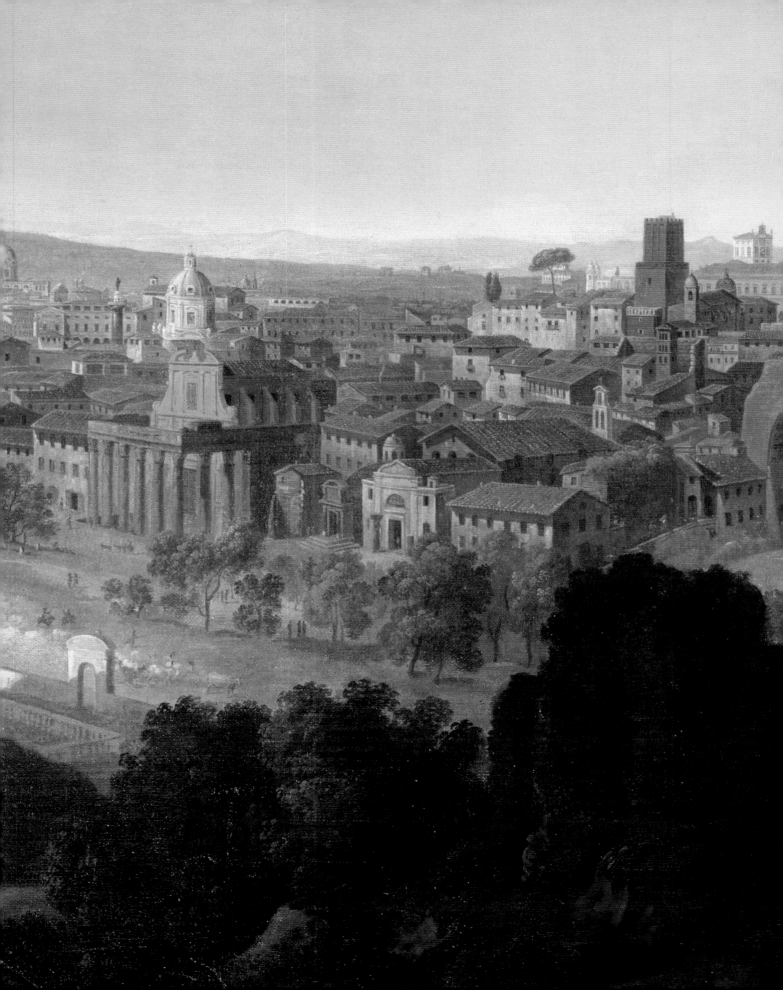

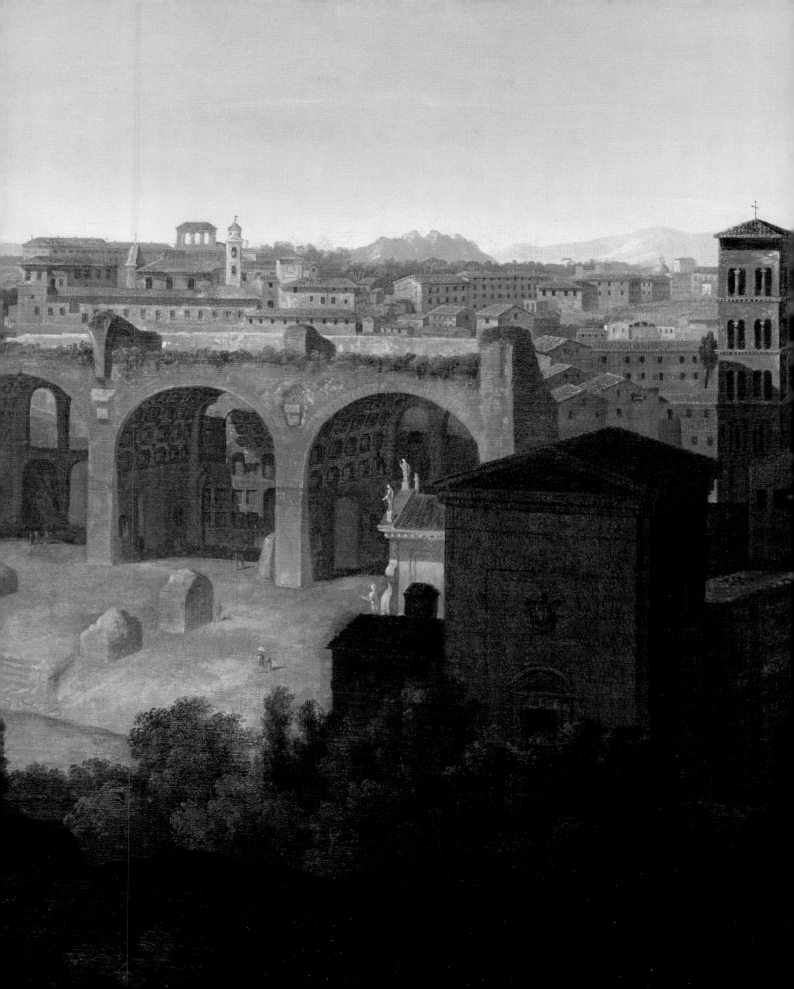

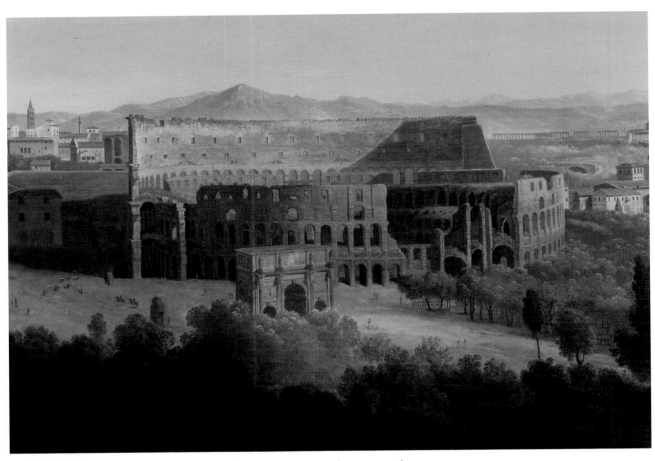

By virtue of its modest dimensions, the *Panorama of Rome* canvas cannot be considered as belonging to the panoramic genre, for it does not fulfil all of the usual criteria (it was not possible for the spectator to stand far enough away from it to appreciate the full effect of the illusion). The study was rediscovered for sale only recently at the Dover Street Gallery. There are very few differences between it and the larger canvas. Carucciolo deviated from reality in his configuration of the monuments of Rome. Poetic license allowed him to condense and group together buildings that would not actually have been visible from a single vantage-point.

112, 113. Two partial installation views from the Victoria and Albert Museum.

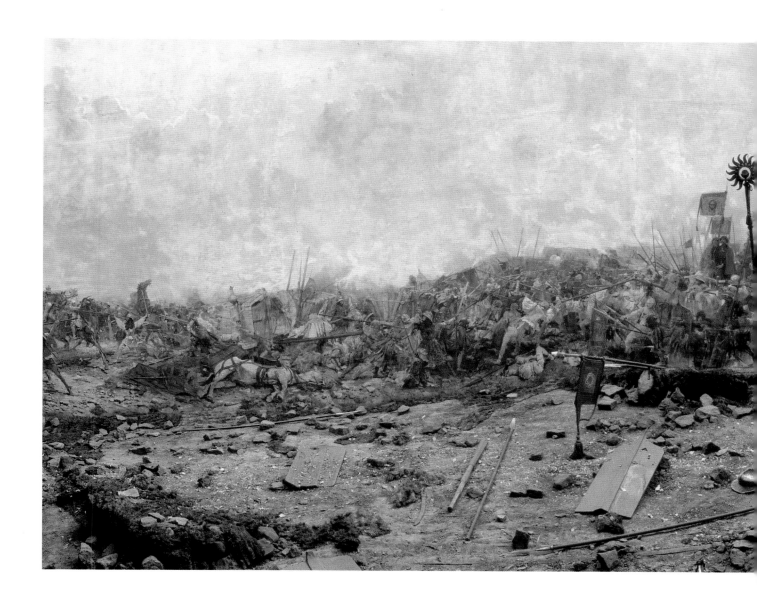

114. Ludek Marold (1865–1898) and Václav Jansa (1859–1913), *Battle of the Hussites at Lipany*, 1897, oil on canvas, 1,100 × 9,000 cm. Prague Exhibition Grounds.

At this famous battle (30 May 1434) fought at Lipany in Bohemia, the army of Emperor Sigismund quelled an uprising by the Taborites, the extremist fringe of the Hussites. The Emperor's army was twice the size of the insurgents', who suffered a bloody defeat. Their leader, André Procope the Bald, and his followers literally fought to the death in a battle they had no hope of winning. Having collapsed in 1929, the rotunda was rebuilt in an enormous amusement park in 1934, to commemorate the battle's 500th anniversary, and there it stands today.

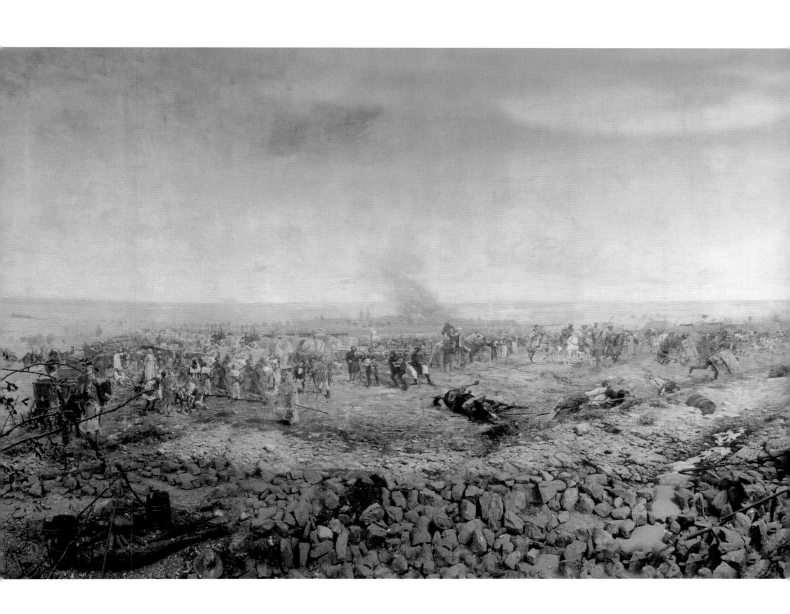

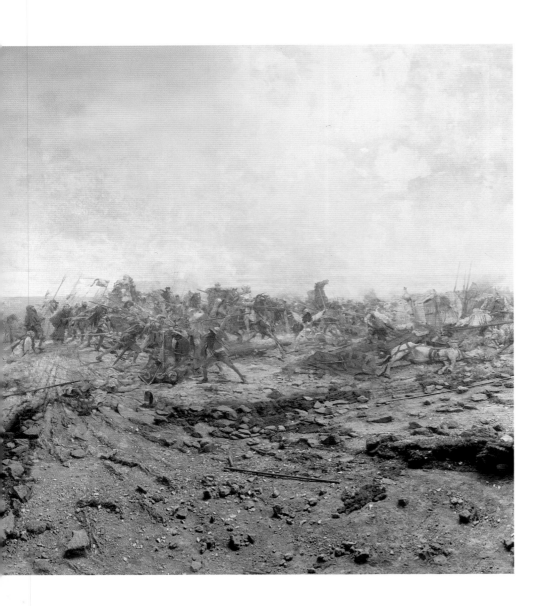

115. French Revolutionary figures, segment of Henri Gervex (1852–1929) and Alfred Stevens (1823–1906), *History of the Century*, 1889, oil on canvas, 236 × 146 cm. Musée du Petit Palais, Paris.

116. French literary and artistic figures, segment of Henri Gervex and Alfred Stevens, *History of the Century*, 1889, oil on canvas. Musée Carnavalet, Paris.

For the 1889 Great Exhibition, on the occasion of the centennial of the French Revolution, Gervex and Stevens had the idea to choose a unique setting (the Jardin des Tuileries) and present the most prominent personalities from the political, military, scientific, literary and artistic

spheres to have emerged in a hundred years of French history. Through the arches at the bottom of the garden, the principal monuments of Paris were portrayed in a composition that was deliberately unrealistic so as to offer an architectural and historic overview. This arrangement had the disadvantage of breaking down any illusion of reality since it suggested impossible co-existences and juxtapositions. The panorama was set up in the Tuileries itself. Intended for display during the exhibition, it remained in place until 1896. Since no buyer was found to purchase it, it was broken up into small paintings which were distributed among the shareholders.

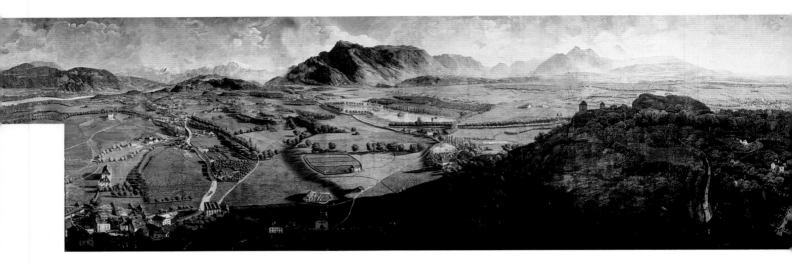

117. Details of Johann Michael Sattler
(1786–1847) assisted by Friedrich Loos
(1797–1890) (landscapes) and Johann Joseph
Schindler (1777–1836) (figures), *Panorama of
Salzburg*, 1829, oil on canvas, 360-degree
panorama, 500 × 2,600 cm. Casino der Stadt
Salzburg, under the auspices of the Museum
Carolino Augusteum, Salzburg.

It is probable that Emperor Francis I of
Austria commissioned this panorama from
Sattler despite the fact that this artist special-
ized in miniatures. Sketches were made in
1824/5, and Sattler then went on to create the
full-size version, having arranged for Loos
and Schindler to help with the landscape and
figures, an accepted division of labour for this
kind of work. In 1870, Sattler's son

bequeathed the panorama to Salzburg
museum; in 1875, it was hung in a specially
built rotunda, which was closed during the
1930s. While in storage in the museum, it was
slightly damaged by wartime bombing raids.
Having been restored, it has hung in a hall in
Salzburg's casino since 1977. Unfortunately,
this venue does not meet all of the traditional
requirements: there is no dark corridor leading
to it; the platform consists of a suspended
bridge; there is no canopy; and there is no
overhead lighting. In addition, the canvas's
circularity has been violated by a rectangular
entrance. However, its artistic quality is
irrefutable, and it is one of the oldest of its
kind to have survived.

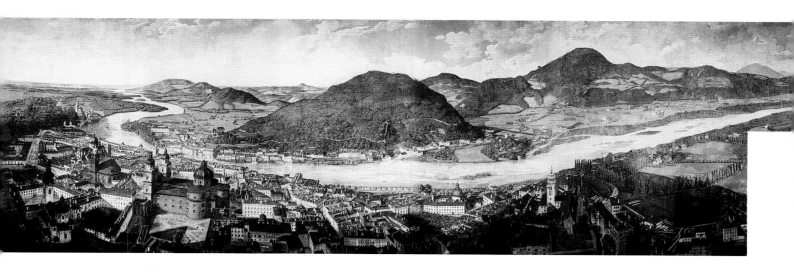

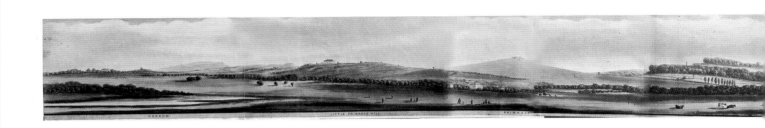

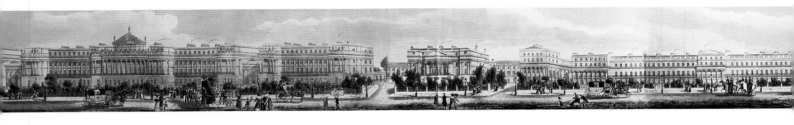

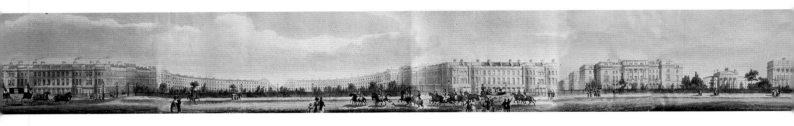

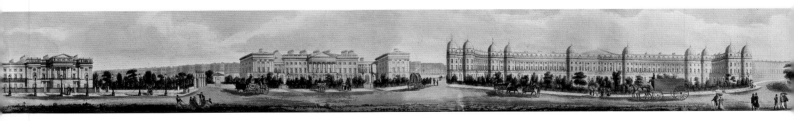

118. Richard Morris (*fl. c.* 1830), *A Panoramic View round Regent's Park*, 1831, coloured aquatint folded in a portfolio, 10.2 × 569 cm. Guildhall Library, Corporation of London.

This is not a panoramic canvas in the true sense of the word, nor is it a sketch for one. It is a folder that could be described as a small 'moving panorama' because of how it was sometimes used inside a lacquered box. This kind of representation became extremely popular and had the obvious advantage of being easier to exhibit than large panoramas. The imposing architecture of the Colosseum is immediately identifiable and gives little idea of the grandiose show it housed.

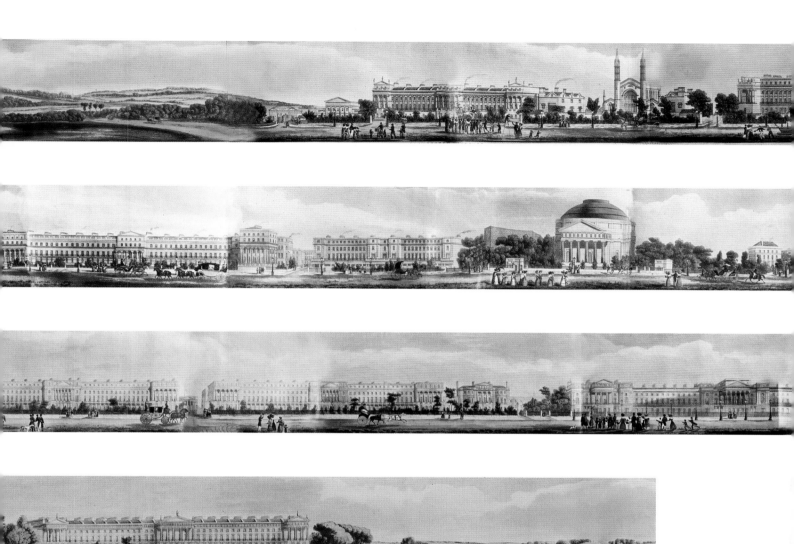

119. Edouard Castres (1833–1902) and others,
The Bourbaki Panorama, 1881, oil on canvas,
980 × 11,500 cm. Bourbaki Panorama,
Lucerne.

This panorama illustrates an event that
took place at the end of the Franco-Prussian
War, when General Bourbaki's eastern army
(relieved by General Clinchant) fled to
Switzerland, crossing the border at Verrières
in February 1871 after a terrible defeat near
Belfort. The French troops were granted
asylum on condition that they lay down their
arms: documents record that 88,000 men
marched into Switzerland, having abandoned
11,000 horses, 1,150 wagons, 285 cannons,
7,200 rifles and 64,000 bayonets. The
wounded were collected by Red Cross
ambulances, while the lame were rescued by
civilians. This panorama represents a dark
view of the terrible consequences of war
rather than the usual celebration of military
victories, while also applauding Swiss
neutrality and hospitality. Castres spent the
whole of the 1876–7 winter at Verrières so
that he could paint the surrounding country-
side. His panorama is designed around the

column of French infantrymen and the
Bernese battalion, with the rails and road
acting as the axes of perspective and the focus
being the perfectly integrated point where
Clinchant and Herzog meet in front of the
Hôtel Fédéral. Castres assembled a team of
painters to work with him, one of whom was
the young Ferdinand Hodler. As Meyer and
Horat noted in their little book on the
Bourbaki Panorama, '. . . a vision that is both
objective and impressionistic contrasts with
the illusion and realism of the panoramic
painting; the representation of the surround-
ings prevails over that of the motif, precise,
true to life and immediately recognizable.'
Having been on exhibit for several years in
Geneva, the *Bourbaki Panorama* was trans-
ferred to Lucerne in 1889, to a rotunda meant
to accommodate a panorama of the Battle of
Sempach commissioned from Louis Braun
but never realized. The size of the canvas was
twice reduced in the course of this century,
resulting in a loss of approximately a third of
its height and a flattening of the sky, which is
higher and more open in the original. It has
been under restoration since 1977.

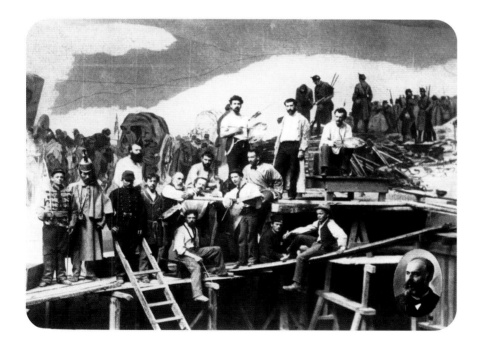

120, 121. The production of a panoramic canvas involved establishing of a team of painters who divided the work amongst them, either according to their areas of expertise. For his *Bourbaki Panorama*, Edouard Castres secured the services of Ferdinand Hodler, the bearded young man seated to the right of the ladder and painting the section that shows the arrival of the Bernese battalion. This segment shows the first signs of a reresentational logic that Hodler would later term 'parallelism'.

122. Emile Charles Wauters (1846–1933), *Cairo Seen from the Kasr-el-Nil Bridge*, preliminary study for *Panorama of Cairo and the Banks of the Nile*, 1881, oil on canvas, 102 × 240 cm. Koniklijk Museum voor Schone Kunsten, Antwerp.

In 1880, an Austrian panorama company sent Wauters to Egypt to study and sketch the terrain with a view to producing a panoramic canvas to be exhibited in the rotunda in Vienna. A trip made by the Archduke Rudolf was probably the inspiration for the subject. Having passed through Munich and the Hague, Wauters's panorama was hung in an oriental-style rotunda in Brussels.

123–6. Four segments of Hendrik Willem Mesdag (1831–1915) and others, *Panorama of Scheveningen*, 1881, oil on canvas, 1,460 × 11,400 cm. Panorama Mesdag, The Hague.

Produced for the Société Anonyme Belge des Panoramas in 1881 by Mesdag, a famous marine artist, this canvas hung initially at the Hague; it was moved to Munich and then exhibited in Amsterdam. Although a great critical success, it made a loss and in 1885 the Société decided to get rid of it. Mesdag bought it back so that it could hang permanently in its town of origin. The canvas has none of the soulless hyperrealism of the art of the time, and it made the artist's name.

The theme – a beach near the Hague – was somewhat unusual at the time (Van Gogh was to paint this view on more than one occasion during his stay in the city, and Robert Altman shot a beautiful scene there for his film *Vincent and Theo*): it revealed a preference for the pictorial over the commercial, as could be seen in the publicity posters. To plot the terrain, Mesdag placed a glass cylinder, mounted on wooden legs and covered in transparent paper, at the top of a dune, so that he could sketch the outline from the interior of the box: this gave him a preliminary drawing that had the same features as the panorama he was preparing.

Once this drawing had been transported to the middle of the rotunda, the painter instructed his assistants as to how they should draw the buildings, ships and other features of the half-urban, half-marine l andscape. The principal advantage of this technique was that distances and propor-tions could be reproduced exactly. After making the sketches and doing the necessary research, it took the painter and his team four months to finish the enormous canvas, which means that they covered about fourteen square metres a day.

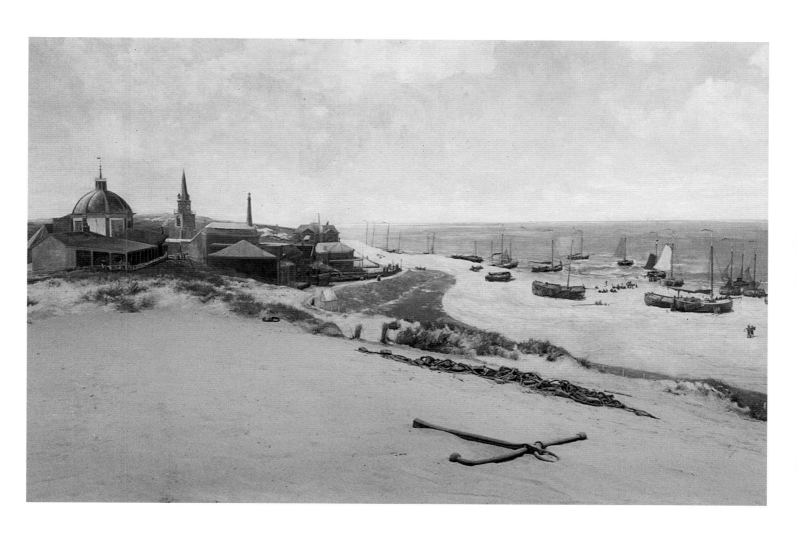

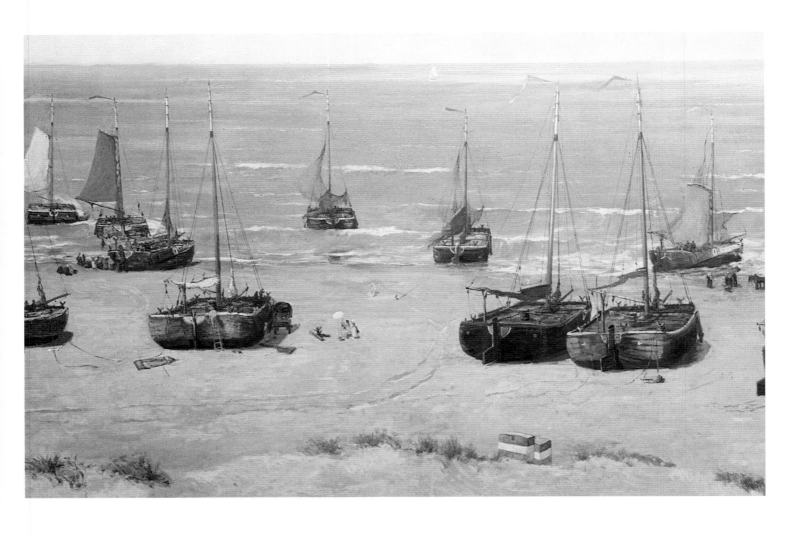

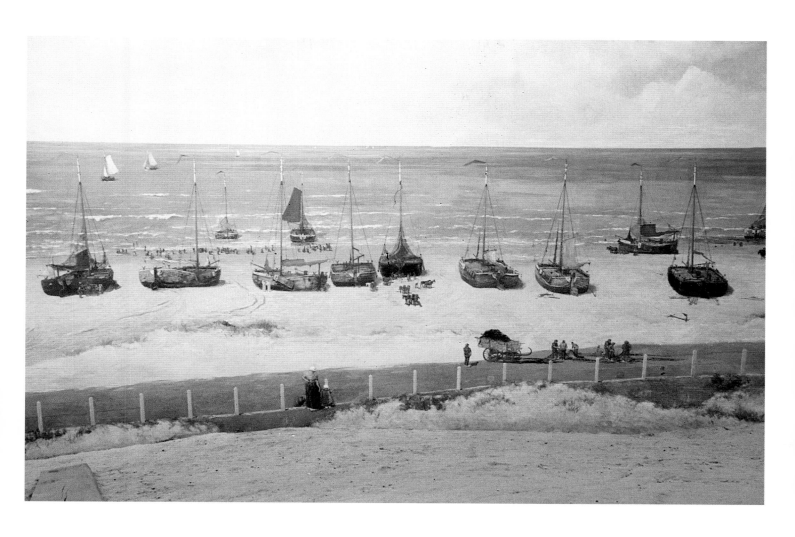

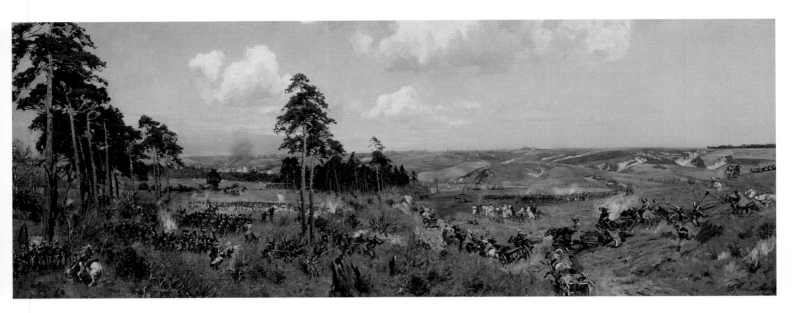

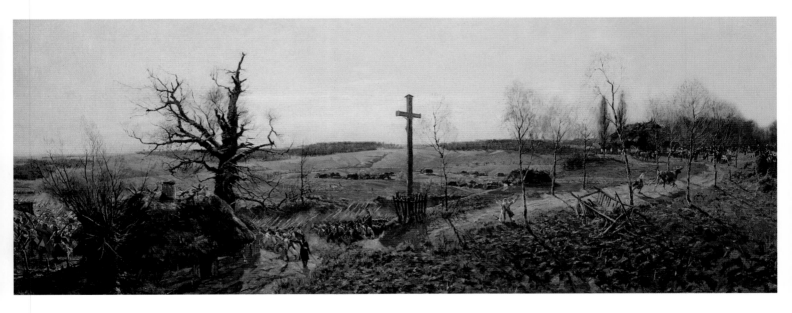

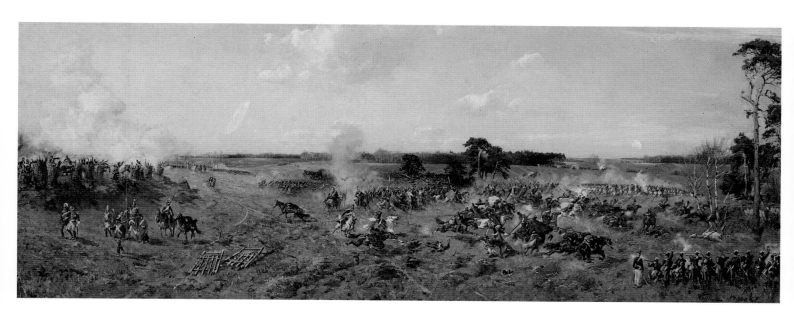

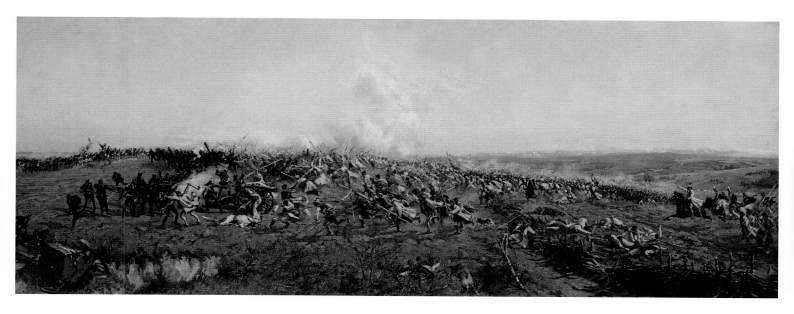

127–30. Wojciech Kossak (1857–1942) and Jan Styka (1858–1925), 1:10 study for *The Battle of Racławice*, c. 1893–4, oil on canvas, four segments, 115 × 295.5 cm; 116.5 × 304.5 cm; 117 × 296 cm; 117 × 295 cm. Muzeum Narodowe w Krakowie, Cracow.

The second partitioning of Poland by Russia and Prussia in 1793 inspired a nationalist uprising in March 1794 led by Kosciuszko. A symbolic moment in this insurrection was the victory of 2,000 peasants over General Tormasov's Russian troops outside Racławice on 4 April. Polish nationalists exploited this event to inspire patriotic feeling, and it was to commemorate the battle's centenary that Kossak and Stycka were commissioned to produce this panorama. In 1894, it opened at the National Exhibition in Lemberg, where it remained until 1944. To protect it during bombing raids, it was stored underground in rolls. A new rotunda was built, and the panorama has been on view to the public since 1985.

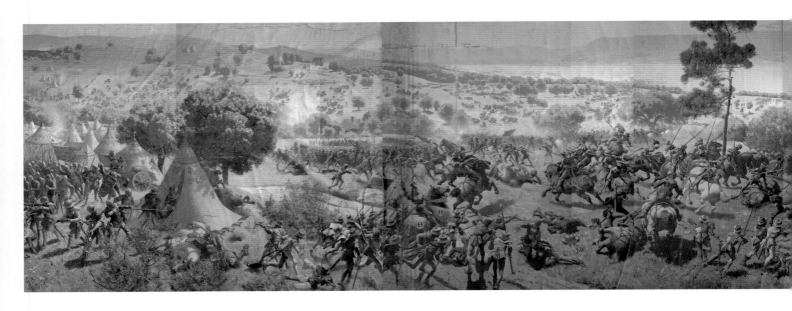

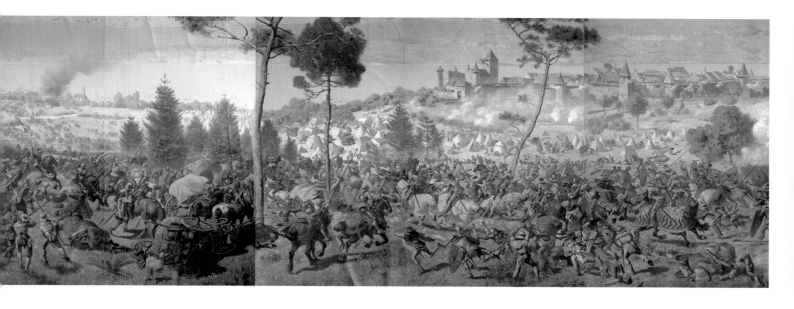

131. Detail of Louis Braun (1836–1916), *Panorama of the Battle of Morat, 22 June 1476*, 1880, oil on canvas, 1,100 × 9,300 cm. Foundation pour le Panorama de la Bataille de Morat, Morat.

The Battle of Morat was a victory for the combined Helvetian forces. The adventure cost the Burgundian army over 10,000 men, put a stop to their European ambitions, and marked the end of Swiss incursions into French-speaking territories. It was only in the second half of the nineteenth century that the battle's commemoration took on national importance, however. In 1894, when this panorama was put on view, the climate was ripe for a spectacle of the type created by Braun, a specialist in the medium. It remained on exhibit for three years before being moved to Geneva, where it remained until 1909. From 1923 on, it was stored in Morat in three roles and deteriorated badly. Essential restoration work is now being carried out. It is hoped that the panorama will go on view as part of the 2001 National Exhibition.

132. Michael Zeno Diemer (1867–1939)
and others, *Panorama of the Street Fighting at
Bazeilles in the Ardennes*, c. 1894–6. Location
unknown.

An artist specializing in Alpine scenes,
Diemer became famous when, in 1893, he
produced a diorama of glaciers for the

Chicago World's Fair. Following his first
panorama showing the Battle of Orleans,
he produced this one, which depicts the
storming of Bazeilles during the Battle of
Sedan, for a rotunda in Munich. The Franco-
Prussian War inspired many panoramic
representations from both sides.

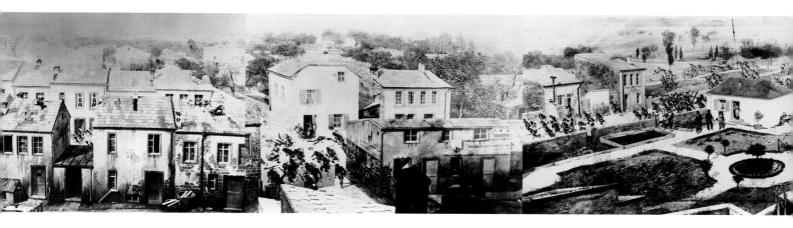

133–5. Giovanni Segantini (1858–1899), *Triptych of Nature: Life*, 1896–9, 190 × 322 cm; *Nature*, 1897–9, 235 × 403 cm; *Death*, 1898–9, 190 × 322 cm; oil on canvas. Segantini Museum, St Moritz, on deposit from Gottfried Keller Collection, Winterthur.

The ageing painter Segantini dreamed of an enormous panorama of the Engadine for the 1900 Great Exhibition in Paris and gave an increasing number of speeches in order to sell the project. The speech he gave to the inhabitants of the Engadine in Samaden on 14 October gives invaluable information on the size of the project and is worth quoting:

'The project that I bring before you, gentlemen of Engadine . . . is bold, but as clear as the light of the sun that shines on our mountains . . . a vast panorama that will represent the most admirable and noteworthy points of interest in our Engadine and that will form its artistic synthesis. This panorama will have nothing in common with those you have been able to see before now. I intend to put down on canvas the entire robust framework of these Alpine places, to their best advantage and in all their purity, giving the spectator the exemplary illusion of being on top of the mountains, among the green and solitary pastures surrounded by steep rocks which pierce the sky, and unending glaciers which glitter in the sun and brighten the wooded slopes with their perennially fresh waters, as well as our green valleys smiling in the light like emerald shells. The mastery of art, achieved after long study and based on a love of Nature, has the power to render light, air, distances and backgrounds, all the true spirit of the mountain with its solemn silence, its august and grave poetry, its profound and smiling peace, broken only by the amiable music of the Alps, the distant rustle of torrent or foliage, the lowing of beasts or the muddled bells of the flock grazing on the grassy slopes. Science will come to our aid in attaining the desired effects, and we will have electric ventilators to produce cool air; variable and calculated distribution of light and shade; hydraulic constructions; acoustic engines and all that will serve to render the visitor's illusion more lively and complete, as if truly he had found himself in our mountains.

The panorama, painted on canvas, will embrace a circumference of 220 metres with a height of 20 metres and an area of 400 square metres. One can easily comprehend how, with such an expanse of painting, one can represent all the best aspects and have

the greatest effects of distance, the most imposing masses, from the most distant of mountains to the massive neighbours of the Bernina or the Albula. All the principal villages of our valley will be found there . . . faithfully reproduced in all their picturesque beauty with their majestic grand hotels . . . all the prominent and notable features of an area extending more than twenty kilometres will present themselves to the spectator's eye . . .

The interior space will occupy an area of 3,850 square metres, and at its centre will be an Alpine promontory of 75 metres in circumference by 16 metres in height, with two pathways, one for ascending, the other for descending, arranged on a semi-circular plan, offering each spectator a view of half the panorama, which can be seen in its entirety from the upper platform. This promontory will form a true likeness of the

mountain with its rocks, pine trees, peaks, crevices, boulders covered in moss and lichen, little bridges, water falling from gorges, bushes of rhododendrons and fragrant herbs – in short, all one can see when one climbs up one of our beautiful mountains paths.

The space between the circle of the panorama and the route up to the promontory will occupy 3,397 square metres with a width of 23 metres, more than sufficient to conduct the eye to the desired illusion on the canvas and capable of containing little houses, stables, barns full of aromatic hay, grazing animals, diverse lighting effects and the most important botanical and zoological species of our region.'

136. Details of Franz Roubaud (1856–1928), *The Battle of Sebastopol*, 1905, oil on canvas, 1,400 × 11,500 cm. Sebastopol, Ukraine.

Inaugurated in 1905, this canvas marked the 50th anniversary of the year-long siege of Sebastopol in 1854–5; it shows the defeat of the allied forces by the Russian army. What we have here is a somewhat belated attempt at inspirational propaganda. Born in Odessa,

Roubaud spent most of his working life in Munich making drawings for his panoramas. For this one, he plotted the terrain and made sketches on the spot; he also met veterans and collected accounts of the battle. The rotunda that houses this canvas was damaged during air raids in 1942. However, 86 fragments were saved and used to reconstruct the whole, which was hung in a new rotunda in 1954.

137. Franz Roubaud, *Panorama of the Battle of Borodino*, 1912, oil on canvas, 1,500 × 11,500 cm. Muzei-Panorama 'Borodinskay Bitva', Moscow.

Although the Russian troops under Koutouzov's command were defeated and General Bagration was fatally wounded, the Battle of Borodino (7 September 1812) lives on in the Russian psyche as an heroic moment. On its centenary, Roubaud, whose *Battle of Sebastopol* had been such a great success (illus. 136), was commissioned to create a panorama. Due to its dilapidated condition, the rotunda had to close its doors in 1918, and the canvas was rolled up and stored somewhat carelessly in a warehouse. Declared beyond repair by a team of experts in 1939, it was restored in 1946 by the Museum of Military History and again in 1962. A new rotunda was built in Moscow to mark the battle's 150th anniversary.

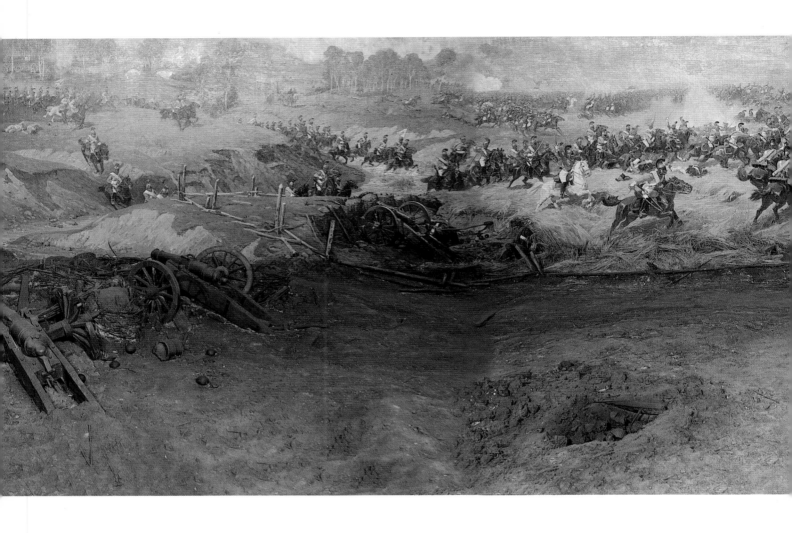

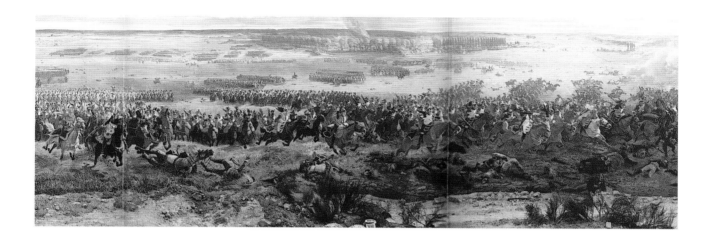

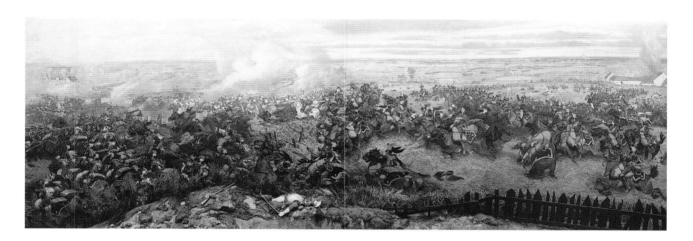

138. Details of Louis Dumoulin (1860–1924) and others, *The Battle of Waterloo*, 1912, oil on canvas, 1,200 × 11,000 cm. Intercommunale Bataille de Waterloo, Braine-l'Alleud/Eigenbrakel, Belgium.

This is the only canvas representing the Battle of Waterloo that is still in existence today. This event was probably one of the most widely exploited themes in the history of the panorama. Dumoulin's canvas hangs in its original rotunda, near the site of the famous battle and next to the artificial mound topped by a lion cast from the bronze of cannons taken from the French. With its array of bodies, horses, smoke and weaponry, Dumoulin's panorama departs from the normal didacticism of the genre, instead inviting viewers to immerse themselves in the battle and take an active, emotive role in the intentionally dramatic atmosphere reinforced by the objects placed on the fake terrain.

139–46. Alfred Bastien (1873–1955) and Paul Mathieu (1872–1932), *Panorama of the Congo*, 1913, eight fragments ('View of the Congo River [the Cauldron of Hell] and a Corner of the Matadi Market'; 'Matadi. – Corner of the Market and View of the Town'; 'Port and Station at Matadi'; 'Native Village'; 'M'Pozo Falls'; 'Bridges and Lianas and Tropical Forest'; 'Palaver'; 'Caravan Route'), originally 1,500 × 11,500 cm.

Koninklijk Museum voor Midden-Afrika, Tervuren.

Created for the National Exhibition of Ghent in 1913, this panorama was, per the wishes of the minister at the time, meant to give young Belgians 'a taste for the colonies'. It was restored in 1935 to be exhibited in the Belgian pavilion at the Brussels World's Fair in 1935. The canvas was then rolled up and so carelessly stored that only fragments

survive today. Bastien and Mathieu visited the Belgian Congo and brought back many sketches. Several different locations along the River Congo were compressed onto the panoramic canvas. The effect was similar to that typified of the 'moving panoramas' of the Mississippi River created during the 1850s.

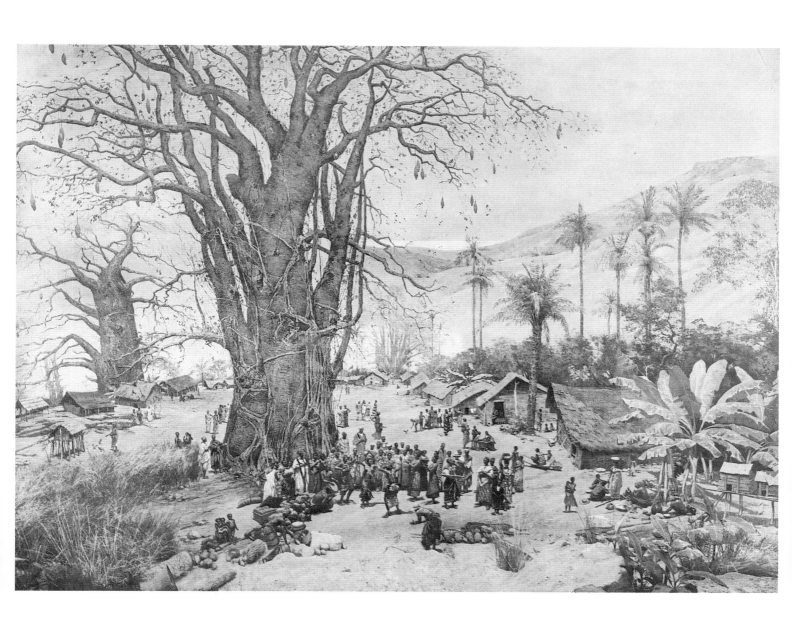

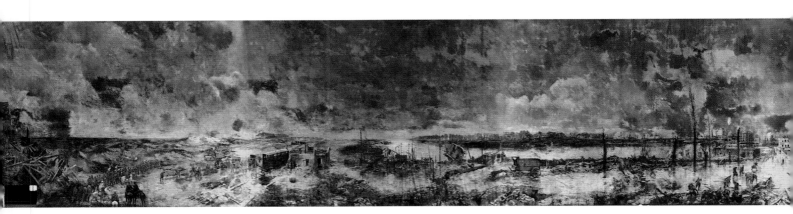

147. Alfred Bastien, *The Battle of the Yser*,
1920, 1,400 × 12,000 cm. Musée Royal de
l'Armée et d'Histoire Militaire, Brussels;
© IRPA-KIK, Brussels.

A member, along with some twenty fellow
painters, of the Section Docu-mentaire de
l'Armée belge en Campagne, Bastien was
commissioned by King Albert I to paint a
panorama depicting the Battle of Yser
(18–27 October 1914). This was a particularly
disastrous encounter, the first instance of the
German use of mustard gas. The focus of
the canvas is the devastated town of Ypres.
Plans are being discussed for an exhibition
space for this canvas.

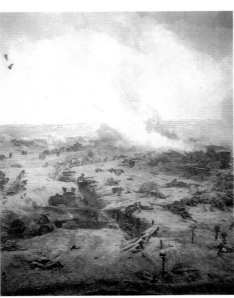
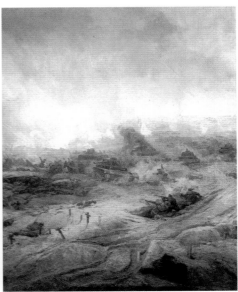

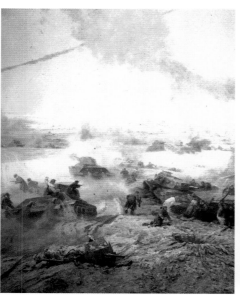
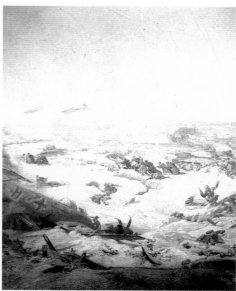

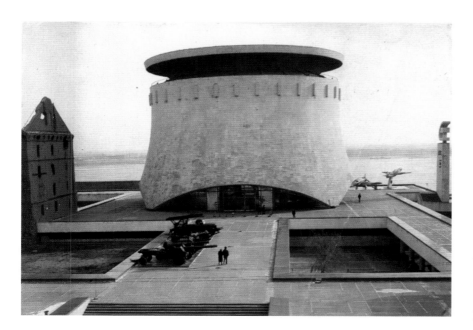

148–54. B. M. V. Grekov and collective, *The Defeat of the German-Fascist Forces at Stalingrad*, 1962, approx. 1,500 × 12,000 cm. Gosudarstvenniye muzei zascity Volgograda.

True to the tradition of the patriotic panorama, this canvas commemorates Stalingrad's valiant attempts to resist the German invasion during the Second World War. Several panoramas were produced depicting the same theme in the context of the Soviet propaganda programme, but this was the only one of its size and is the only one to have survived.

155. The building that houses the Grekov panorama.

156. Henk Guth, *The Panorama of Central Australia*, 1975, oil on canvas, 600 × 6,100 cm. 'Panorama Guth', Alice Springs, Australia.

A Dutch painter who emigrated to Australia in the 1960s, Guth was inspired by Mesdag's *Panorama of Scheveningen* (illus. 123–6) to create this local scene with its sweeping semi-arid landscape and elements of Aboriginal culture. The area between the spectators' platform and the panoramic canvas served as a gallery for the exhibition of Guth's other paintings.

157–9. Werner Tübke (*b.* 1929), *Panorama of the Peasant Uprising*, 1983–7, oil on canvas, 360-degree panorama, 140 × 12,300 cm. Panorama Museum, Bad Frankenhausen.

This panorama depicts an episode from the 1524–5 peasant uprising against the Prince of Hesse and Duke of Saxony. On 15 May 1525, a rainbow appeared that was interpreted by the rebellion's leader as a sign of victory. This led to the massacre of six or seven thousand soldiers. Somewhat surprisingly, the painting brings together a variety of sixteenth-century influences to create a whole which does not respect the strict realism required of a panorama, being more characteristic of the esoteric vision of Hieronymous Bosch and of Mannerism in general. Having taken fifteen years and a substantial investment to complete, Tübke's panorama was one of the most prestigious productions to emanate from the former East Germany in its last hours.

160–61. Detail of Roger Hallett, *Panorama of the City of Bath*, *c*. 1984–7, oil on canvas, 700 × 7,000 cm. Formerly on display at the South Bank and Thames Barrier, London; collection of the artist.

A GENEALOGY OF THE PANORAMA

At the turn of the century, the panorama became an object of nostalgia and pleasure, something people felt fondness for because it was becoming obsolete. Here is a relevant quote from Max Brod's extraordinary book *On the Beauty of Detestable Images*, published in 1913:

> Poor panorama, the joy of our grandparents, relic of the Biedermeier era: today it is the cinema that makes our nerves tingle. We want to be dazzled by the dancing eyes that watch us from a chalky screen and not be staring, silent and calm, into a black box through a lorgnette.

Having condemned indoor views and decided that landscapes were the only appropriate images, Brod concluded:

> The only people who still go [to see panoramas] are noisy children, poor couples who, the honeymoon over, want to wallow in memories, retired officers come to seek battlefields that correspond to the colonial wars of their fantasies. You can also take a lady to a panorama, and if you place yourself so that you are the first to see the images, you can describe what she is about to see in an agreeable and informed way.

In his 'Journal of a Voyage to Friedland and Reichenberg', Kafka wrote of the same *Kaiserpanorama* described by Brod: 'The images are more lifelike than in the cinema because, as in reality, they allow the gaze to linger. In the cinema the objects shown move awkwardly; it strikes me that the immobility of the gaze is more important.'

Although the panorama has been out of fashion for a long time now, there are still a few places where a nostalgia for the past and a yearning for outmoded pleasures can be satisfied. There are no fewer than 28 panoramas on view around the world. Twenty-three of these are in rotundas specially built (some at the time, some not) to accommodate them, one is in a casino (in Salzburg), and four are in museums. To these we should add three others that are not available to the public: the *Battle of Morat, 22 June 1476* painted by Louis Braun in 1880 (undergoing restoration), the *Panorama of the Nile and Cairo* painted by Edouard Wauters in 1882, and the *Battle of the Meuse* painted by Alfred Bastien in 1937. Finally, we should not forget the scattered fragments of *History of the Century* painted by Alfred Stevens and Henri Gervex in 1889, some of which are still in Paris and Brussels, and those segments (six in all) of the *Panorama of the Congo* painted in 1913 by Alfred Bastien.

The original panoramas can be divided into two groups.

THE FIRST GENERATION

The Panorama of Thun, painted by Marquard Fidelis Wocher in 1814, measures 7.5 × 38 m. Schadaupark, Thun.

The Palace and Gardens of Versailles, painted by John Vanderlyn in 1819, measures 3.6 × 50 m. Exhibited in the Museum of Modern Art, New York.

The Panorama of Rome, painted by Ludovico Carucciolo in 1824, measures 1.67 × 13.4 m. Restored in 1982, it hangs in the Victoria and Albert Museum, London.

The Panorama of Salzburg, painted by Johann Michael Sattler in 1825–9, measures
5.5 × 26.2 m. Salzburg Casino.

The Battle of Trafalgar, painted by W. L. Wyllie in 1828–9, measures 3.6 × 13.4 m. This
semi-circular canvas cannot be classed as a panorama because of its small size, which
severely diminishes its illusory effect. Exhibited in Portsmouth Royal Navy Museum.

THE SECOND GENERATION

The Panorama of the Battle of Morat, 22 June 1476, painted by Louis Braun in 1880,
measures 10.5 × 93 m. Undergoing restoration, it is due to be exhibited in a new
rotunda for Expo 2001 in Morat, Switzerland.

The Bourbaki Panorama, painted by Edouard Castres in 1880, measures 7 × 112 m.
Undergoing restoration in Lucerne.

The Panorama of Scheveningen, painted by Hendrik Willem Mesdag in 1881, measures
14 × 120 m. The Hague (Netherlands).

The Panorama of the Nile and of Cairo, painted by Edouard Wauters in 1882, measures
13.4 × 111.7 m. Six fragments are stored at the Eeuwfeest, Brussels.

The Panorama of Jerusalem with the Crucifixion of Christ, painted by Paul Philippoteaux in
1882, measures 14 × 110 m. Hangs in its original rotunda at Ste-Anne de Beaupré,
Canada, a Christian pilgrimage centre.

The Battle of Gettysburg, painted by Paul Philippoteaux in 1884, measures 15.5 × 122 m.
Exhibited in Boston in 1884–92, it now hangs in the Gettysburg National Military
Park.

The Battle of Atlanta, painted by William Wehner in 1885–6, measures 13 × 106 m. Now
referred to as the *Cyclorama of Atlanta*.

The History of the Century, painted by Alfred Stevens and Henri Gervex in 1889. After its
successful run, it was cut up into as many pieces as possible and sold to collectors.
Many of the fragments are still extant, the majority in the Musées Royaux d'Art et
d'Histoire, Brussels and the Musée Carnavalet and Musée du Petit-Palais, Paris.

The Battle of Racławice, painted by Jan Styka in 1892–4, measures 15 × 115 m. This
panorama was restored in 1986 and exhibited at the National Museum, Wroclav.

The Crucifixion of Christ, based on photographs of the original taken in 1893, repainted by
Joseph Fastel and Hans Wulz in 1962 on a surface of 10 × 100 m. Housed in a rotunda
rebuilt in 1962 in Einsiedeln, Switzerland.

The Liberation of the Hungarians at Pleven, painted by Arpád Feszty in 1891–4, measures
15 × 120 m. Hung in Szeged, Hungary. Major restoration work was undertaken in 1976.

The Battle of Bergisel, painted by Michael Zeno Diemer in 1894–6. Four metric tons of
paint were needed to cover the 10 × 100-m canvas. Having been shown at the Great
Exhibition of 1906 in London, and then unsuccessfully in Vienna, it was hung in
Innsbruck as a tourist attraction.

The Battle of the Hussites in Lipany, painted by Ludek Marold and Václav Jansa in 1897.
Hangs in Prague in a rotunda in the Julius Fucik Cultural and Recreational Park.

The Panorama of Jerusalem with the Crucifixion of Christ, modelled on Bruno Piglhein's
composition, painted by Gerhardt Fugel in 1903, measures 12 × 95 m. Hangs in its
original rotunda in Altötting in Bavaria.

The Battle of Sebastopol, painted by Franz Roubaud in 1905, measures 14 × 115 m.
Inaugurated in 1905, it marked the 50th anniversary of the 1854–5 siege.

The Battle of Waterloo, painted by Louis Dumoulin in 1912, measures 12 × 110 m. The
only canvas from a huge number on the same theme to have survived, it is exhibited in
its original rotunda at Eigenbrakel in Belgium, on the site of the famous battle.

The Battle of Borodino, painted by Franz Roubaud in 1912, measures 15 × 115 m.
Commissioned to commemorate the centenary of the famous battle. Badly damaged

over the years, the panorama was restored to mark the battle's 150th anniversary; a few alterations were made, mainly to the sky. It hangs in Moscow.

Panorama of the Congo, painted by Alfred Bastien and Paul Mathieu in 1913, measures 13.5 × 150 m. Only eight fragments remain, in the Koninklijk Museum von Midden-Afrika, Tervvuren.

The Battle of the Yser, painted by Alfred Bastien in 1920, measures 14 × 120 m. The canvas is exhibited flat in the Musée de l'Armée et d'Histoire Militaire, Brussels.

Battle of the Meuse, painted by Alfred Bastien in 1937, measures 8.5 × 72 m. The last of the second-generation works, created long after the genre had run out of steam, it is stored as two rolls in the Musée de l'Armée et d'Histoire Militaire, Brussels.

The 'new generation' of panoramas includes:

The Defeat of the German-Fascist Forces at Stalingrad, painted by B. M. V. Grekov in 1962, measures 14 × 120 m. Gosudarstvenniye muzei zascity Volgograda.

The Battle of Al-Qadissiyah, a collective painting created in 1968, measures 15 × 110 m. Hung in Al-Mada' some 40 miles from Baghdad, it depicts a battle fought by the Arabs against the Persians in AD 637, in which elephants (the principal figures in the panorama) caused panic when their eyes were put out by the enemy. This canvas was an important propaganda tool before and during the Iran–Iraq conflict, used to inspire young recruits.

The Panorama of Central Australia, painted by Henk Guth in 1975, measures 6 × 61 m. Alice Springs.

Panorama of the Arab–Israeli War. Commissioned by the Egyptian army, it opened in October 1988 in an extremely large rotunda in Heliopolis, near Cairo, where it still hangs.

Panorama of the City of Bath, painted by Roger Hallett. Based on a series of photographs taken from a hot-air balloon on 14 October 1983, this panorama took four years to complete and has been on exhibit in Bath since 1988.

Panorama of the Peasant Uprising, undertaken in the 1980s by Werner Tübke, measures 14 × 123 m. Inaugurated in 1989.

To these must be added the *Panorama of the Battle of Tetschou, Pyongyang* in North Korea, and the *Panorama of the Taking of Liao Sen* in Jinzhou, in the province of Liao Nin, China, about which we have very little information.

It will not have gone unnoticed that none of the complete panoramas listed here hang in France, even though Paris, more so even than London, was, in the nineteenth century, at the heart of the phenomenon. On the other hand, two important architectural witnesses still exist in Paris: the rotundas of the present-day Marigny and Rond-Point theatres, the first designed by Charles Garnier and the second by Gabriel Davioud.

SELECT BIBLIOGRAPHY

Stephan Oettermann, in his enormous book *Das Panorama: Die Geschichte eines Massenmediums* (Frankfurt, 1980), presents a very thorough and well-documented history of the panorama. To this day, it is still the best reference book available, apart from odd inaccuracies as regards the panorama in France, which I have rectified.

I have not included a discussion of two products often linked to, if not integrated into, panoramas: wallpaper and photography. In fact, neither the one (because the spectator's space is not predetermined and because there is no definitive way to effect the continuity of the representation) nor the other (because it is so much smaller and because it did not have the right configuration) struck me as belonging *completely* to the phenomenon of the panorama as I see it. However, there are books devoted to these subjects which I would recommend to the reader to complement this study: Odile Nouvel-Kammerer's catalogue *Papiers peints panoramiques* (Paris, 1990), produced to accompany an exhibition at the Musée des Arts Décoratifs in Paris; and the catalogue of the Bonnemaison collection published for the exhibition *Panoramas, photographies 1850–1950*, organized within the framework of the Arles XXe Rencontres Internationales de la Photographie (1989).

ABOUT PANORAMAS AND DIORAMAS

Alési, Hugo d', *Exposé d'un projet de panorama mobile, dit Maréorama* (Paris, 1897)

Altick, Richard, *The Shows of London* (Cambridge, MA, 1978)

Avery, Kevin J., *John Vanderlyn's Panoramic View of the Palace and Gardens of Versailles* (New York, 1988)

Balzac, Honoré de, *Le Père Goriot*, vol. III (Paris), pp. 91–3 (and correction p. 1247)

Bapst, Germain, *Essai sur l'histoire des panoramas et des dioramas: Extrait des rapports du jury international de l'Exposition universelle de 1889*, with unpublished illustrations by Edouard Detaille (Paris, 1891)

Barthes, Roland, 'La Cathédrale des Romans', *Bulletin de la guilde du livre* (March 1957)

Benjamin, Walter, 'Panorama Impérial', in *Enfance berlinoise*, trans. Jean Lacoste (Paris, 1978), pp. 35–8

——, *Paris, capitale du XIXe siècle: Le Livre des passages*, trans. Jean Lacoste (Paris, 1989)

Bonnemaison (collection), *Panoramas, photographies 1850–1950* (Arles, 1989)

Bordini, Silvia, *Storia del Panorama: La visione totale nella pittura del XIX secolo* (Rome, 1984)

Born, Wolfgang, 'The Panoramic Landscape as an American Form', *Art in America*, XXXVI/1 (1948), pp. 3–10

Bourquin, Marcus, *Franz Niklaus König: Leben und Werk* (Bern, 1963)

Bourseul, C., *Biographie du Colonel Langlois* (Paris, 1874)

Breysig, Johann Adam, *Skizzen, Gedanken, Entwürfe, Umrisse die bildenden Künste betreffend* (Magdeburg, 1798–1801)

——, *Neue Skizzen* (Danzig, 1806)

Brod, Max, 'Panorama', *Von der Schönheit hässlicher Bilder* (Leipzig, 1913), pp. 59–67

Buddemeier, Heinz, *Panorama, Diorama, Photographie: Entstehung und Wirkung neuer Medien im 19. Jahrhundert* (Munich, 1970)

Caillois, Roger, 'Paris mythe moderne', *Nouvelle revue française* (1 May 1937)

Castellani, Charles, *Confidences d'un panoramiste, aventures et souvenirs* (Paris, 1895)

Chateaubriand, François René de, Introduction to 'L'Itinéraire de Paris à Jerusalem', in *Oeuvres romanesques et voyages*, Bibliothèque de la Pléiade, vol. II (Paris)

Chevreul, Michel-Eugène, 'Explication déduite de l'expérience de plusieurs phénomènes de vision concernant la perspective', in *Mémoires de l'Académie des Sciences*, XXX (Paris, 1859), pp. 20–24

——, 'Note sur le panorama', *Comptes rendus hebdomadaires des séances de l'Académie des Sciences*, LXI (Paris, 1865), pp. 670–72.

Christian, Joseph-Gérard, 'Brevet d'invention et de perfectionnement de dix ans, pour les panoramas, au Sieur Fulton, des Etats-Unis', in *Description des machines et procédés spécifiés dans les brevets d'invention, de perfectionnement et d'importation*, vol. III (1799), p. 44

——, 'Brevet de perfectionnement de dix ans, du 3 juin 1816, pour l'art de peindre les panoramas, au sieur Prévost à Paris', *Description des machines et procédés spécifiés dans les brevets d'invention, de perfectionnement et d'importation*, vols XIII—XIV (1816), p. 1

Claretie, Jules, *La Vie à Paris* (Paris, 1881)

Comment, Bernard, 'Note intorno al frammento e al panorama', in *Frammenti, interfacce, intervalli: Paradigmi della frammentazione nell'arte svizzera* (Genoa, 1992)

Corner, G. R., 'The Panorama: With Memoirs of its Inventor Robert Barker and its Son', *Art Journal*, n.s. 3 (1857), pp. 46–7, also pp. 131, 162, 230

Daguerre, Louis-Jacques-Mandé, *Historique et description des procédés du daguerréotype et du diorama* (Paris, 1839)

Deferrière, Alex, 'Lettre aux rédacteurs', *La Décade philosophique, politique et littéraire*, 27 (30 prairial VIII)

Delacroix, Eugène, *Journal* ([c. 14 April 1858], republ. Paris, 1981), pp. 715–16

Delécluze, E. J., 'Panorama' and 'Diorama', *Précis d'un traité de peinture* (Paris,1828)

Dickens, Charles, 'The American Panorama', *The Examiner*, 16 (1848) (repr. in *Works*, vol. XXXV [London, 1908])

Dickinson, H. W., *Robert Fulton, Engineer and Artist: His Life and Works* (London, 1913)

Diehl, Günther, *Panoramabilder und Panoramabauten* (Karlsruhe, 1977)

Dolistowska, Matgorzata, and Jósef Piatek, *Panorama Racławicka* (Wroclaw, 1988)

Donnet, Orgiazzi and Kaufmann, *Architectonographie des théâtres* (Paris, 1837–40)

Dufourny, M., 'Rapport fait à l'Institut national des Sciences et des Arts, sur l'origine, les effets et les progrès du panorama' (28 fructidor VIII), in *Mémoires de la Classe des beaux-arts de l'Institut*, V, p. 55

Dupuis, A., 'Le Panorama-Marigny', *La Semaine des constructeurs*, VIII/24 (1883), pp. 282–4

Eberhardt, J. A., *Handbuch der Aesthetik* (Halle, 1807), pp. 171–9

El Nouty, Hassan, *Théâtre et pré-cinéma: Essai sur la problématique du spectacle au XIXe siècle* (Paris, 1978), pp. 49–64

Frantz, G., 'Les Panoramas', *Gazette des architectes et du bâtiment* (1882)

Fruitema, Evelyn J., and Paul A. Zoetmulder, *The Panorama Phenomenon* (The Hague, 1981)

Fulton, Robert, Import license for a panorama to France, 7 Floréal VII (26 April 1799); Report of the Institut National des Sciences et des Arts (15 September 1800)

Ganz, Paul Leonhard, *Das Rundbild der Stadt Thun, das älteste erhaltene Panorama der Welt von Marquard Wocher (1760–1830)* (Basel, 1975)

——, 'Das Zeitalter der Bildpanoramen', *Werk*, 12 (1963), pp. 478–82

Goethe, Johann Wolfgang von, *Voyage en Italie*, trans. J. Naujac (Paris, 1961)

Grundmann, G., 'C. D. Friedrich: Topographische Treue und künstlerische Freiheit, dargestellt an drei Motiven des Riesengebirgs Panoramas von Bad Warmbrunn', *Jahrbuch der Hamburger Kunstsammlungen*, 19 (1974), pp. 89–105

Helft, B. d', and M. Verliefden, 'Les Rotondes de l'illusion', *Revue des monuments historiques*, 4 (1978)

Hément, Félix, 'Le Panorama de la Cie Transatlantique de l'Exposition universelle de 1889', *La Nature* (1889), pp. 33–5

Hillairet, Jacques, *Dictionnaire historique des rues de Paris*, 2 vols (Paris, 1963)

Hittorf, Johann Ignaz, 'Description de la rotonde des panoramas élevée dans les Champs-Elysées: Précédé d'un aperçu historique sur l'origine des panoramas et les principales constructions auxquelles ils ont donné lieu', *Revue générale de l'architecture et des travaux publics*, II (1841)

Hittorf, un architecte du XIXe siècle, Musée Carnavalet (Paris, 1986), pp. 163–9

Horat, Heinz, and André Meyer, *Les Bourbakis en Suisse et le grand panorama de Lucerne* (Lausanne, 1983)

Humboldt, Alexander von, *Cosmos, essai d'une description physique du monde*, trans. C. Galusky, vol. II (Paris, 1855), pp. 105–7

Hyde, Ralph, *Panoramania: The Art and Entertainment of 'All-embracing' View* (London, 1988)

Kafka, Franz, 'Journal d'un voyage à Friedland et Reichenberg', in *Journal*, trans. Marthe Robert (Paris, 1954)

Kämpfen-Klapproth, Brigit, *Das Bourbaki-Panorama von Edouard Castres*, Beiträge zur Luzerner Stadtgeschichte, vol. V (Lucerne, 1980)

Kleist, Heinrich von, 'Lettres à la fiancée' [16 August 1800], in *Correspondance*

Kober, Karl Max, *Werner Tübke: Monumentalbild Frankenhausen* (Dresden, 1989)

Labédollière, Emile de, *Le nouveau Paris* (Paris, 1860), pp. 29–30

Langlois, Charles, *La Photographie, la peinture, la guerre: Correspondance inédite de Crimée*, eds F. Robichon and A. Rouillé (Nice, 1992)

——, Various souvenir programmes from panoramas, including *Bataille de la Moskowa* (1835); *Relation du combat et de la bataille d'Eylau* (1844); *Explication du panorama et relation de la bataille des pyramides* (1853); *Explication du panorama représentant la bataille et la prise de Sébastopol* (1861); *Explication du panorama et relation de la bataille de Solférino* (1867)

Mareschal, G., 'Les Panoramas de l'exposition: I. Le Stéréorama: Le Transsibérien', *La Nature* (19 May 1890), pp. 399–403; 'II. Le Maréorama' (30 June 1900), pp. 67–70; 'III. Le Cinéorama Ballon' (21 July 1900), pp. 119–22

Mariette, Edouard, 'Le nouveau panorama des Champs-Elysées à Paris, par M. Charles Garnier, architecte, membre de l'Institut', *Revue de l'architecture et des travaux publics*, 4th ser., XI (1884), pp. 17–20

McDermott, J. F., *The Lost Panoramas of the Mississippi* (Chicago, 1958)

Mercier, Louis-Sébastien, *Tableau de Paris* (Amsterdam, 1788–92)

Merson, O., 'Panorama national', *Le Monde illustré* (November 1882), pp. 289–92

Meyer, F. J. C., *Briefe aus der Hauptstadt und dem Inneren Frankreichs* (Tübingen, 1802)

Miel, E. F., *Essai sur le Salon de 1817* (Paris, 1817)

Millin, Aubin-Louis, *Dictionnaire des beaux-arts* (Paris, 1806), pp. 38–41

Mitchell, R., *Plans and Views in Perspective with Descriptions of Buildings Erected in England and Scotland* (London, 1801)

Nanssouty, Max de, 'Le Panorama du pétrole', *La Nature* (12 October 1889), p. 305

Nerval, Gérard de, 'Diorama: Odéon' (published in *L'Artiste*, 15 September 1844), in *Oeuvres complètes*, Bibliothèque de la Pléiade, vol. I (Paris, 1989), pp. 840–82 (also p. 792, an article published in *L'Artiste*, 3 May 1844)

Nouvel-Kammerer, Odile, ed., *Papiers peints panoramiques*, Musée des Arts Décoratifs (Paris, 1990)

Oettermann, Stephan, *Das Panorama: Die Geschichte eines Massenmediums* (Frankfurt am Main, 1980)

Old, Humphrey (pseud. George Mogridge), *Walks in London* (London, 1843)

Périer, C., 'Le Panorama français', *La Semaine des constructeurs*, 34 (18 February 1882)

Périer, Manuel, *Brevet pour un nouveau panorama et diorama* (24 March 1882)

Philippoteaux, Félix-Emmanuel-Henri, *Panorama de la défense de Paris contre les armées allemandes, peint par F. Philippoteaux: Explication précédée d'une notice historique avec carte du département de la Seine* (Paris 1872)

Polieri, J., 'L'image à 360° et l'espace scénique', *Le Lieu théâtral dans la société moderne* (Paris, 1963)

Pragnell, Hubert J., *The London Panoramas of Robert Barker and Thomas Girtin circa 1800* (London, 1968)

Prévost, Jean, *Notice historique sur Montigny-le-Gannelon* (Châteaudiun, 1852)

Pujol, A., 'Panorama français, rue Saint-Honoré, 251, à Paris, par M. Charles Garnier', *Revue de l'architecture et des travaux publics*, 4th ser., IX (1882)

Quatremère de Quincy, 'Panorama', *Dictionnaire historique de l'architecture* (Paris, 1832),
———, *Essai sur la nature, le but et les moyens de l'imitation dans les beaux-arts* (Paris, 1823, republ. Brussels, 1980)

Quinsac, Annie-Paule, *Segantini, catalogo generale*, 2 vols (Milan, 1982)

Recht, Roland, *La Lettre de Humboldt: Du jardin paysager au daguerréotype* (Paris, 1989)

Robert, Hubert, 'Lettre sur le panorama, à Fulton, datée du 14 fructidor an VII', *Le Moniteur universel* (22 fructidor an VII [September 1799])

Robichon, François, 'Les Métamorphoses architecturales', *Cahiers Renaud-Barrault* (1981)
———, 'Le Panorama, spectacle de l'histoire', *Le Mouvement social*, 131 (1985), pp. 65–86
———, 'Les Panoramas de Champigny et Rezonville par Edouard Detaille et Alphonse Deneuville', *Bulletin de la société de l'histoire de l'art français* (1979), pp. 259–80

Ruhland, Elisabeth, *Panorama und Diorama im 19. Jahrhundert* (Munich, 1974)

Ruskin, John, *Praeterita* (Oxford, 1989)

Solar, Gustav, *Das Panorama und seine Vorentwicklung bis zu Hans Konrad Escher von der Linth* (Zurich 1979)

Stanton, T., A. Stevens and H. Gervex, 'The Paris Panorama of the Nineteenth Century', *The Century*, 39 (1889–90), pp. 256–69

Sternberger, Dolf, *Panorama oder Ansichten vom 19. Jahrhundert* (Hamburg, 1938, republ. 1974)

Texier, Edmond, *Tableau de Paris*, vols I and II (Paris, [c. 1852])

Thomson, Patrice, 'Essai d'analyse des conditions du spectacle dans le panorama et le diorama', *Romantisme*, 38 (1982), pp. 47–64

Tissandier, Gaston, 'Le Globe terrestre au millionième', *La Nature* (15 June 1889), pp. 39–42

Toulet, Emmanuelle, 'La Caméra à l'Exposition universelle de 1900', *Revue d'histoire moderne et contemporaine*, 33 (1986), pp. 179–209

Valenciennes, Pierre-Henri, *Eléments de perspective pratique à l'usage des artistes* (Paris, 1800, republ. Geneva, 1973), pp. 339–43

Vibert, Paul, *Les Panoramas géographiques de Paris: Souvenir de l'Exposition universelle de 1889* (Paris, 1890)

COLLECTIONS, ANONYMOUS PUBLICATIONS AND REVIEWS

Annales des arts, VIII (1804), p. 203

L'Architecture aujourd'hui, 199 (1978) (article by Christian Dupavillon, 'Les Lieux du spectacle')

L'Artiste, V (1833), pp. 45, 184, 207; VII (1834), p. 228; X (1835), p. 111

Le Cabinet de lecture (24 January 1831)

Chamber's Journal of Popular Literature, 'Panoramas' (London, 1868), pp. 33–5

Chronique des arts et de la curiosité, 'Panorama de Jeanne d'Arc' (Paris, 1889), p. 156

A Collection of Descriptions of Views Exhibited at the Panorama, Leicester Square, and

Painted by H. A. Barker, Robert Burford, John Burford and H. C. Selous, London
1798–1856, British Museum Library, cote [8° 10349 t. 15; *Panorama Strand*, cote [8°
10349 t. 15]; also cf. British Museum catalogue, CXLII, pp. 1469–70

Le Combat naval: Grand spectacle réaliste, 2 vols (Paris, 1899)

La Construction moderne (Week of 20 October 1888), pp. 13–15, 18 (article signed L. et S.,
'L'Exposition des beaux-arts à Munich'); (Week of 2 February 1889), p. 197 (article by
B. Archambault, 'Exposition universelle: Chronique des travaux: Panorama le Tout-
Paris'); (Week of 25 May 1889), p. 395 ('A la veille de la grande inauguration')

Du (Zurich, July 1982)

L'Echo de Paris (28 November 1881)

L'Exposition de Paris 1900, I. P. Combes, 'Le Tour du monde à l'Exposition de 1900',
pp. 147–9, 156–8; II. G. Moynet, 'Les Coulisses d'un panorama', pp. 313–14

Guide bleu du Figaro et du Petit Journal: Exposition de 1889 (Paris, 1889)

*Histoire des théâtres de Paris – Les Jeux gymniques (1810–21) – Le Panorama dramatique
(1821–23)*, by Louis-Henry Lecomte (Paris, 1908, republ. 1973)

L'Illustration, journal universel (12 October 1844)

L'Illustration, 'Le Géorama des Champs-Elysées' (2 May 1846), p. 133ff.

Journal des artistes, III (1829), p. 121; IX (1831), pp. 82–4, 412; XIII (1833), pp. 184, 208, 361;
XV (1834); XVIII (1835)

Journal des Luxus und der Moden, XIV (1799), pp. 51, 647 ('Panorama oder Allansicht von
London'); XV (1800), pp. 282–93 ('Die Panoramen: Allgemeine Betrachtung darüber
und Nachricht von ihrem Ursprunge und ihrer Verplanzung nach Deutschland'); pp.
408ff. ('Fortgesetze Nachrichten über die Panoramen in Paris und Berlin'); pp. 642–9;
(1801), p. 143; XIX (1803), pp. 494–7 ('Panoramen: Des Bürgers Pierre pittoreskes und
mechanisches Theater in Paris')

Journal London und Paris, I (1798), pp. 314–24; III (1799), pp. 306–13; IV (1799), pp. 3–5; VII
(1801), pp. 13, 103–13; IX (1802), pp. 17ff.; XII (1803), pp. 3–8; XIV (1804), pp. 50–53,
97–104, 203–6; XVI (1805), pp. 13–17; XVII (1806), pp. 84ff.; XVIII (1806), pp. 16–19;
XIX (1807), pp. 331–3; XXI (1808), p. 139

Kunstblatt, Tübingen/Stuttgart, 'Das Panorama von Athen zu Paris' (25 October 1821),
pp. 341–3; 'Das Panorama von Rio de Janeiro' (1824), p. 306; 'Das Panorama von
Constantinopel' (1825), p. 257

Le Livre des Expositions universelles (Paris, 1983)

Mode-journal (September 1800), p. 477

Moniteur des architectes, 'Panorama de Genève' (Paris, 1883), p. 138, pl. 62

Le Moniteur universel, 352 (22 fructifor an VII [1799])

Nouvelles annales de la construction, 3rd ser., VII (May 1882), p. 65–6 (technical note on 'Le
Panorama de la place d'Austerlitz par M. Revel, architecte')

*Panorama d'Alger, peint par M. Charles Langlois, chef de bataillon au Corps royal d'Etat-
Major, officier de la Légion d'honneur, auteur du panorama de Navarin* (Paris, 1833)

Le Panorama de Sedan: 1880–85, exh. cat. (Sedan, 1988)

Paris Exposition 1900: Guide de l'Exposition (Paris, 1900), p. 267

Penny Magazine, 'On Cosmoramas, Dioramas and Panoramas' (1842), pp. 363–4

The Raclawice Panorama (Wroclaw, 1988)

Revue générale de l'architecture, II (1841), p. 2227

Revue illustrée de l'Exposition, 10 (February 1899), p. 177

Revue suisse d'art et d'archéologie, 42 (1985)

Swissair gazette, 9 (Zürich, 1986)

L'Univers illustré (1880), p. 430; 1436 (30 September 1882), p. 619 (article signed G. P., 'Le
Panorama de Lourdes')

Le Voltaire (3 January 1881)

OTHER REFERENCES

Alberti, Leon Battista, *De la peinture/De Pictura*, trans. Jean-Louis Schefer (Paris, 1992)

Arasse, Daniel, *Le Détail: Pour une histoire rapprochée de la peinture* (Paris, 1992)

Barthes, Roland, *Michelet* (Paris, 1954)

——, 'La Cathédrale des Romans', *Bulletin de la guilde du livre* (March 1957)

——, *La Tour Eiffel* (Paris, 1964)

Baudelaire, Charles, 'Salon de 1846', in *Oeuvres complètes*, Bibliothèque de la Pléiade, vol. II (Paris)

Bentham, Jeremy, *Le Panoptique* (Paris, 1977)

Carus, Carl Gustav, *Neuf lettres sur la peinture de paysage* (Paris, 1983)

Debord, Guy, *La Société du spectacle* (Paris, 1971)

Diderot, Denis, *Salons de 1759, 1761 et 1763* and *Salon de 1765* (Paris, 1984)

Didi-Huberman, Georges, *Invention de l'hystérie* (Paris, 1982)

Foucault, Michel, 'Le Panoptisme', *Surveiller et punir* (Paris, 1975)

Gilpin, William, *Three Essays on the Beautiful Picturesque* (1792)

Gordon, Robert, and Andrew Forge, *Monet*, trans. H. Ternois (Paris, 1984)

Grimoin-Sanson, Raoul, *Le Film de ma vie* (Paris, 1926)

Leiris, Michel, *L'Afrique fantôme* (Paris, 1934)

Lessing, Gotthold Ephraim, *Le Laocoon*, trans. J. Białostocka (Paris, 1990)

Madec, Philippe, *Boullée* (Paris, 1986)

Marin, Louis, 'Le Descripteur fantaisiste', in *Des pouvoirs de l'image* (Paris, 1993)

Mercier, Louis-Sébastien, 'La Ville de Paris en relief', *Le nouveau Paris* (1798–99; republ. in part in *Paris le jour, Paris la nuit* [Paris, 1990])

Poe, Edgar Allan, 'L'Homme des foules' and 'Le Jardin paysage', in *Contes, essais, poèmes*, trans. Charles Baudelaire Paris 1989)

Raeber, Willi, *Caspar Wolf, 1735–83, sein Leben und sein Werk* (Munich, 1979)

Saussure, Horace Bénédict de, *Premières ascensions du Mont-Blanc* (Paris, 1979)

Starobinski, Jean, 'La Cité géométrique', in *1789, les emblèmes de la raison* (Paris, 1973)

——, *Diderot dans l'espace des peintres* (Paris, 1991)

——, *L'Invention de la liberté 1700–89* (Geneva, 1964)

Vidler, Anthony, *Ledoux* (Paris, 1987)

Virilio, Paul, *L'Inertie polaire* (Paris, 1990)

ABOUT CINEMA AND THE PROJECTION ARTS

Ceram, C. W., *Une archéologie du cinéma* (Paris, 1966)

Derobe, Alain, 'Procédés de cinéma 360°, alias Circorama', *Le Technicien du film et de la vidéo*, 396 (15 November–15 December 1990)

Deslandes, Jacques, and Jacques Richard, *Histoire comparée du cinéma*: I. *De la cinématique au cinématographe (1826–96)*; II. *Du cinématographe au cinéma 1896–1906* (Tournai, 1968)

Dubois, Alain, *Les Vues d'optique* (Paris, 1912)

Grimoin-Sanson, Raoul, *Le Film de ma vie* (Paris 1926)

Marey, Etienne-Jules, *Le Mouvement* (Paris, 1894)

Milner, Max, *La Fantasmagorie* (Paris, 1982)

Prieur, Jérôme, *Séance de lanterne magique* (Paris 1985)

Robertson, Etienne-Gaspard, *Mémoires récréatifs, scientifiques et anecdotiques*, 2 vols (Paris, 1831–3)

Sadoul, Georges, *Histoire générale du cinéma*: I. *L'Invention du cinéma: 1832–97* (Paris, 1948)

Vivié, Jacques, 'Le plus grand Complexes de cinémas du monde à Bruxelles: Kinepolis', *Le Technicien du film et de la vidéo*, 375 (15 December 1988–15 January 1989), pp. 10–13

PHOTOGRAPHIC ACKNOWLEDGEMENTS

The author and publishers wish to express their thanks to the sources listed below for illustrative material and/or permission to reproduce it (this excludes cases where such material and/or permission to reproduce has been supplied by the individual or institution named in the caption). In a few cases, it has not been possible to trace the sources or copyright holders for particular images; the publishers would be grateful to hear from any such persons or bodies with a view to crediting them fully in any subsequent edition.

ACL, Brussels: 45; Atelier de Photographie CARAN, Paris: 48, 49, 73; Bridgeman Art Library London/New York: 81, 118; Trustees of the British Museum, London: 54–6; Geremy Butler: 5, 7, 13, 14, 21, 34, 37, 42, 61, 69; City Art Centre, Edinburgh: 103; © DACS: 160; courtesy of the Fondation Bourbaki-Panorama, Lucerne: 119; P. J. Gates: 12, 41; Giovanni Segantini Stiftung, St Moritz: 133–5; © Glasgow Museums: 100; Guildhall Library, Corporation of London/Geremy Butler: 37, 69; courtesy of Roger Hallett: 160–61; courtesy of Ralph Hyde: 136, 148–55; Institut Royal du Patrimoine Artistique, Bruxelles/Koninklijk Instituut voor het Kunstpatrimonium Brussel (© IRPA-KIK Bruxelles): 147; Herbert Jäger: 83; Kulturstiftung Meiningen: 91, 92; © Kunstmuseum Thun: 60; Mary Evans Picture Library, London: 5; © Museum in Docklands Project, London: 106; Öffentliche Kunstsammlung Basel (Kupferstichkabinet): 33; Öffentliche Kunstsammlung Basel (Kupferstichkabinett; Schenkung H. Albert Steiger-Bay): 32; Photothèque des Musées de la Ville de Paris: 12, 59, 115, 116; Prudence Cuming Associates: 111; Raiffeisen Reisebüro Tirol/Arno Gisinger: 79; Antonia Reeve: 75; Rheinisches Bildarchiv Köln: 19; Jean Rochaix/Kodak Pathé, Paris: 58; St Louis Art Museum (Eliza McMillan Fund): 93–7; Christoph Sandig, © DACS: 160; Schweizerisches Institut für Kunstwissenschaft, Zürich: 52; Ursula Seitz-Gray: 84; Staatliche Kunstsammlungen Dresden: 72; Staatliche Museen zu Berlin – Preußischer Kulturbesitz (Kupferstichkabinett – Sammlung der Zeichnungen und Druckgraphik): 22; © Swiss Federal Institute of Technology: 131; © The Board of Trustees of the Victoria and Albert Museum, London: 104, 107–10, 112, 113; Výstáviśte Praha: 114; Elke Walford: 71; Zentralbibliothek Zürich: 53.

INDEX